Come Together: Surviving Sandy, Year 1

COME TOGETHER

Surviving Sandy, Year 1

SKIRA | DEDALUS FOUNDATION

Cover
Industry City, Sunset Park, Brooklyn
Photo by Zack Garlitos

Back Cover
Bruce High Quality Foundation
The Raft of the Medusa, 2004
Courtesy of the artist

Design
Marcello Francone

Editorial Coordination
Emma Cavazzini

Copy Editor
Emily Ligniti

Layout
Barbara Galotta

First published in Italy in 2014 by
Skira Editore S.p.A.
Palazzo Casati Stampa
via Torino 61
20123 Milano
Italy
www.skira.net

Printed and bound in Italy. First edition

ISBN: 978-88-572-2502-9

Distributed in USA, Canada, Central
& South America by Rizzoli International
Publications, Inc., 300 Park Avenue
South, New York, NY 10010, USA.
Distributed elsewhere in the world by
Thames and Hudson Ltd., 181A High
Holborn, London WC1V 7QX, United
Kingdom.

Come Together:
Surviving Sandy, Year 1

Industry City, Brooklyn, New York
October 17, 2013 – December 15, 2013

- *Catalogue edited by*
 Jack Flam

- *Photographs of the artworks*
 Brian Buckley
 Taylor Dafoe
 Zack Garlitos
 Rachel Styer

- *Exhibition curated by*
 Phong Bui

- *Exhibition organized by*
 The Brooklyn Rail
 The Dedalus Foundation
 Industry City

- The exhibition organizers wish to
 extend a special thanks to the
 Dedalus Foundation, *The Brooklyn
 Rail*, Industry City, the Jamestown
 Charitable Foundation, the
 Pollock-Krasner Foundation,
 and the Helen Frankenthaler
 Foundation for making this
 catalogue possible. And most
 especially, thanks to all the artists
 who participated in the exhibition
 and authorized reproduction
 of their works in this catalogue.

THE BROOKLYN RAIL

DEDALUS
FOUNDATION

Helen Frankenthaler Foundation

JAMESTOWN
CHARITABLE FOUNDATION

THE POLLOCK-KRASNER FOUNDATION, INC.

Acknowledgments

Right from the time we began to work on the exhibition, *Come Together: Surviving Sandy, Year 1*, we discussed publishing a catalogue that would properly commemorate the event. Given the scale of the show and the complex logistics involved in realizing it, our hope was to have copies of the catalogue ready to celebrate the first anniversary of the exhibition; and we are now very pleased to have been able to do so.

In this undertaking, the Dedalus Foundation was materially helped by four partners, who provided both moral and financial support for the project: Industry City, the Jamestown Charitable Foundation, the Pollock-Krasner Foundation, and the Helen Frankenthaler Foundation.

Industry City and the Jamestown Charitable Foundation have been involved with the Sandy project right from the very start in planning the exhibition, to which they lent great support in a number of areas, including significant contributions to various preparatory and operating expenses, such as building out the space and acting as partners with security, shipping, and gallery minders, as well as sponsorship of the large and festive opening events. Under the leadership of Michael Phillips, Industry City and the Jamestown Charitable Foundation have also been main sponsors of this catalogue.

One of the great pleasures of the exhibition was the opportunity it gave us to walk through the galleries with a number of our colleagues from museums, universities, and foundations. Two memorable visits inspired colleagues to offer to help support the costs involved in the publication of this catalogue.

The Pollock-Krasner Foundation, which was established in 1985 to assist individual working artists of merit with financial need through the generosity of Lee Krasner (1908–1984), a leading abstract expressionist painter and widow of Jackson Pollock, is one of the best established and most highly regarded artist-endowed foundations. It was also one of the principal contributors of relief to artists affected by Sandy. Deeply concerned for the welfare of artists, the Pollock-Krasner Foundation opened its Hurricane Sandy Emergency Relief Fund within days of the storm and began accepting emergency requests for grants to professional visual artists. Under the guidance of its officers, Charles C. Bergman (Chairman and CEO), Samuel Sachs II (President), and Kerrie Buitrago (Executive Vice President), the Foundation award-

ed fifty-eight grants totaling almost half a million dollars to artists affected by the disaster. The Pollock-Krasner Foundation also partnered with La Napoule Art Foundation, MacDowell Colony, the Vermont Studio Center, and Woodstock Byrdcliffe Guild in providing residency space to artists affected by the storm.

When Charles C. Bergman and Kerrie Buitrago came to see the Sandy exhibition, they were not only very enthusiastic about the show itself but also impressed by how many of the participating artists had at one time or another been supported by the Pollock-Krasner Foundation: some before Sandy, others after, still others both before and after. With typical generosity, they volunteered to contribute to the production of this catalogue, which among other things is also a way of lending even further support to artists who were affected by Sandy.

We were equally gratified by the enthusiastic support of the Helen Frankenthaler Foundation, which is one of the newest artist-endowed foundations in the United States, and which has already begun to develop a rewarding series of philanthropic programs. Their support was also initiated by a visit and enthusiastic reaction to the Sandy exhibition by the Chair of their board of directors, the artist Clifford Ross. We were gratified when he and his fellow board members, Fred Iseman (President), Michael Hecht, and Lise Motherwell, along with their Executive Director, Elizabeth Smith, offered to contribute to the costs of producing this catalogue.

We also want to thank the board of directors of the Dedalus Foundation, which initiated this exhibition and made substantial financial contributions to both the exhibition and to the production of this catalogue. All the members of the board of directors—John Elderfield, Jack Flam, Steven R. Howard, Katy Rogers, David Rosand, Richard Rubin, and Morgan Spangle—were solidly behind this project, from the time it was first proposed to the creation of this catalogue.

During the production of the publication, a number of individuals played crucial roles. Most especially, we want to thank Sara Christoph and Katy Rogers, both of whom were moving forces behind the exhibition as well as important contributors to all aspects of the production of the catalogue.

• • •

This catalogue, of course, would not have come into being without the exhibition itself. And here we would like to thank at least some of the hundreds of people who worked on both creating and maintaining it. First and foremost, we want to thank our colleagues at Industry City for generously donating the spaces for the exhibition and undertaking the elaborate build-outs with a remarkable combination of speed and care. In addition to the corporate participation of Industry City (and its partners, Jamestown LLP, Angelo Gordon, Belvedere Capital, FBE Limited, and Cammeby's International), it was a pleasure to interact with so many individuals who worked so tirelessly to make the exhibition such a success. We especially want to thank Michael Phillips and Glen Siegel, who were so courageous in taking the risk of doing such a large exhibition; also Brian Flanagan and Andrew Peerless, who were so instrumental in how the exhibition took shape. Sal Coppola kept everything running ahead at full speed, even when it entailed staying until the wee hours of the morning. We also want to thank Andrew Kimball, Ben Berger, Jessika Cannon, Izzy Nachum, and Peter Terranova for their contributions.

At the Dedalus Foundation we especially want to thank Katy Rogers and Morgan Spangle, who played such crucial roles in putting together the exhibition and the programs that accompanied it, as well as Claire Altizer, Michael Mahnke, and Gretchen Opie, who contributed so much to making things come together so well.

At *The Brooklyn Rail*, Maggie Barrett, Elizabeth Bidart, Walter Chiu, Sara Christoph, Margaret Graham, Cy Morgan, Sara Roffino, Anna Tome, and David Willis gave sustained full-time support to putting the exhibition together, along with part-time volunteer curatorial assistants Jana Brooks, Gaby Collins-Fernandez, Taylor Dafoe, Owen Keogh, Sabrina Locks, Nathalie Nayman, Eric Sutphin, and Terence Trouillot. In addition, the contributions of John Ryan and John Thomson were instrumental to the exhibition's completion.

A number of the curatorial assistants have also written texts about individual artists in the show, which are being published on a new, elaborately illustrated website, "Come Together: Surviving Sandy," designed by Amelia Maffin, Dylan Fisher, and Seth Hoekstra. The authors of these texts for the website include Alex Allenchey, Rabia Ashfaque, Helena Blackstone, Williamson Brasfield, Gaby Collins-Fernandez, Sara Christoph, Taylor Dafoe, Noah Dillon, Margaret Graham, Maya Harakawa, Juliet Helmke, Megan Liu Kincheloe, Tori Potucek, Sara Roffino, Elizabeth Sultzer, Colin Sundt, Eric Sutphin, Samuel Swasey, Anna Tome, Terence Trouillot, Stephen Truax, and David Willis.

And finally, of course, we want to thank the artists, who were at the heart of the exhibition's success, and who have been so cooperative in supplying imagery and reproduction permissions for this catalogue. We cannot thank them enough for their generosity in lending works, and in many cases volunteering to help deliver and install their works, and for working together in such a heartening spirit of cooperation and camaraderie as the show was being installed. One of the most wonderful aspects of this show was the way in which it was full of intensely individual expressions in a broad range of mediums, and at the same time became an admirable manifestation of group solidarity. It was not only a great show, but also became a kind of embodiment of the innate generosity and energy of artists working in and around New York City.

Phong Bui and Jack Flam

Contents

15 Introduction
Jack Flam

19 The Beginning
Phong Bui

69 The Poetry of Space
Katy Rogers

93 The Beauty of Friends
Coming Together
Sara Christoph

121 Works

Introduction

Jack Flam

This book documents an extraordinary exhibition that was mounted at Industry City, a large industrial complex on the western shore of New York Harbor, in the Sunset Park area of Brooklyn, from October 17 to December 15, 2013. The reproductions consist mostly of installation photographs of works of art that were in the exhibition, along with photographs of the various events that took place while it was on view. Taken together, they are meant to evoke the breadth and energy of this historic event.

This monumental undertaking had its origins in a disaster of extraordinary proportions, the Atlantic storm named Sandy, which struck the northeastern United States in October 2012 and came to be known as "Superstorm Sandy." One of the most destructive storms in United States history, Sandy caused hundreds of lives to be lost, and resulted in property damage estimated at around $70 billion.

The full force of the storm hit New York City on the night of October 29. The timing and circumstances could not have been worse: the storm struck at high tide and during a full moon, which greatly magnified its effects. Surge levels in New York Harbor were almost fourteen feet higher than normal that night, and individual waves measured as high as thirty-two feet. In the wake of the storm, millions of people remained without electric power or were forced to leave their homes; major bridges and tunnels were closed; subways were flooded and railroads suspended service; and downtown hospitals had to evacuate their patients. Such conditions lasted for days in much of the city, and in some areas for weeks, even months; a number of neighborhoods are still recovering.

New York's artist community was especially hard hit. Many artists had studios in low-lying areas in Brooklyn, Manhattan, and Queens, which were flooded or lost power for extended periods of time. A number of art galleries and storage facilities were also damaged. In several instances, artists lost much of their life's work.

The storm was devastating, but the response to the devastation generated an enhanced sense of community. On the most direct and personal level, the friends and colleagues of individual artists came to help them clean up and try to salvage works and materials; and those friends were often joined by *their* friends, and even by strangers, which created a radiating network of assistance (figs. 1–2). Another important source of help came from a number of foundations and government

agencies that provided financial aid to artists, and in some cases found them temporary studio spaces.

Many professional conservators pitched in by donating their time and skills to help save damaged works. One of the most pressing, time-sensitive issues that follows in the wake of any kind of water damage is mold. In order to combat this, especially in works on paper, it was necessary to secure spaces for the volunteer conservators to work in that were large enough to allow air to circulate freely, so that the water-saturated works could dry properly. Especially significant efforts were made by members of the American Institute for Conservation Collections Emergency Response Team and by the Craft Emergency Relief Fund (CERF+), who quickly secured space in which to intervene with the greatest urgency. Industry City donated 18,000 square feet of space in which the conservators could do their salvage work.

That same fall, shortly before the storm, the Dedalus Foundation, which was established by the artist Robert Motherwell (1915–1991), had been in contact with Industry City about moving some of its activities there and about making Industry City the hub of its educational and curatorial programs. The buildings there, which were designed by the industrial architect William Higginson at the turn of the last century, contain large high-ceilinged spaces that are full of light and air. Our plan was to start with an exhibition in June 2013 of works by the winners of scholarships that Dedalus gives to graduating seniors in New York City public high schools, and to follow up with a larger, more general exhibition a few months later, during the following fall.

Given the enormous effect that Sandy had on so many New York artists, and the admirable pluck that the artistic community had shown in the face of the adversity created by the storm, we decided to devote our first large exhibition at Industry City to a commemoration of the first anniversary of Hurricane Sandy—a kind of coming together of artists who work in different mediums, which would emphasize the courage and resiliency of the New York art community.

In order to make such an undertaking succeed, we realized that we would need a gifted and well-connected curator who was close to the pulse of contemporary art. At the suggestion of Dedalus board member John Elderfield, I asked the artist and writer Phong Bui, who is also the publisher of *The Brooklyn Rail*, if he would be interested in curating such a show. Phong, who had lost the greater part of his own artistic production to the storm, was enthusiastic about the idea, and that July we went out to Industry City together to look at the potential space. Initially, the show was to have been confined to a gallery space of around 15,000 square feet located in the flagship building of the complex. But Phong, who was determined to include as broad a spectrum of artists as was possible, asked about another space that he thought might be available on the third floor of the same building; this was the space where the exhibition of the high school scholarship winners had recently been held. As we walked through that space, and through the beautiful, high-ceilinged space adjacent to it, Phong began to envision an exhibition that would run through several large areas of the building. His enthusiasm became contagious. Within a short time, the management at Industry City offered to make available some 65,000 square feet of space on the first, third, and sixth floors of the building, along with an adjoining 35,000-square-foot courtyard, for large-scale sculptures (figs. 3, 22). What had started out as a relatively modest proposal quickly turned into plans for one of the largest independent art exhibitions ever mounted in New York City.

I should clarify what I mean when I say that these spaces were made "available." All of these spaces were empty and quite raw, so in promising them for the exhibition, Industry City undertook—at its own expense—an enormous construction project. This included the refinishing of floors, the building of temporary walls,

installing lighting, and even activating automatic elevators expressly for the show. As the construction crews began the build-out, Phong and his team of curatorial assistants began to contact artists, make studio visits, and build scale-models of the exhibition spaces (fig. 5). This was an exciting time, and it became even more so when we announced an opening date of October 17, which put everyone under an extremely tight deadline. As the pace of organizing the show picked up, it was hard to say which was more impressive: the extraordinarily speedy construction of the gallery spaces by the Industry City crews or the extraordinary speed and intensity with which Phong and his team of curatorial assistants put the show together.

The way Phong worked with his team of a dozen young curatorial assistants added a significant dimension to the educational aspect of the exhibition. Right from the beginning, the Dedalus Foundation wanted the exhibition to have a strong educational component, in line with its goal of informing the public about modern art and modernism. To this end, we planned a number of educational activities, such as visits by school groups and programs about the protection and conservation of artworks. The curatorial workshop that Phong in effect conducted as he and his assistants put the show together added yet another dimension to the educational aspect of the show. The curatorial assistants learned important lessons about constantly keeping in mind the overall concept of the show while paying careful attention to small details. This intense learning experience embedded the educational aspect of the exhibition right into the very fabric of its creation. (And several of the curatorial assistants later led gallery tours for children.) Moreover, they got a kind of baptism by fire as they learned how to put together such a vast exhibition in such a short time.

Early on, Phong decided not to confine the exhibition only to artists whose work had been directly damaged by Sandy, but to include other artists who would exhibit in solidarity with their storm-ravaged colleagues. This gave the exhibition a greater breadth and also made it clear that even artists who were not directly hit by Sandy were nonetheless affected. The feeling of openness was further enhanced when Phong asked the artists themselves to suggest other artists whose work they thought should be included. Having friends choose friends echoed the ways in which artists had helped not only their friends, but also the friends of friends, in the immediate aftermath of the storm. And this, too, allowed for greater inclusiveness.

While the exhibition was taking shape, we also began to work on a number of programs that would run throughout the duration of the show. These were organized largely by Katy Rogers, Programs Director of the Dedalus Foundation, and Sara Christoph, Managing Director of *The Brooklyn Rail*. The impulse behind these programs was to emphasize the coming together of all the artistic communities of New York. So in addition to putting on display the works by visual artists, we also invited choreographers, dancers, musicians, poets, and writers to participate. This resulted in a number of splendid dance performances, curated expressly for the exhibition spaces, which made those spaces come alive in exciting and dynamic ways (figs. 35, 39). One wonderfully idiosyncratic event was a whole afternoon and evening of musical performances by visual artists whose works were in the show (fig. 45). A number of poets read works that we commissioned, on themes of disaster; and a panel of writers discussed their own treatments of themes that touched on historical disasters. There were also programs related to how artists could protect and, when necessary, conserve or restore works of art. In addition to panel discussions between artists, curators, and conservators, Lauren Shadford Breismeister, the Executive Director of the United States section of the International Network for the Conservation of Contemporary Art-North America (INCCA-NA), organized a series of videotaped oral history interviews that took place every Satur-

day during the run of the exhibition, in which artists whose works and studios were damaged by Sandy spoke at length with conservators from a number of different museums and universities.

As the reader will see, this exhibition had an enormous range. It included artists working in many different styles, and in a broad range of mediums that included painting, sculpture, photography, video, film, and installation art. It also mixed together, often side by side, works by well-known artists, such as Chuck Close, Alex Katz, Nari Ward, Rona Pondick, Richard Serra, and Kiki Smith, with works by artists who were less well-known, and in some cases hardly known at all. Further, it brought together artists of many different ages: the youngest of the more than 325 artists in the show was in his early twenties, the oldest in his early nineties.

In this book, we have tried to convey the way the show was installed by illustrating most of the works as they appeared in it, often with some of the surrounding floor or walls visible. The installation, with works by such a wide variety of artists sharing the same large industrial spaces, was electrifying. It conveyed the sense that here, at last, was a real, unfiltered cross-section of the dynamism and variety of the actual New York art world. This was remarked by many visitors to the show, and eloquently expressed by Roberta Smith in her review of the exhibition for *The New York Times*, where she noted that the exhibition was "an affirmation of New York's cultural vitality through a wide sampling of artists," and asserted that "this egalitarian show makes palpable the greatness of New York's real art world."[1]

The exhibition was very well received. Large numbers of people came to see it, including the directors and curators of many museums, and it was widely praised in the press. *New York* magazine even listed it first among the best art exhibitions in New York during 2013! All of this gave us great pleasure. But an even greater source of pleasure came from the way in which the exhibition brought together so many different constituencies: not only artists, dancers, musicians, poets, museum people, and writers; but also school children who became involved in spirited discussions; people from the local neighborhood, who were stimulated by having such an event held right near their own front doors; college students, who came both individually and along with classes that were studying modern art; and citizens, by which I mean people who had no professional relationship to the arts, but who wanted to see and partake in the energy of contemporary art in an informal and welcoming setting.

For the Dedalus Foundation, this sense of community is especially important. Our founder, Robert Motherwell, who coined the term "New York School" back in 1950, would have been very proud of this exhibition, which brought together the artists of New York in such a dynamic and impressive way. Motherwell was deeply involved in art education, and was a great advocate for solidarity in the community of artists; indeed he was a great proselytizer for modern art at a time when visual artists—and American modernists in particular—were not nearly as widely accepted as they are now.

This catalogue, like the exhibition on which it is based, presents a cross-section of some of the most exciting work produced in contemporary art over the last decade, by artists whose careers have spanned the last half-century. It is a testament to the courage and resiliency of the community of artists in all mediums, and, in the very fullest sense, a coming together.

[1] Roberta Smith, "Art, a Balm After the Storm," *The New York Times*, December 7, 2013, pp. C1, C7.

The Beginning

Phong Bui

"Some memories are like friends in common; they can effect reconciliations."[1]
Marcel Proust

When I was growing up in Hue, Vietnam, in the late 1960s and 1970s, two primordial forces of destruction colored my life. The first force was man. Just as it did the country, the war divided members of my family—after the Geneva Conference in May 1954, one-half went to the north, the other half remained in the south. The second force was nature. Because of Vietnam's tropical wet climate, monsoons constantly flooded the land. (I remember on one occasion our family stayed on the second floor of our house for two weeks; after another storm, my siblings and I went to school by boat.) Since then, I've seen many reminders of man's potential for destruction. Endless conflicts have afflicted the world since my departure from the old country and arrival in the US in 1980. But my memories of the potency of nature lay dormant until "Superstorm Sandy" abruptly rekindled them in October 2012.

The night before the storm's arrival, the New York City subway system shut down at 7 pm. That same evening, my solo exhibition was scheduled to open at Showroom Gallery on the Lower East Side. Curiously enough, that exhibition (*Work According to the Rail, Part I: After the Flood*), was titled after what then seemed to be a devastating event—a relatively minor flood that had destroyed some works in my basement-level Greenpoint studio a few weeks earlier. Too excited (and logistically overwhelmed) to postpone the opening reception, we simply moved it up to 5 pm. Despite the early opening time, a crowd gathered at the uncharacteristically early opening undeterred, disregarding the eerie mood that was settling over the city. It was an oddly exemplary New York moment.

The next morning, my wife, a friend with a neighboring studio, and I set to work battening down. We covered tabletops resting on three-foot high sawhorses with everything we could fit: oil paintings, works on paper, books, art materials, equipment, and everything else we hoped to safeguard from the storm. We sealed the doors and windows with insulation boards and weatherproof expanding foam. Despite our thoroughness, when we finished our preventive efforts, our faces were filled with expressions of apprehension; we were hoping against hope that Sandy would be much milder than the news predicted. After all, the previous summer,

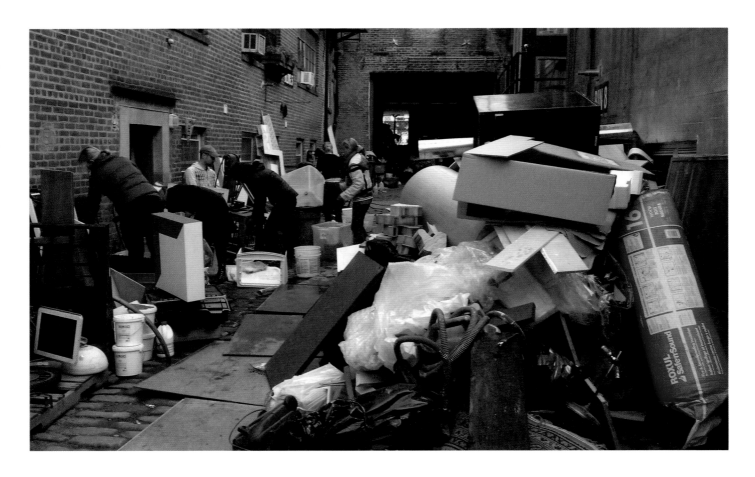

1. Studio of participant artist Rachel Beach, Brooklyn. October 2012
Photo courtesy of the artist

Mayor Bloomberg had ordered an unprecedented mandatory evacuation of the city's coastal areas in anticipation of Hurricane Irene—only to have the storm fail to inflict much damage. So it was with some optimism, and a certain amount of self-denial, that we waited for the storm to hit, hoping that the media's predictions were simply overblown.

Sandy made landfall that evening. By 9 pm, the water level was rising. We decided to wait it out in the *Rail* headquarters on the second floor of our building, even though we were located in the mandatory evacuation ("red") zone. We didn't, maybe couldn't, quite grasp the gravity of the situation. Desiring a distraction (and perhaps, subconsciously, a model of courage), we watched Bruce Lee's *Enter the Dragon*—and miraculously never lost electric power. Periodically we checked downstairs, and it became apparent that the severity of the storm far surpassed our expectations; a great flood was inevitable. Our building is only about 300 feet from the shore of New-town Creek, its first floor at ground level. Soon enough, a river ran clear through the building from the street to the opposite end; the rising water completely obscured the creek and surrounding streets.

By 1 am the water subsided. The next day it became clear, to my great sadness, that the vast majority of my work from the last twenty-five years, along with a substantial portion of *The Brooklyn Rail*'s archives, had been submerged and destroyed. My friend Cy Morgan's studio, only three months old, suffered the same fate, as did the studios of several of our fellow artists.

We had underestimated not only the storm but also the erosive qualities of the North Atlantic saltwater. The floodwater destroyed virtually everything that was submerged in it. All the artists in the building attempted to salvage what they could. Rachel Beach's precise wood sculptures became swollen, their joints contorted and displaced (fig. 1). Most of her carpentry tools and machinery were ruined; Bill Schuck's idiosyncratic paper and ink contraptions, built with mechanical apparatuses, were also ruined; Lee Tribe's welded steel sculptures survived—though with undesired patinas—but the saltwater decimated his welding facility; Cy Morgan's delicate as-

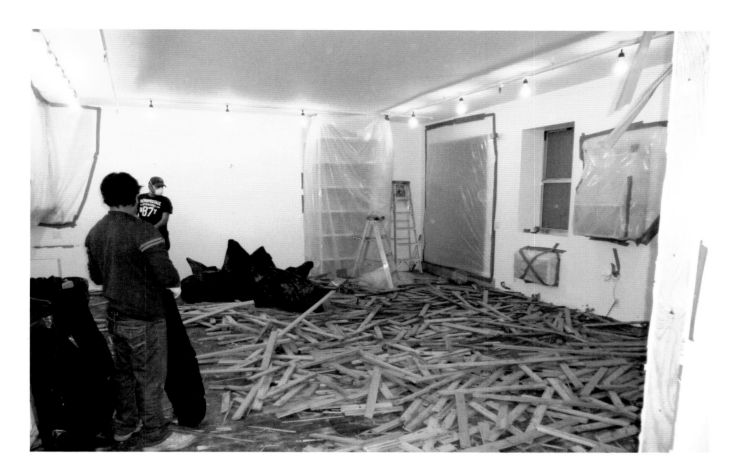

semblages, made with found objects and ephemeral materials such as paper, card-
board, wood, and plastics, had floated apart into unidentifiable detritus. Sorting
through the aftermath in the studio and (with the help of the *Rail* team) cleaning up
the wreckage while keeping up with the daily demands of publishing our beloved
journal and other myriad commitments, was, needless to say, a profoundly memo-
rable experience. Not since the formative years of the *Rail* had I felt such a commu-
nal spirit. Everyone rose above his or her usual capacity to keep the publication run-
ning smoothly, and stayed late to restore stability to the studio. During the course
of recovery, I willfully distracted myself by keeping busier than ever, never stopping
to dwell on the trauma. But the time to address it did come several months later.

On an afternoon in early June 2013, Jack Flam paid a visit to *Rail* headquarters.
He and I had met before a few times, but had not had a chance to talk at great length.
I had known his books on Matisse since my college days, and so looked forward to
talking about French painting. But our conversation turned out to be quite wide-
ranging and free-flowing, and touched on poetry and music as well as art. Then at
one point Jack asked whether I would consider curating an exhibition to mark the
occasion of Hurricane Sandy's one-year anniversary at the Dedalus Foundation's
satellite space in Sunset Park's Industry City. I accepted his invitation without blink-
ing an eye because I felt I was about to embark upon something of great symbolic
significance. I remembered this story told by Oscar Wilde:

> There was a king with one eye. To replace the missing eye the king searched across the
> land and found a renowned magician whom he commissioned to craft him an artificial
> eye. When it was complete, no one in the kingdom could tell the difference. One day a
> murderer was brought before the king, to be either pardoned or put to death. The king
> told this murderer of his artificial eye and its perfection, how no one in the court and the
> kingdom could tell the difference. He said, 'Now, if you can tell me which eye of mine is
> real, I will pardon you!' Without a blink and barely a glance, the murderer responded,
> 'Your right eye is the real eye, your majesty.' The king, impressed by the murderer's quick

3. Industry City, Sunset Park, Brooklyn
Photo by Zack Garlitos

4. Industry City, Sunset Park, Brooklyn
Photo by Zack Garlitos

reply said, 'You're right! But how did you know?' The murderer answered, 'I know because the right eye has a glint of mercy in it.'[2]

I believe that intuition should be used judiciously—but decisively, when it's important. At that moment, I trusted my intuition.

I took part in several meetings with the principal owners of Industry City, but I entrusted Jack to be the main proponent to rally the collaboration between the *Rail*, the Dedalus Foundation, and Industry City. As our working relationship developed and became firm, our exhibition expanded from a 15,000-square-foot space to six spaces, scattered through the enormous building and its expansive courtyard, which altogether totaled 100,000 square feet, three times bigger than the Whitney Museum's exhibiting space. I chose to take on a space of this magnitude because I knew, from my experience as publisher of the *Rail*, that since I had access to many artists I could feature a wide range of the art that had been produced during the last few years. Although the exhibition would entail a great deal of work with a very close deadline, I thrive on working under pressure, and I knew that I would have the team at the *Rail* completely behind me.

By late June, when the total space was completely committed, I began to make a preliminary list of artists I knew firsthand in Greenpoint, Red Hook, Lower Manhattan, Staten Island, and the Rockaways who had lost work to Sandy. My original shortlist named nearly sixty artists, including Diana Cooper, Ron Gorchov, Suzanne Joelson, Ronnie Landfield, Ray Smith, Darren Jones, Donald Moffett, and Gary Stephan.

Meanwhile, discussions continued about the exact shape and scope of the exhibition, and we parsed out the brass tacks of transportation, budgeting, and installation. Given the size and raw condition of the space, this was no mean feat; we had to consider the cost and logistics of building out the walls, installing track lights, utilities, and insurance, in addition to taking care of security, art handlers, installers, gallery minders, and a number of other administrative expenses. I quickly assem-

bled a curatorial team—comprised of many volunteers—which included *Rail* production assistants and my former graduate students at the School of Visual Arts. Cy and I began to build models for the six galleries, as well as set up large wall calendars for the next four months (figs. 5–6), counting out and scheduling events for the exact number of days leading to the VIP opening that was planned for October 17, 2013. Even before many details were finalized, I began an exhaustive schedule of studio visits. We were off to a running start.

"Call and Response" Curation[3]
"To live in a long tube, be thin. To live in a barrel, be round."[4]
Vietnamese Proverb

The first two weeks of July proved to be the most challenging in clarifying the vision of the exhibition. How could we devise a legible, efficient timeline on everyone's calendar with such a sprawling, massive project? We hit a roadblock when we discovered that several organizations, such as the New York Foundation for the Arts and a number of Sandy-damaged Chelsea galleries, were unable to disclose their lists of artist victims for legal reasons. Since people are often ill disposed to look backward, especially to tragic events, I realized that we had to proceed quickly, and with other options, namely, by having the artists themselves be the main resource.

On Wednesday, July 3, I visited the ground-floor studios of James Hyde and Josiah McElheny. Both artists have studios in a building close to the Gowanus Canal; a four-foot-high waterline was boldly visible on the building's outside walls. Several of Hyde's glassed box paintings were in the process of being restored. McElheny's new ceramic kilns had recently replaced those that had been shattered by Sandy. All of their walls and electrical outlets had been rebuilt and rewired. Both were filled with brilliant optimism. They were excited by the exhibition, and in turn speedily suggested I immediately visit Mike Cloud, Wendy White, Dustin Yellin, Michael Joo, Bosco Sodi, and Ray Smith.

It's important to note that though the artist network instantly spiraled outward, several were not able to participate because they either had no work or were in the middle of legal disputes with their respective galleries or insurance companies, not to mention matters such as illness or previous commitments to travel. Still, the trail branched out. Word of mouth traveled fast.

Within a day after our visits to the studios of Dustin and Ray, which was followed by a meeting with G.T. Pellizzi, they in turn provided us more names among their friends who were Sandy victims. These included Daniel Turner, Rita Ackermann, Colin Snapp, Ben Keating, Nicole Wittenberg, and the Bruce High Quality Foundation (BHQF, or The Bruce). Every single one of the artists was more interested in talking about how to rebuild and revivify what he or she could from the salvageable works, as well as ideas for the exhibition, than grieving over what had been lost.

Anecdotes emerged. Ray, for example, discovered the theretofore-unknown extent of his daughter Mariana's organizational prowess when she charged herself with the responsibility of reconstructing his studio and restoring the works in it. She is now Ray's studio manager. Michael Joo matter-of-factly detailed the loss of all his personal archives, along with several works from the past few years, and his precious vintage motorbikes. He spoke movingly of fellow artists Byron Kim, Lisa Sigal, and their three children, who lent their hands to clean up the studio for days and days afterward.

All of the little accidents and generous gestures of sharing reaffirmed the cause. This generative, quick pace soon led to a natural decision to forego a mournful and sad sentiment in favor of the more affirmative spirit of solidarity. The exhibition would

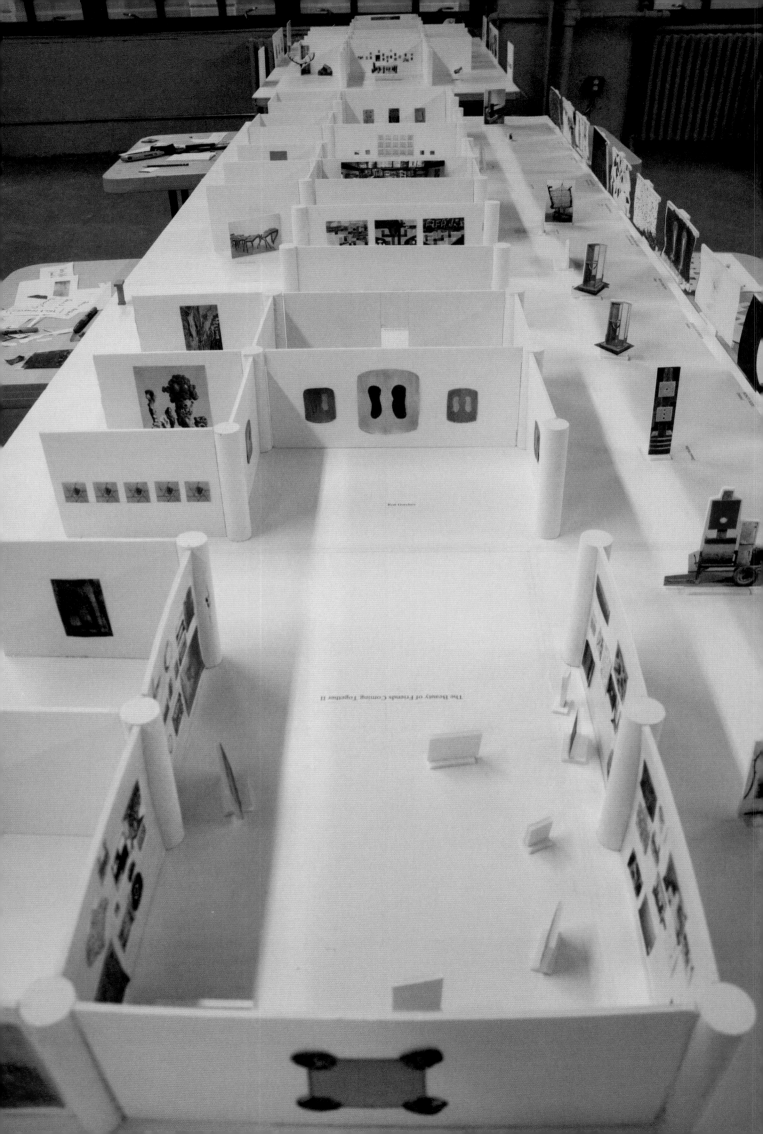

The Beauty of Friends Coming Together II

be divided in half: one half would be dedicated to the artist victims, and the other half would be comprised of artists invited to join in the esprit de corps.

While I was in Daniel Turner's Greenpoint studio, looking at his ambiguous sculpture (from a distance it seems to be two caskets, and up close it resembles a trough or a countertop sink), he explained how the subtle erosion and soot on the surfaces of the aluminum tops resulted from a pool of saltwater left over from Sandy's retreat (fig. 8). Images of paintings of seas and lakes that I had seen in Alex Katz's studio over the years flashed into my mind. As soon as Daniel offered his diptych for the show, I telephoned Alex. We selected three monumental paintings: *Marine II*, *Rock 2*, and *Rocks*. They, like the artist's other paintings of rural Maine, were images of Lincolnville Beach, where he and his wife have spent every summer since 1952. Their sizes were perfectly proportioned to the entire front wall on the ground floor— a natural rapport. The dynamic between the works by Turner and Katz was interesting not only because they both contained representations (subtle and overt) of water as an eerie presence, but also because it embodied the cross-pollination of generations (an older artist and a younger one) and prominence (a very well-known artist with a lesser-known one). Back at the office, Cy printed out the scaled images, and the steadily filling foam core model acquired more content.

In the same way that works placed together can contrast with and complement each other, so also can an installation artist counter-balance his or her space, by sensitivity to the specific site. Diana Cooper, whose archives had been destroyed, was one of the first who came to Industry City for a site visit. She quickly noticed a sprinkler system painted in fire safety bright red at the front of the third floor. Her visual recognitions became her work's pictorial vehicle in terms of form and color, and prompted a specific configuration of the wall build-outs in her space (figs. 9–10). In her installation of four elements, *Constellation Vanity (2)*, *Bale*, *Safety Last*, *Silver City*, the viewer was faced first with a blue wall, centered by a very large reproduction of an electrical outlet and a generous patch of AstroTurf (upon which two groups of red and white plastic cones were scattered on either side). Behind this was a back wall (part of a discrete square-shaped room) that blocked the windows facing New York

5. Curatorial model built by Phong Bui and curatorial assistants. August 2013

6. Curatorial model. August 2013

Harbor. Into this wall several circular holes of various sizes were cut, through which the vista of the waterfront, along with the Statue of Liberty, could be seen. Alongside the holes she placed many smaller, circular mirrors mounted on red Sonotubes. PVC pipes extending from red sprinklers wove in and out of the holes; they evoked a fragmented constellation.

Diana's response to detail and mass, encapsulated by the winding red sprinklers, naturally responded to G.T. (Tona) Pellizzi's installation *The Red and the Black*, which was situated right next to hers. Conceptually based on Stendhal's famous novel of the same title, the installation was made of nine plywood walls, a two-by-four-foot skeleton of a room (slightly scaled down from its original incarnation at Y Gallery on the Lower East Side). At Y Gallery, Tona had put the room's glossy red walls up for sale by the square foot according to the real estate values of the neighborhood; on the final day of the show they were cut to order. In *Come Together*, Tona's piece, now the armature alone with its carpeted interior, altar-like pedestal, and a couple of cut pieces hanging on the wall nearby, occupied just a fragment of the third floor space. The stark contrast to its original context introduced issues of displacement, re-placement, and the slippage of capital into the work.

Meanwhile, the organizational meetings continued to evolve with positive results. Additional funding was committed by the Dedalus Foundation and Industry City, and a vigorous public relations campaign was mounted. We decided to use BHQF's *Raft of the Medusa* on posters, t-shirts, and the website. The central image is a copy of Géricault's *Raft of the Medusa*—a painting famously depicting a news story of the time about the heroism and treachery of desperate passengers on a wrecked ship. BHQF's version is set on the shores of the East River, and mingles absurdity with the aftermath of a storm. *Rail* Art Director Walter Chiu designed the Sandy logo—which graced not only all promotional materials but also an enormous banner that flew outside Industry City's massive warehouses—in response to this image. The logo features a circle—the universal symbol of unity and continuity—with a pigeon inside, flying while grasping a rat in its talons (fig.14). We all know there are plenty of rats in New York (and pigeons!). They are tough and durable. The much-maligned pigeon is essentially the larger version of the peace-evoking dove—and it was a dove that found land when Noah's Arc was afloat, as the story goes. The absurdity of this unlikely friendship, and the deliverance from the deluge to a new beginning—in essence, their solidarity to be free—carries the pair over the lapping wave within the circle. Artists, more than most, understand the relentless struggle required to sustain a rhythm of work over a lifetime. And they also understand the lightness of spirit they gain as a reward. In times as unnatural as natural disasters, that lightness of spirit comes from the artist's community, as the words that curl around the logo's outer edge indicate: "Come Together."

The exhibition spaces began to take shape. Floors were patched and sanded. Walls went up. And every day it seemed the total budget needed to be adjusted to accommodate the needs of the art. Several artists (or their gallerists) whose works were heavy and large in scale graciously offered to cover transportation costs themselves (notably Mark di Suvero, Mel Kendrick, Joel Shapiro, and Dustin Yellin). Many others volunteered to bring their works to the site on their own (including Ethan Ryman, Cordy Ryman, Ben Keating, Ray Smith, Chris Larson, who drove from St. Paul, Minnesota, and Cameron Gainer, who flew over from Minneapolis). And almost all of the 200 participants of *The Beauty of Friends Coming Together I & II* brought their own works (pp. 93–119).

Dustin Yellin's *The Triptych*—a 12-ton glass, acrylic, and collage sculpture measuring 49 by 216 by 27 inches and resting on six blocks of solid wood—most directly addressed Sandy's deluge (fig. 11). I first saw it in his Red Hook studio and knew

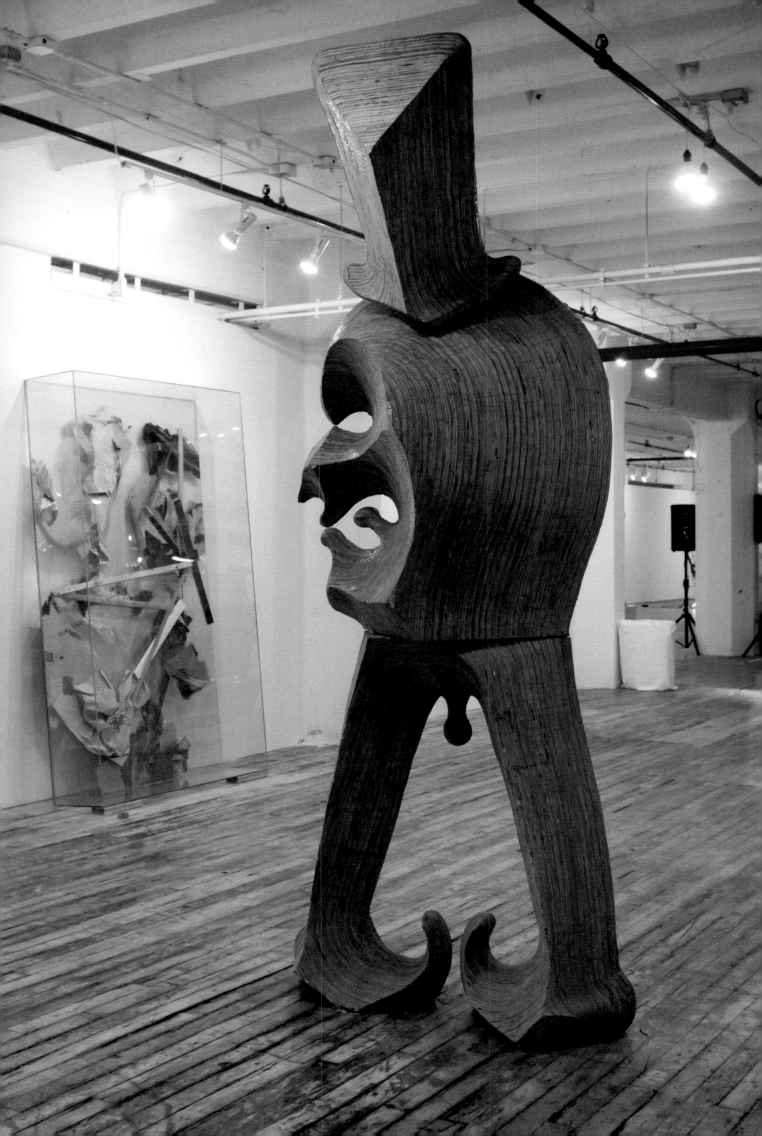

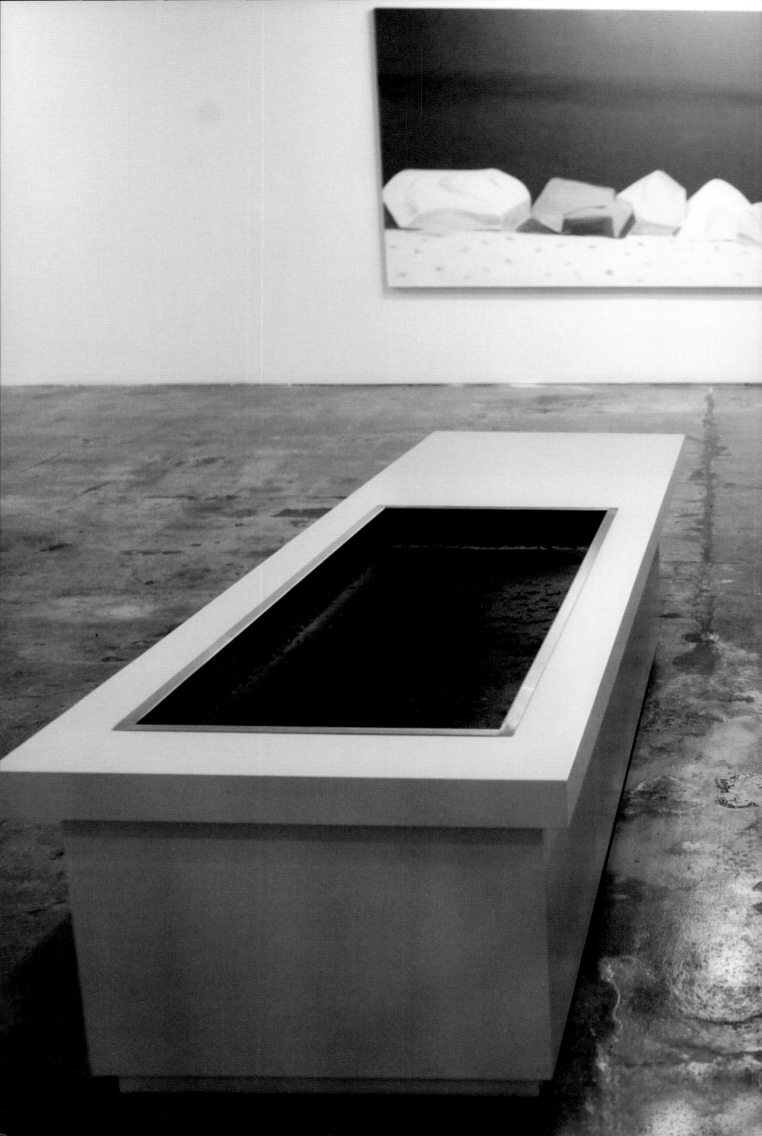

9. Site-specific installation by
Diana Cooper, *Safety Last*, 2013
Courtesy of the artist. Photo by
Zack Garlitos

Following pages
10. Site-specific installation by
Diana Cooper, *Constellation
Vanity (2)* (detail), 2013
Courtesy of the artist. Photo by
Cathy Carver

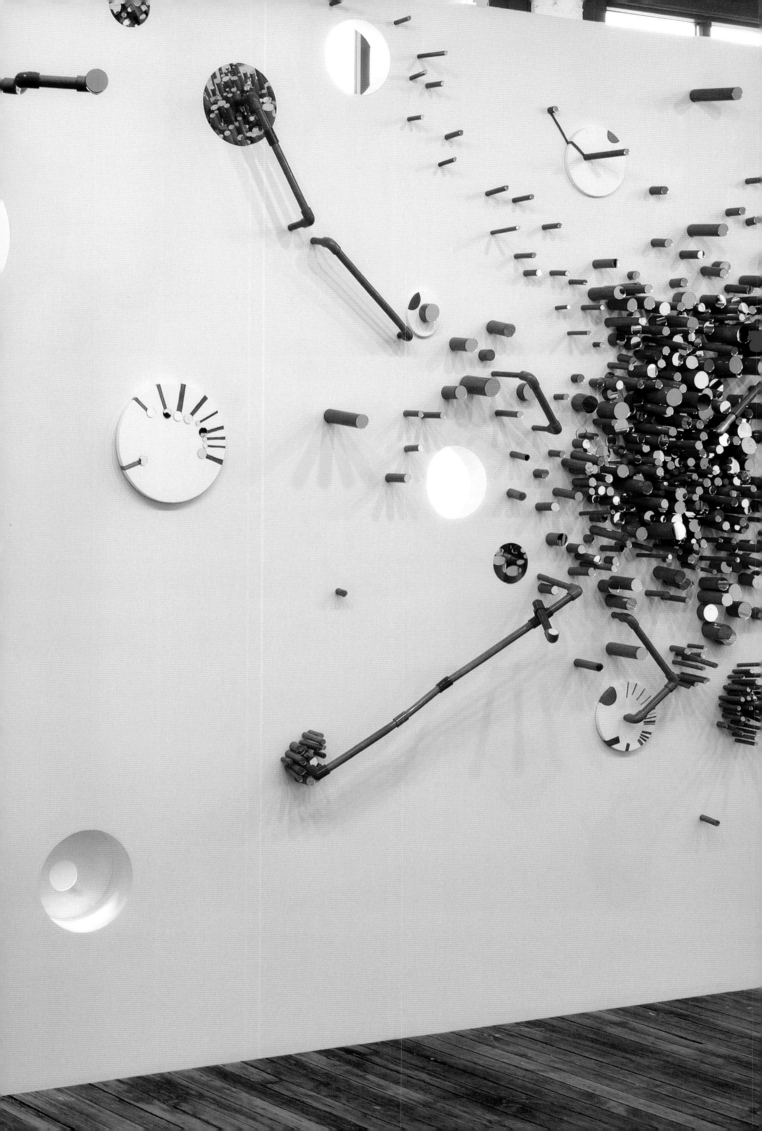

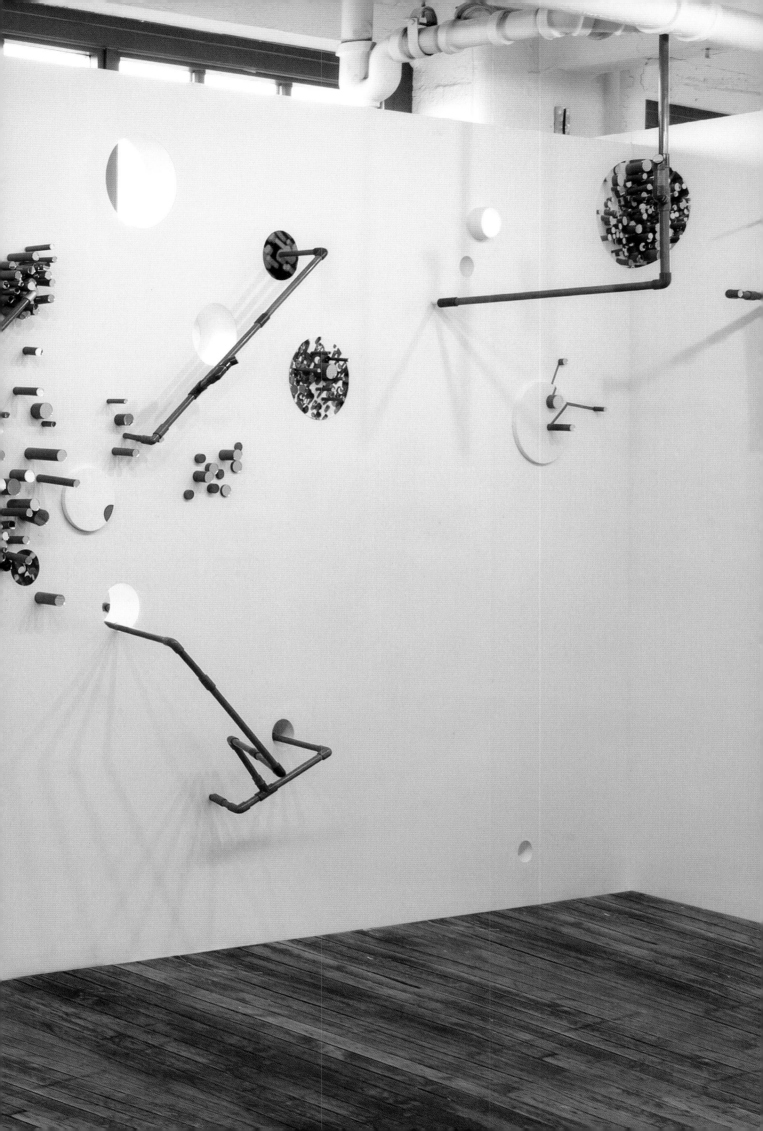

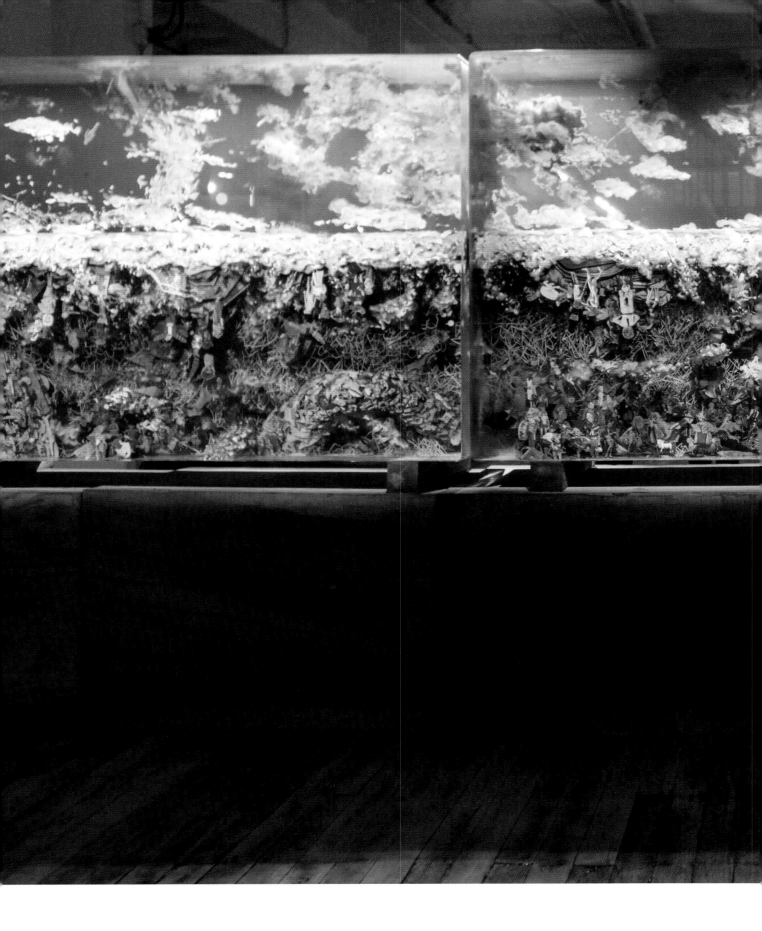

11. Dustin Yellin, *The Tryptich*.
Installation view
Photo courtesy Billy Farrell Agency

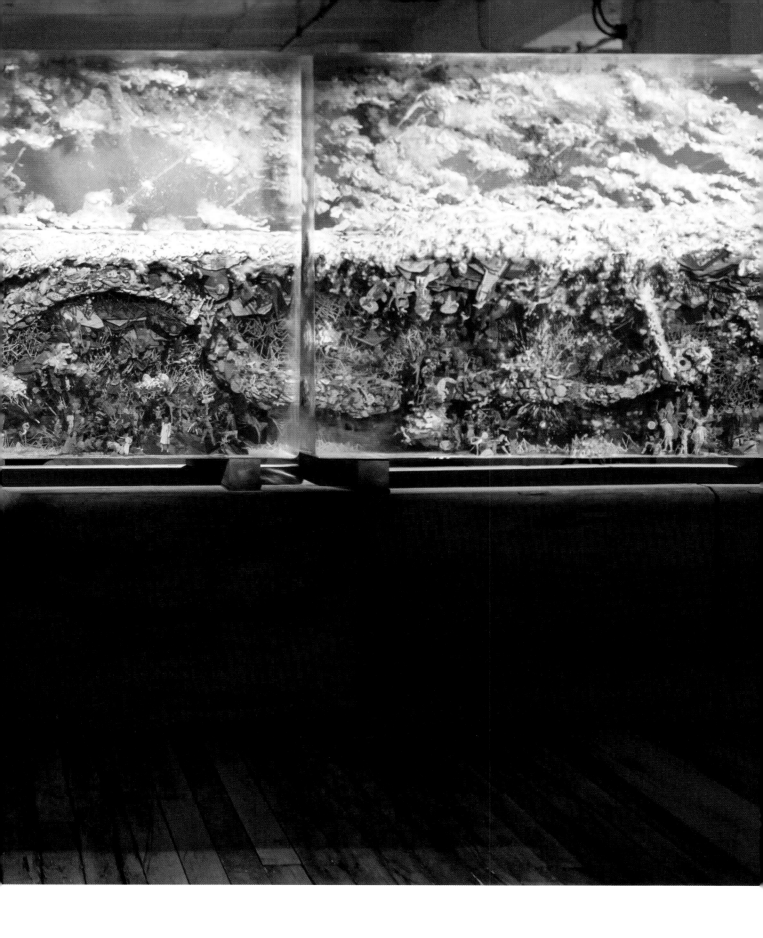

immediately that I wanted to feature it. It's a visual feast that prompts simultaneously apocalyptic and utopian visions, while achieving the improbable synthesis of pseudo-history, pseudo-science, and pseudo-archaeology, ultimately fusing the senses of times past, present, and future. *The Triptych*, a scene of the artist's "Lost City of Atlantis" series was finished just weeks before Sandy's arrival—soon after its creation, it was submerged in the storm's floodwaters. (Thanks to the glass's impenetrable surface *The Triptych* was untouched by the water.)

Installing it was a feat. We had to consult with Industry City's Chief Engineer Dan Wapner, who provided exact instructions on loading the work, which Dustin's own team efficiently carried out. (Dan had raised the question of installing I-beams as a supporting structure to the basement ceiling, but he came to the conclusion that the concrete floor was strong enough; and indeed it was.) After the apprehensive installation we saw it was a "coup d'état,"[5] on both counts—Dustin's final commitment to display the work and the success of the installation—as the artist himself said; it held the weight of deceptive translucency.

Ben Keating's solid aluminum casts of dilapidated furniture (*Living Room Trio, Portrait of her by a sculptor 1pm, Portrait of her by a sculptor by 7:30pm, Her Door is Always Open, On her time*) looked as though they had been sunk within Atlantis (fig. 12). Culled from his now-deceased grandmother's home, as though they were metaphors for the violence of devastating weather that flooded his entire studio with water from the East River, the objects felt like an exploration of the power of negative space. One senses that Benjamin is gesturing an equally assertive puncture as that of Lucio Fontana's powerful slashed canvases.

As the process of building the exhibition developed, so did the athleticism of the whole endeavor. And I don't mean my own—although I did plenty of running around—or that of the workers, though their labor was tremendous. What I'm referring to is the energetic "call and response" pattern that began to take root and grow. One finds the call and response in sports arenas or in protests; it creates enthusiasms, forges connections, and transmits messages. With each new artist added, an apt reply seemed to almost automatically appear. The instruments of many different minds came together and became orchestral.

Ray Smith has been a mentor figure for his younger comrades of The Bruce; since the collective was founded in 2004 (in the same Bond Street studio as Ray's), they have in so many ways reaffirmed the fluidity of collaboration. In this exhibition, Ray's sculpture of a quasi-figure with an enormous head, *Keegan*, stood on the threshold of the ground floor gallery like a guardian angel-cum-club bouncer (fig. 7). His three other abstract assemblages, *Chico Huevon, La Inferneva, Pollo Peking*, demonstrate his masterful ability to maximize simple materials and forms into endlessly associative images. Ray was also able to turn the havoc wrought by Sandy to positive advantage. Sandy's saltwater had created irregular patinas and rust on the wood and metal surfaces, which he was able to assimilate into works that fed off the vigorous collision between abstraction and figuration without trivializing either. The spirit of anarchy and critical perspective that bubbles below the surface of Ray's sensibility is also evident in The Bruce's oeuvre. BHQF is generally known for the way it makes institutional critiques through playful intervention. The two works featured in the show, *Stay with Me, Baby* and *Pizzatopia*, are as much about the intense economics of New York City as about the issues of labor and authorship (fig. 13). These pieces were sequestered in an iron and glass room on the first floor, a cage of sorts, in which they evoked the intersections of history and art. *Stay with Me, Baby* (two blow-up union picketing rats; one inflates while the other deflates, like lungs) evokes the flying pigeon grasping her hanging rat; the intersection of the two animals displays a solidarity to be free from the cage.

12. Ben Keating, *Her Door is Always Open*. Installation view
Photo by Brian Buckley

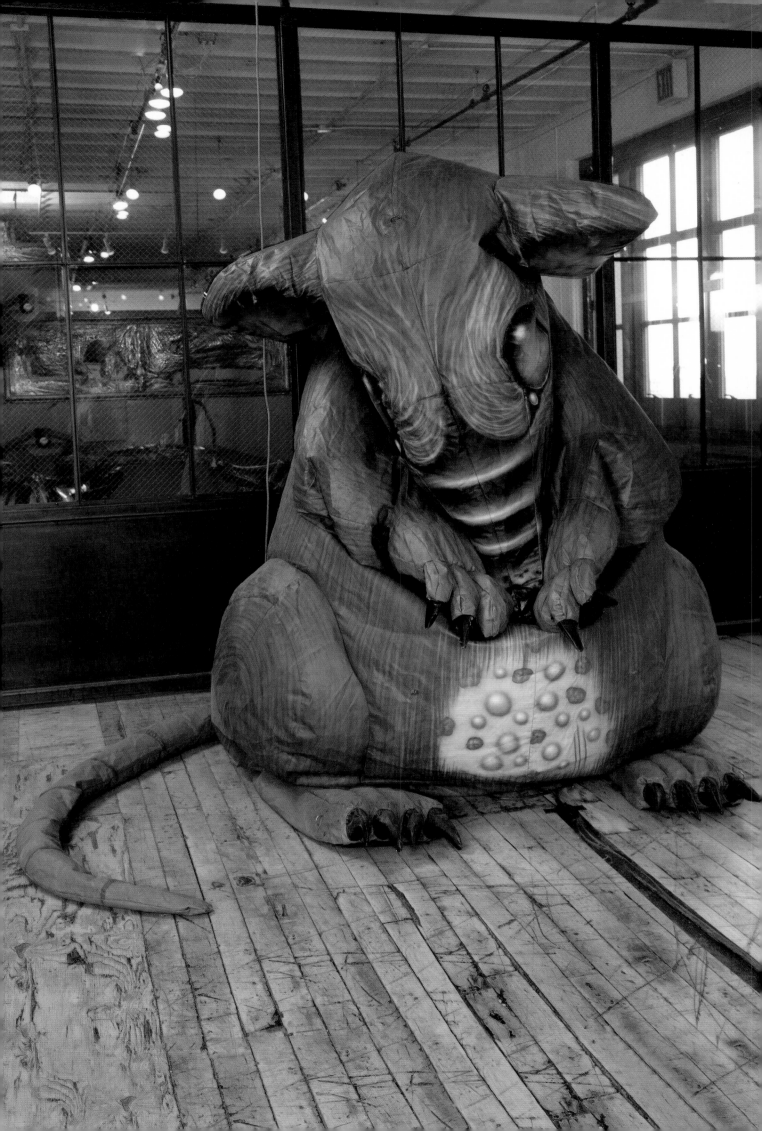

Color and light, as well as order and spontaneity, also began to evoke "call and response" throughout the show. Joanna Pousette-Dart's geometric abstractions and Ronnie Landfield's lyrical abstractions, facing each other from opposite walls, were equally compelling in contrast (pp. 189, 232). Joanna's *2 Part Variation (Yellow, Red, Green, Black)* and *2 Part Variation #2 (Red, Yellow, Blue)* avoids identification with a pre-determined language of abstraction, and offers a highly personal commitment to expand the constraints of particular, curvilinear color modulations. The shaped canvases are stable in form yet unstable in movement. Landfield's soft edges and infused images, by contrast, refer to natural phenomena. *The Deluge* and *After the Deluge* seem, in both their titles and pictorial language, predictive of Sandy by more than a decade.

SUPERFLEX's film *Flooded McDonald's* inadvertently augured Sandy's arrival by more than four years (pp. 264–265). I thought of this work, in fact, as one of the hearts of the exhibition, and it was displayed in the very center of the third floor center gallery. *Flooded McDonald's* depicts a spot-on replica of a McDonald's interior gradually filling up with water until it is flooded from floor to ceiling. This extraordinary film—at once lyrical and violent, funny and frightening—engages the consequences of climate change and global warming. Its subtle biblical references also offer a social critique of corporate culture and of capitalism itself.

Among other works that related indirectly to the storm were Cameron Gainer's video *Luna del Mar*, in which, Luna del Mar Aguilu, an Olympic synchronized swimmer, spirals in slow motion through a bay of bioluminescent plankton against a score of ethereal strings, invoking an embryonic image akin to Jackson Pollock's *The Deep* (p. 155). Juan Gomez's monumental canvas *Mawinzhe* evokes an indecipherable atmosphere that is neither polluted air nor mucky, toxic water. And Max Becher and Andrea Robbins's three photographs of Las Vegas's kitschy replica of Venice—*Venice, Las Vegas #1*; *Venice, Las Vegas #2*; *Venice, Las Vegas #3*—seemed to suggest the real fragility of the frequently flooding real city of Venice, Italy, rather than just the artists' usual document of what they term "the transportation of place" (pp. 128–129).[6]

The Sandy exhibition featured the last collage and neon installation of the late Stephen Antonakos—a true privilege (fig. 15). Stephen was one of the first artists who came to see the site when the space was in its raw condition, and he was able to select and design two works for two walls just before his passing two weeks later. Stephen's *Blue Incomplete Circle on Blue and Red Wall* generates a cradle of comfort through time; his incomplete circle adroitly recalls Uccello's crescent moon in *Saint George and the Dragon*. The beauty of the gentle blue was a constant source of solace and joy for our curatorial team and *Rail* office staff, who worked alongside this piece for the duration of the show.

Michael Joo and Francis Cape had an understated, but potent, rapport. Michael installed an ensemble of five works: *Megafawn (Extincted)*, *Drawn (Japonensis)*, *Untitled (Herkimer Unfolded)*, *Untitled (Impacted)*, and *Parasite (Landscape)*. The first four are reconfigurations of his ongoing Sisyphean excursion into the terrain between nature and human intervention, science and religion, fact and fiction (fig. 16). In the fifth piece, *Parasite (Landscape)*, Michael reconstructed a partial wall (only the aluminum studs exposed) of his Sandy-damaged Red Hook studio. Having noticed Francis's poignant installation in a room nearby (a series of eleven color photographs showing the waterline marks left on houses in New Orleans after Hurricane Katrina, reiterated in the exhibition space by actual wainscoting built to the height of the water), Michael poured a substantial portion of road salt between sheets of glass slid between his studs to match the height of Francis's wainscoting (fig. 17). It was a subtle homage paid at once to the memory of Sandy, to a fellow artist in the exhibition, and to the horrific Hurricane Katrina.

13. Bruce High Quality Foundation, *Stay With Me, Baby*. Installation view Photo by Brian Buckley

14. *Come Together: Surviving Sandy, Year 1* exhibition logo, designed by Walter Chiu

Following pages
15. Stephen Antonakos, *Blue Incomplete Circle on Blue and Red Wall*, and Mel Kendrick, *Spool #1, Spool #2, Spool #3*. Installation view Photo by Brian Buckley

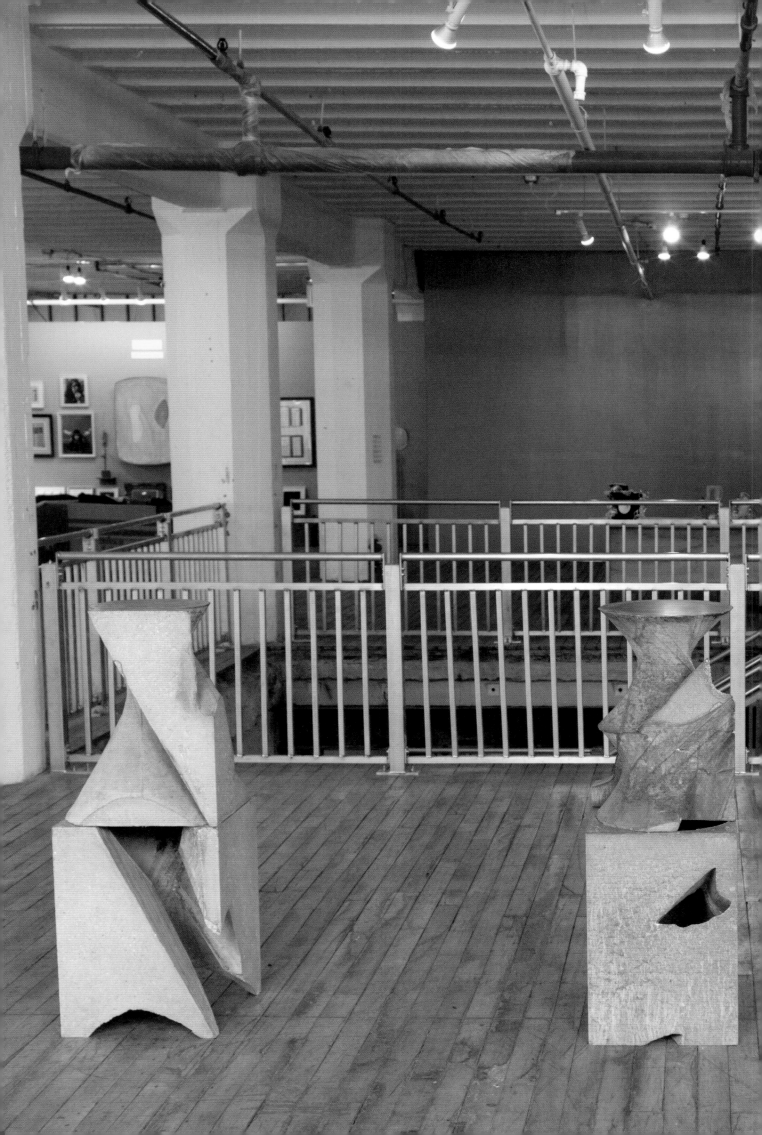

16. Site-specific installation by
Michael Joo, *Megafawn (Extincted)*,
2010
Courtesy of the artist. Photo by
Zack Garlitos

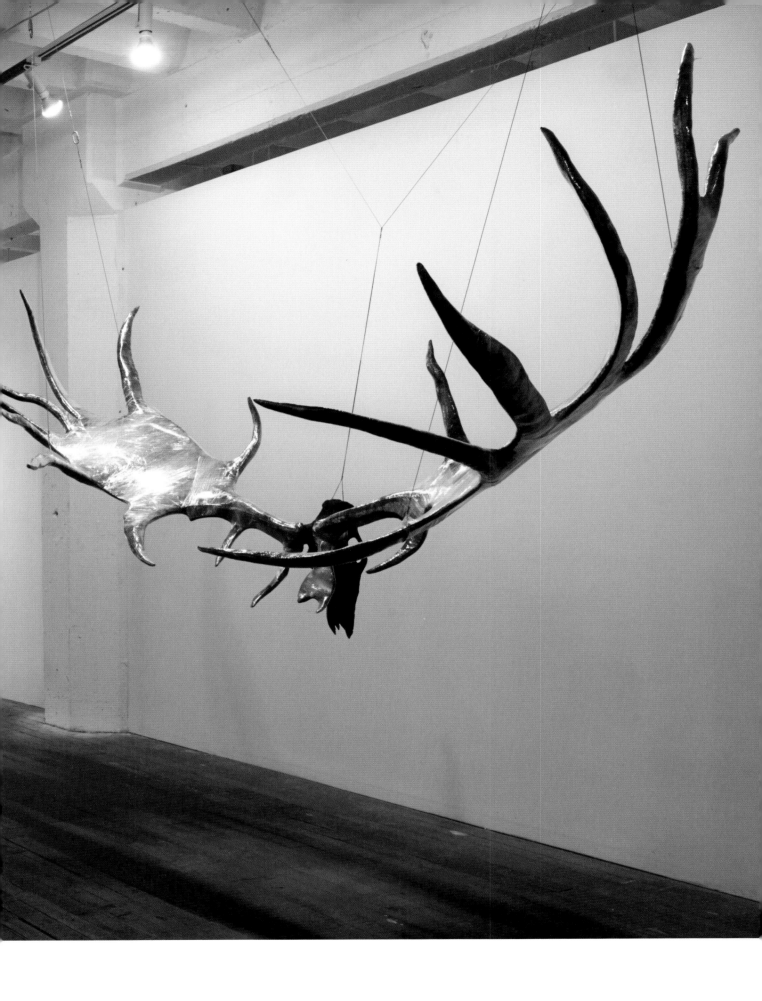

17. Site-specific installation by
Francis Cape, *Waterline*, 2006
Courtesy of the artist. Photo by
Zack Garlitos

By a wonderful stroke of luck, we secured in their entirety a group of thirteen painted backdrops (98 by 187 inches each), made by thirteen artists to accompany a program of jazz-inflected opera (*Vivere*), organized by Bosco Sodi as a Sandy fundraising auction in his Red Hook studio in May 2013 (fig. 18). All proceeds benefitted the post-storm rebuilding efforts in the neighborhood. The participating artists included Teresita Fernàndez, Natalie Frank, Ron Gorchov, Douglas Gordon, Michael Joo, Antón Lamazares, Adam Pendleton, James Siena, Ray Smith, Bosco Sodi, Mickalene Thomas, Corban Walker, and Dustin Yellin. This expanse of immensely varied imagery and styles miraculously fit the long stretch of the large third floor middle gallery space and embodied in a wonderfully persuasive way the communal spirit of artists coming together for a cause (fig. 19).

While conceiving the geography of the exhibition I consciously applied the "call and response" conceit to my fullest ability, as the selected works kept providing plenty of similarities and dissimilarities, pairs, parallels, and patterns. I also found great pleasure in maximizing other more subtle options when possible. For example, taking a cue from Diana Cooper's embrace of the red sprinklers, I selected two large canvases by Chris Martin, *Red, Yellow, Green #1* and *Red, Yellow, Green #2*, both painted with precarious, robust rectilinear grids comprised of red, yellow, and green, hung facing each other in the second floor front gallery. A constellation of John Newman's six small, highly idiosyncratic sculptures, some inflected with glowing red and yellow, were set in the middle on a low table. Between Chris's paintings, John's sculptures, Stephen's neon, and the pipes, the colors and forms were in constant conversation (fig. 20).

Nearby, in front, works by Wendy White, Mike Cloud, Allan Graham, Loren Munk, EJ Hauser, and Ben Keating were installed on one wall to call attention to their shared interest in text-based images (fig. 21). Visual conversations ranged from Wendy's focus on urban ephemera (advertising, posters, and other frenetic graphics) to EJ's painterly turns of phrase, which seem to propose and revise legible structures. This wall also included Ben Keating's small, improvisational welded works on the floor, far below Allan Graham's highly premeditated, thoughtful reduction of typographic form and semiotic ambiguity (in an unusually elongated horizontal format). Finally, Mike Cloud's irregularly sized hexagonal canvas pleasantly collided with Loren Munk's offbeat diagrams of reconstructed art history.

The sculpture courtyard required a tremendous amount of planning. Given the size of the space and the large scale of the works, decisions had to be made quickly about the number of artists who would be included, and about which pieces might be made available from the artists' studios or galleries' inventories. Although the process was very complex, the selection and installation actually took less time than initially planned—because to some degree the works seemed almost to choose themselves. After my first visit to Lee Tribe's studio in late July, I knew that I would include the three quasi-figural, totem-like welded steel sculptures, *Orator I, Wisdom, Orator II, Dignity*, and *Orator III, Aspiration*, which are static yet dignified in their upward verticality (p. 266). I also realized that they would be effectively complemented by Joel Shapiro's *Untitled*—a bronze work I had seen first in the artist's exhibit at Pace Wildenstein in 2008 and numerous times afterward, standing in front of his Long Island City studio (pp. 250–251). In my opinion, it is by far the most complex, up-to-date work in Joel's oeuvre; in it he articulates a perfectly engineered joinery that oscillates between a quick and slow malleability while retaining the abstract presence of a human body.

The courtyard lights, 20 feet above the ground, dictated the height limit for the sculptures, so works had to be somewhere between 9 and 15 feet. The am-

18. Sculpture Hall with *Vivere Series* and Donald Moffett, *Lot 020412 (port)*. Installation view Courtesy of the artists. Photo by Rachel Styer

Following pages
19. Sculpture Hall with *Vivere Series* and Donald Moffett, *Lot 080711 (the radiant future)*. Installation view Courtesy of the artists. Photo by Rachel Styer

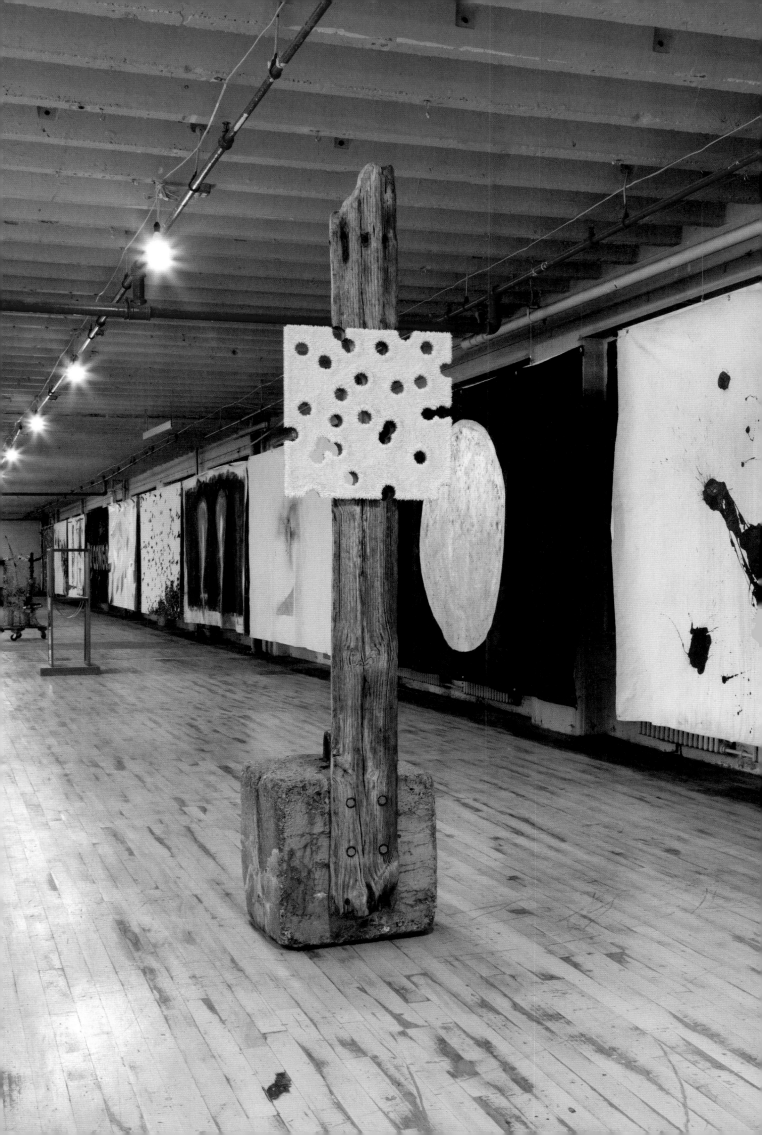

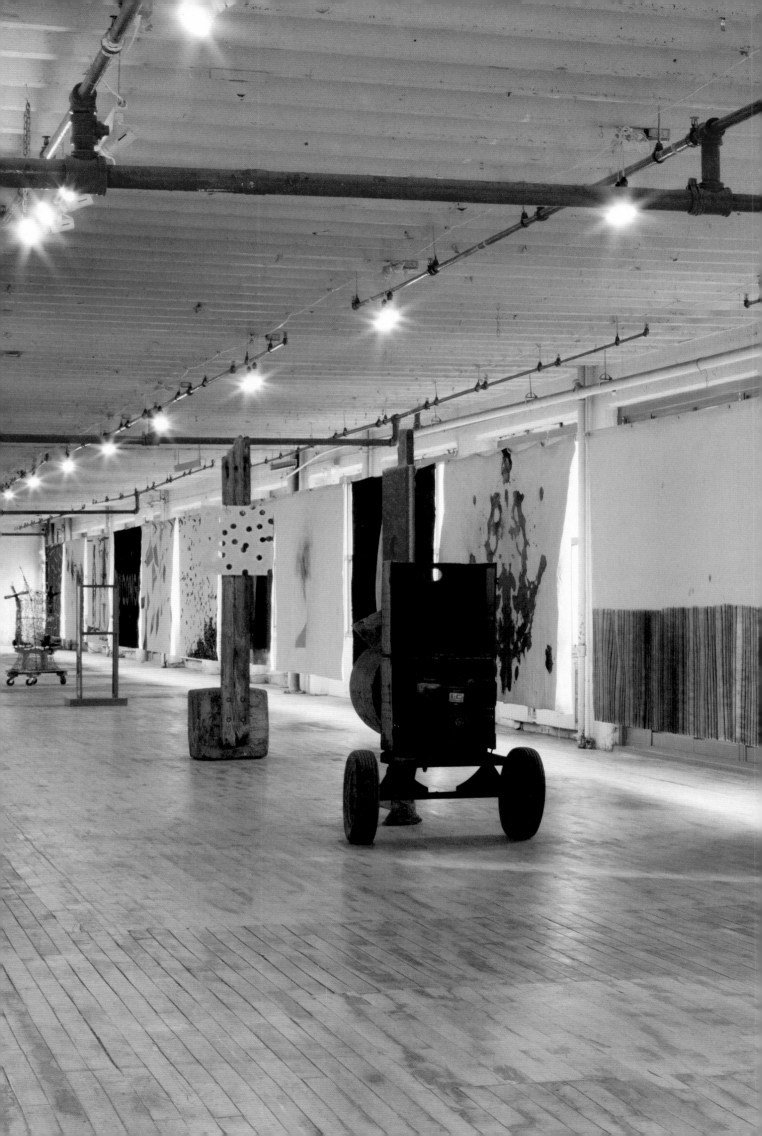

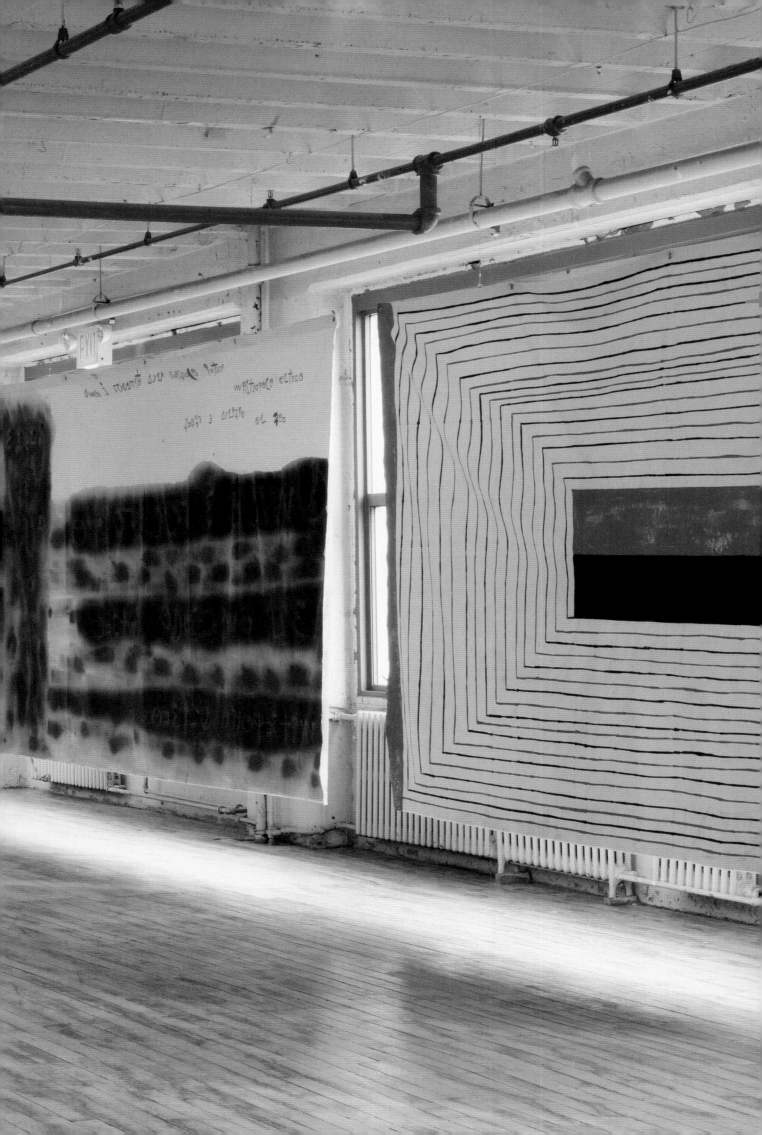

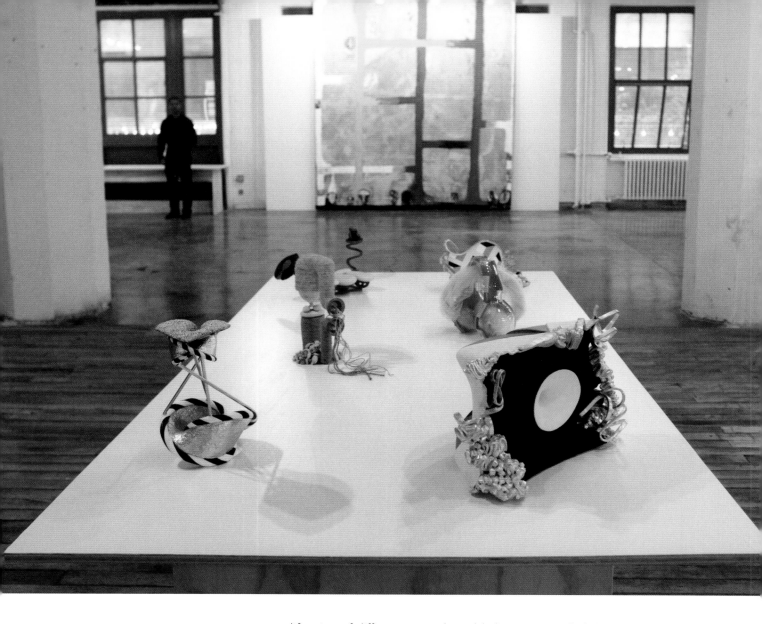

plification of differences made visible between Mark di Suvero's *Rust Angel* and Mel Kendrick's *Marker 4* and *Marker 5* was a particularly rewarding moment (fig. 22). Mark's piece was created out of a single, large painted steel plate, cut in such a way to allow its sweeping curvilinear forms to bend and extend in two directions, which were then bolted by a steel beam from either side. In Mel's works, each cast concrete layer was stacked with the negative (internal section) on top of the positive (external section), in addition to the black and white striations. Both pieces together emphasized their solidity and architectural weight, and as winter approached it was a joy to see them covered in snow.

My first visit to the studio of Rona Pondick, a Sandy victim, in late July initiated a concept that became central to the exhibition design: artist couples. Robert Feintuch, Pondick's husband, makes luminous, small paintings (self-portraits, sometimes with full figures and other times with body fragments) that I thought could be shown together for the first time with Rona's sculptures of merged human and animal bodies. The two presented a compelling contrast (fig. 23).

In an adjacent gallery, Bill Jensen and Margrit Lewczuk shared the center wall with a constellation of primarily smaller works on paper (fig. 24). Bill's work is obsessively emotional and fuses gravity and matter together in a single improbable unity, as seen in *Passion According to Andrei (Rublev/Tarkovsky)*. Margrit creates a musical accompaniment of ubiquitous signs and symbols that feed off lightness and convergence, as affirmed in *Connie's Dream* and *Green & Purple*. Among the artist couples shown, their works were probably the most startlingly different from one another—polar opposites.

Thomas Nozkowski and Joyce Robins, who have been together for over four decades, switched places in their respective mediums in the early 1980s (fig. 25). He completely stopped making sculpture and focused solely on painting canvases that initially measured exclusively 16 by 20 inches (in recent years he has increased the dimensions to 22 by 28 inches). She, on the other hand, ceased to paint in favor of a commitment to painted and glazed ceramic sculptures. Both credit their mutual fascination with abstraction to a continuing dialogue, which has lasted since they met in college in 1962.

Carrie Moyer and Sheila Pepe have long been committed to their shared ambitions—art, politics, and feminism—while pushing and extending the boundaries of lyrical abstraction (fig. 26). For Carrie, the visceral coalescence and graphic clarity of boundless abstract shapes and infinite explorations of textures have been the main vehicles in her painting. For Sheila, the simultaneity of a site-specific, web-like installation of her hand-knit, crocheted textiles and her mixed-media sculptures bespeak the intrinsic beauty that lies just below the vivid, subversive spirit of rebellion.

James Siena and Katia Santibañez, while sharing similar pursuits of visual algorithms through the intricacy of patterned abstractions, set forth their own independent inquiries into geometric interlace, patterns that emerge from difference and repetition. James's *Leviathan* and *La Grotte et la Falaise* demonstrate his concern with the negotiation of a priori mental images through a given regulated procedure. Katia's *Between the Waves* and *Shadows Upon Shadows* make the case for the coexistence of abstraction with occasional representational, natural forms.

A Social Sculpture/Environment

"Art as social activity."[7]
Tom Marioni

The most unwieldy, exciting task was figuring out how to materialize this large-scale exhibition alongside *The Brooklyn Rail*'s operations. Unsnarling unimaginable logistical complexities, spending endless evenings and weekends making back-to-back studio visits (189 in total by the end of August), while feeding off the collective excitement that our activity generated, we were able to install over 600 works of art by more than 300 artists in less than three weeks. We worked in one gallery space while the walls were still being built in another. (A striking quality of scale is its ability to change as a person changes; in this case, after just a couple of days the spaces began to feel quite manageable, even small to me.) The decision to move the *Rail* headquarters from Greenpoint to be a part of the exhibition was a natural solution to the problem of looking after the editorial demands of the journal during and after the installation of the show (fig. 27). The *Rail* headquarters has been a live/work space in my loft since October 2003, when the *Rail* transitioned from a bi-monthly to a monthly publication. Since I've been personally so invested in the lived experience of art and culture, I find living and working are inseparable from one another.

At Industry City we constructed six solidly built tables, placed them directly in front of six large windows, and equipped them with several computers and laptops. One-half of my table had an adjustable top for making portrait drawings for the three issues of the *Rail* that would be produced in the space (November 2012, December/January 2013, and a special Ad Reinhardt centennial issue that was created while the show was on view) (fig. 28).

Following pages
21. Allan Graham, Loren Munk, Ben Keating. Installation view
Photo by Brian Buckley

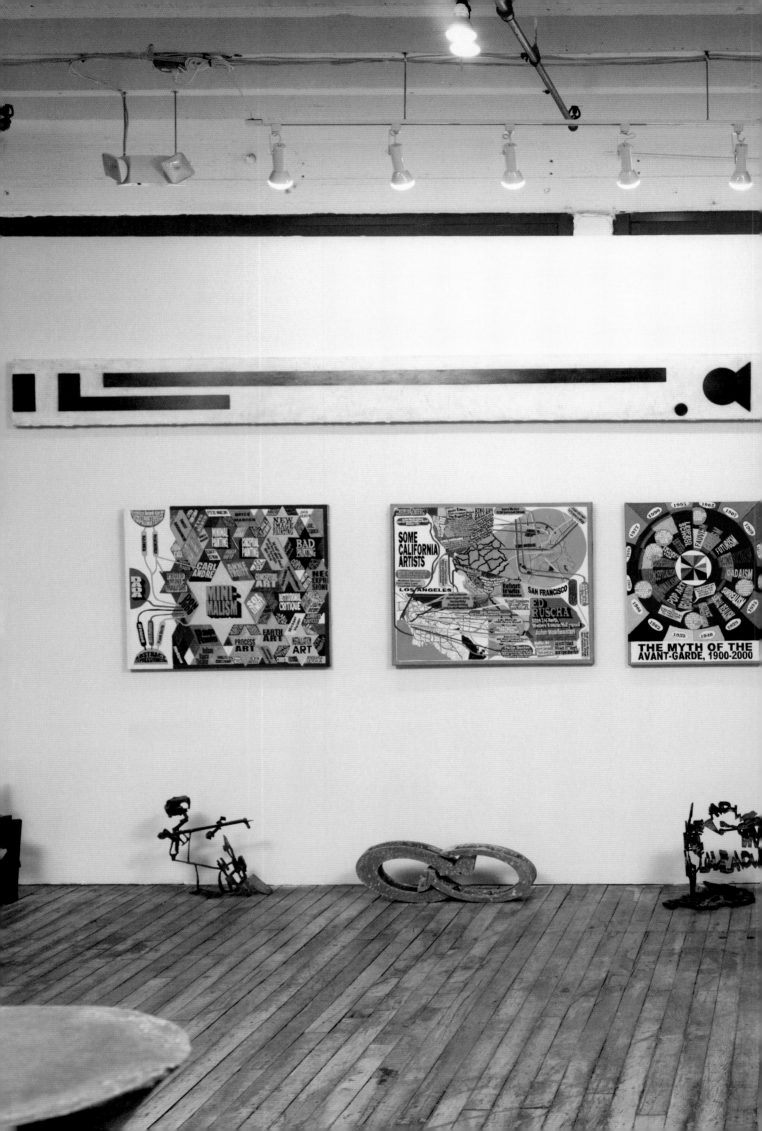

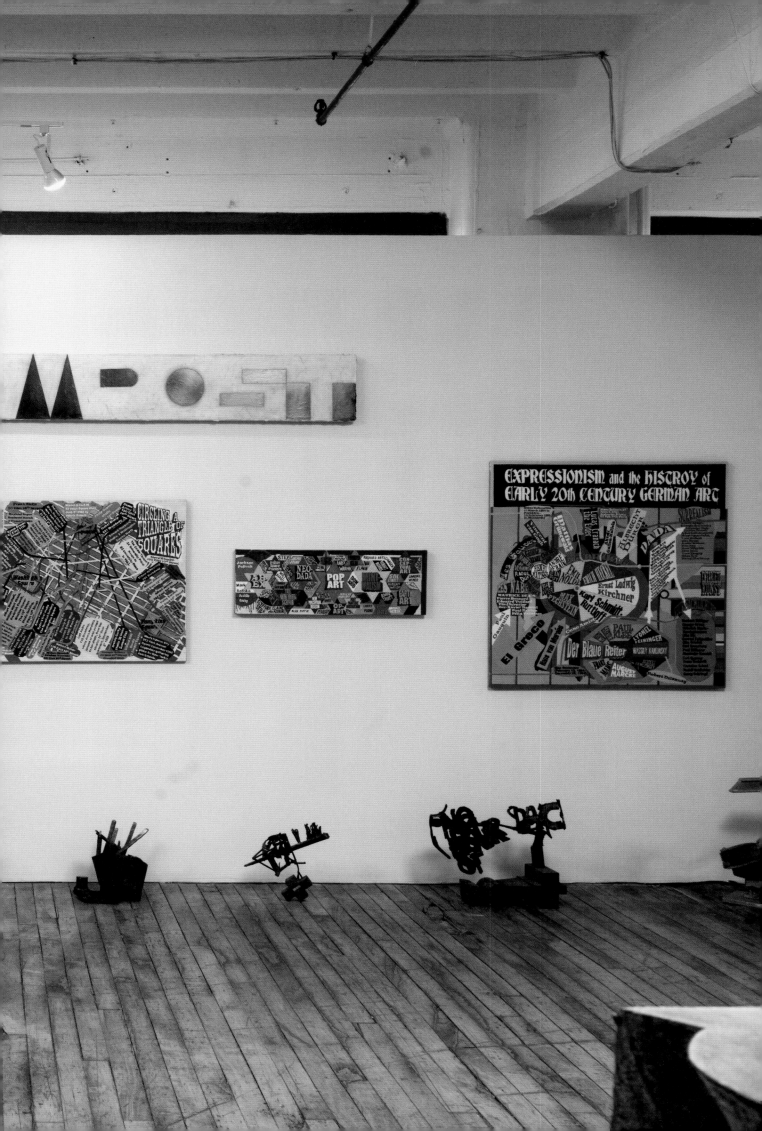

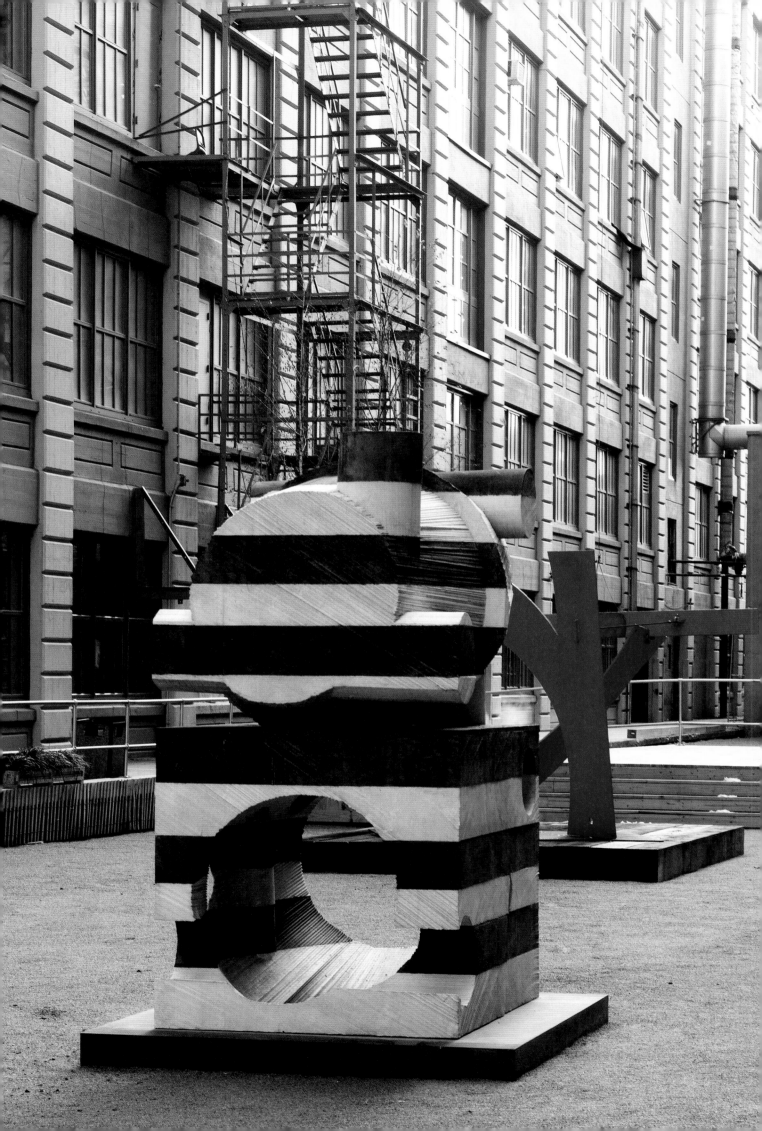

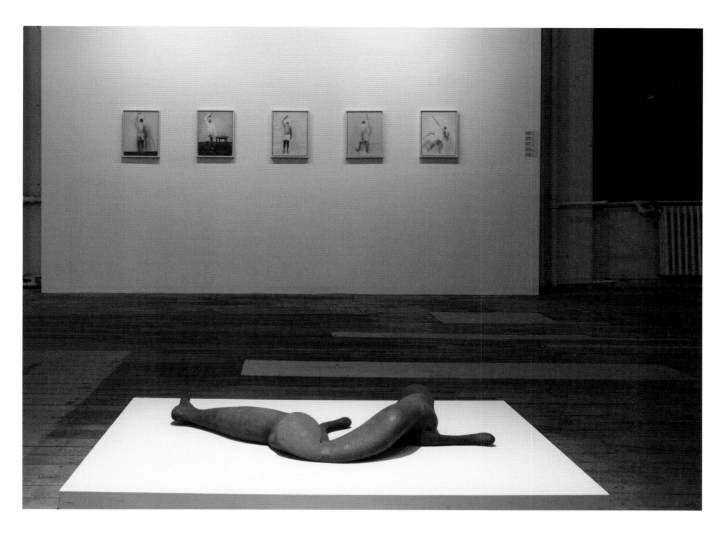

There was a large, dramatic opening in the middle of the second floor, accessible from the first floor by a metal staircase that arrived the day before the opening. This second floor space was an ideal location for our temporary office and provided plenty of room to host additional events, including poetry and fiction readings, performances, film screenings, and panel discussions.

The two large walls on either side of Stephen Antonakos's neon piece were painted a light olive green color, nearly identical to the green on Wendy White's two big paintings across the room. The color subtly enclosed the space, providing respite and intimacy. These two olive walls were filled with an eclectic selection of works: prints by Goya and Johann Christian Reinhart; a small oil of a beach scene by Eugène Boudin on loan from a friend; Jonas Mekas's "self-portrait"; an oil painting by Meyer Schapiro; and an exquisite ink drawing by Ellen Phelan, among other works. These were installed alongside other objects, such as old fishing lures, non-functional carpentry tools, metalwork, and flea market bric-a-brac. This "salon style" installation was another expression of the theme of "coming together," which recurred throughout all aspects of the installation and programmed events. The inviting array of objects and images generated more warmth than a formal, conventional display would have done, and provided a pretext for filling the wall without making it appear cluttered or too busy. It harmonized with our ever-evolving concept of visual democracy, which required a supple mindfulness to embrace stability and instability, high and low, beauty and horror, right and wrong, and other pairs of apparent opposites with apparent equilibrium. To "call" and to hear a "response" is unlike shouting into a ravine, where all you get is an endless repetition of your own echoing cry. The magnificent unknown of others and what they do generates unexpected responses that in turn generate energy in the in-between that makes us feel *alive*.

22. Mel Kendrick, *Marker 5,* Mark di Suvero, *Rust Angel*, Installation view Photo by Brian Buckley

23. Rona Pondick and Robert Feintuch. Installation view Courtesy of the artists. Photo by Zack Garlitos

Following pages
24. Margrit Lewczuk and Bill Jensen, Installation view
Photo by Brian Buckley

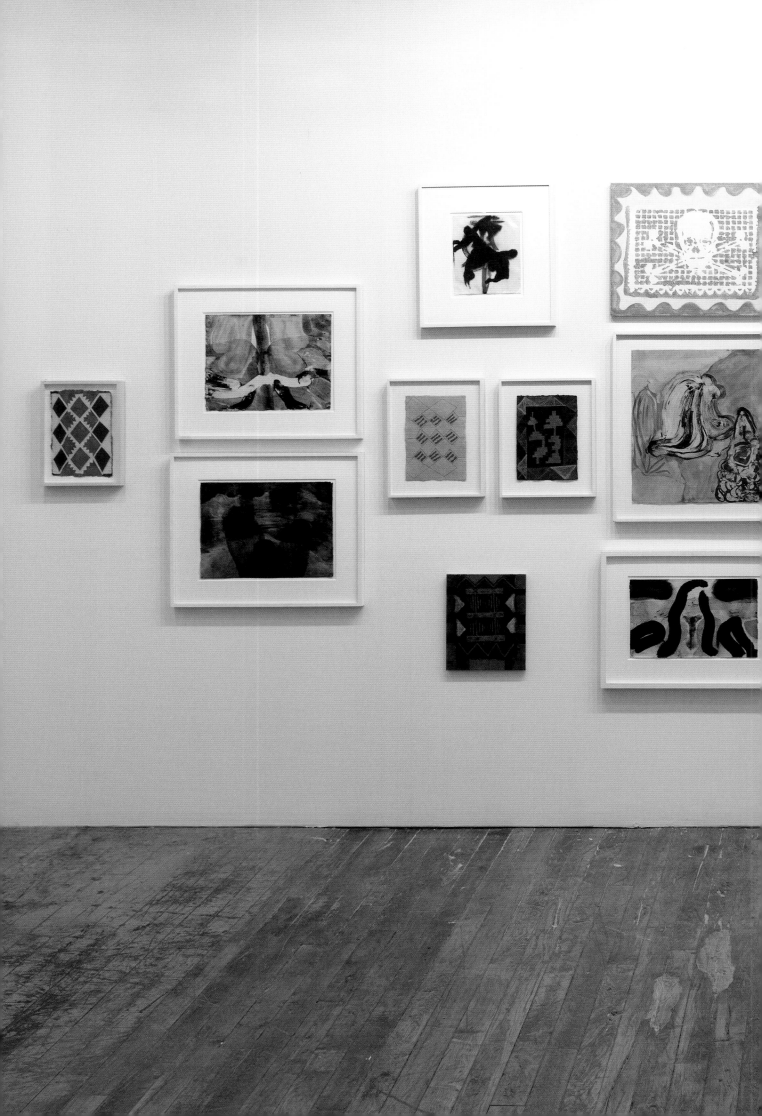

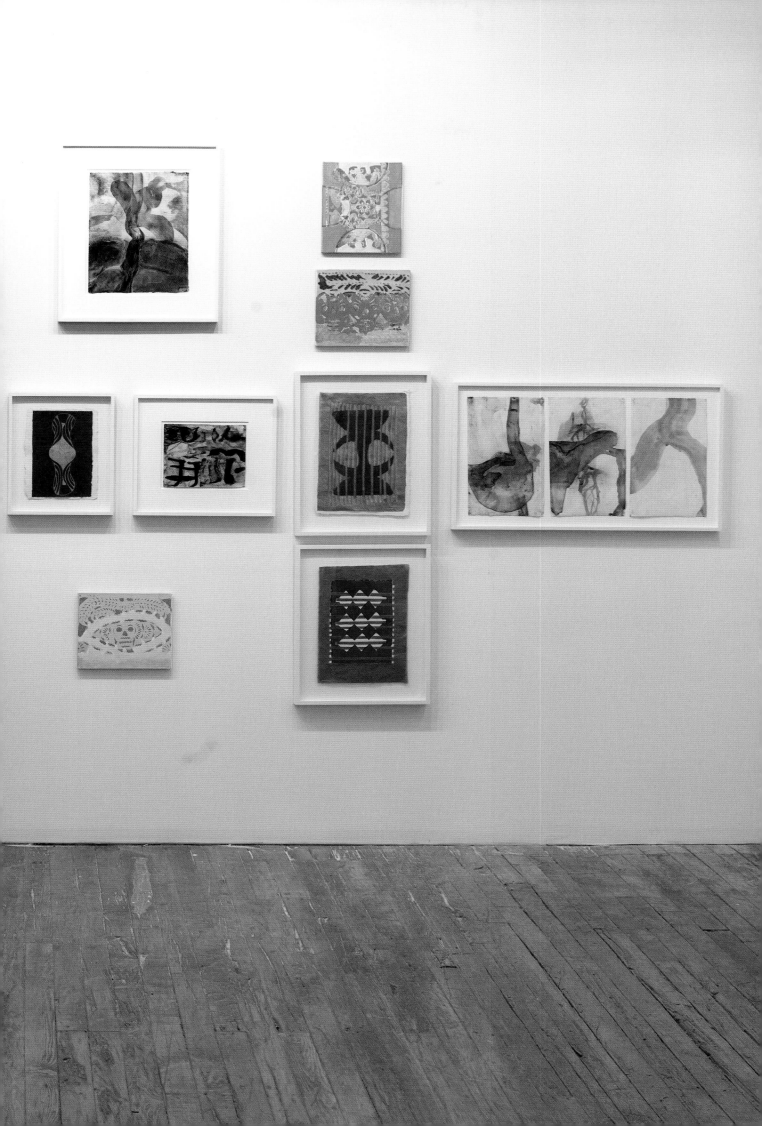

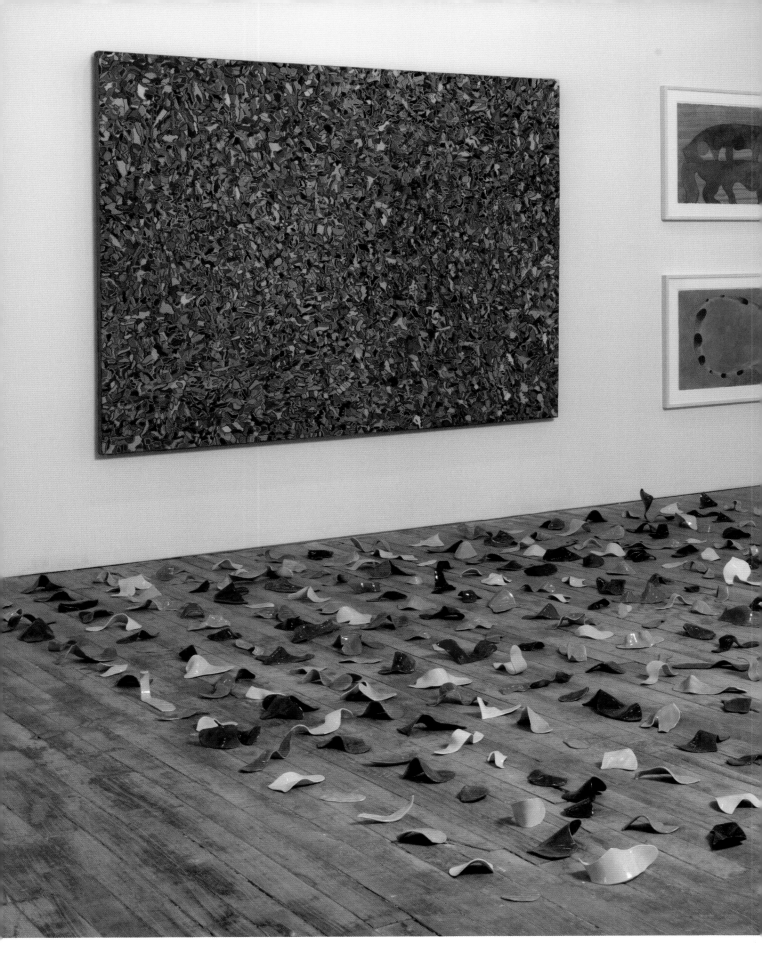

25. Joyce Robins and Tom Nozkowski.
Installation view
Courtesy of the artists. Photo by
Brian Buckley

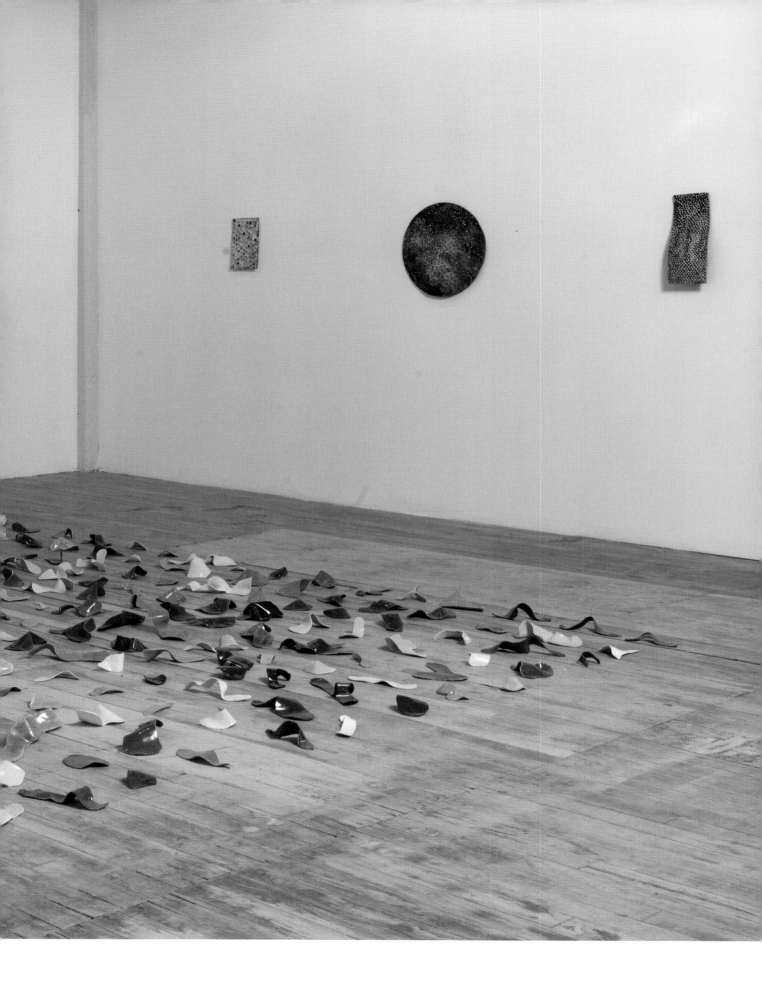

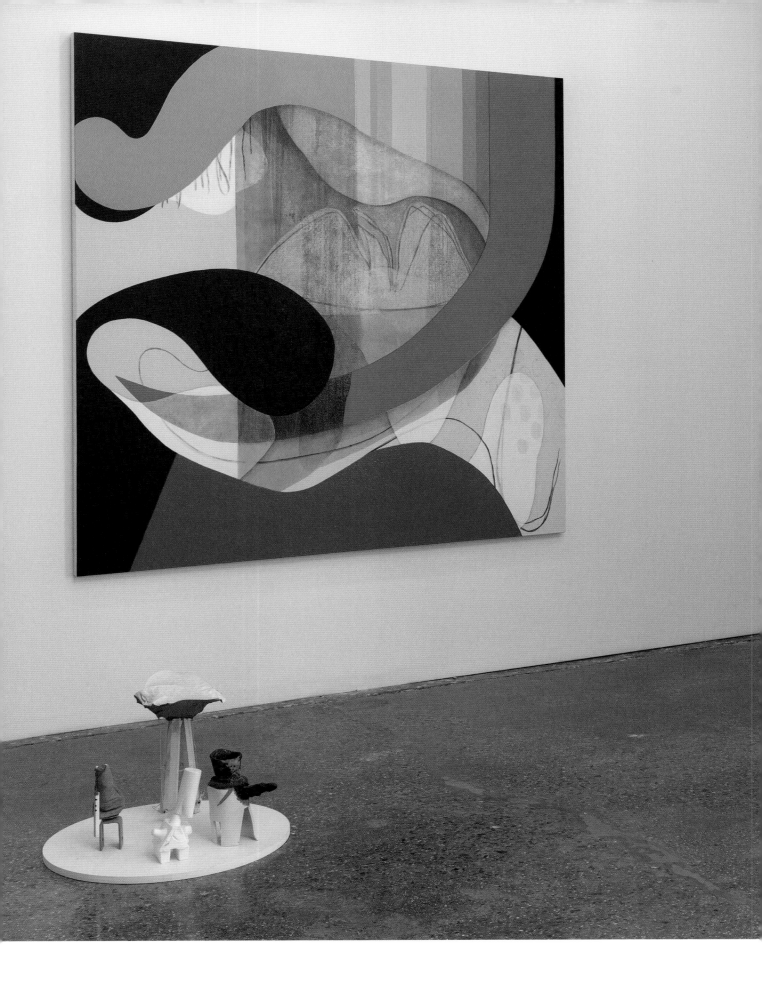

26. Carrie Moyer and Shelia Pepe.
Installation view
Courtesy of the artists. Photo by
Brian Buckley

27. *The Brooklyn Rail as Social Sculpture*. Installation view
Photo by Brian Buckley

The Beginning of Becoming

"The fine arts and unity of mankind."[8]
Meyer Schapiro

Among other things, this exhibition offered an opportunity to materialize the spirit of *The Brooklyn Rail*. As I proceeded, I worked to have its poetic and democratic sensibility resonate with those of us who can't imagine living life fully without the arts and humanities. My staff and I, and Jack Flam and the members of the Dedalus staff, all had similar feelings about this. Katy Rogers, the Dedalus Programs Director, organized more than half of our featured programs, all of which were as significant to *Surviving Sandy* as the installed artworks. Every one of us knows the amplified insights and emotions one feels in the presence of an artwork, just as we all instinctively understand the significance of an encounter with a great dance performance, a moving poetry reading, a memorable concert, or an unforgettable discussion around the human struggle to find meaning in life.

Thinking back now about the storm surge and the resulting exhibition, I recall Uccello's fresco *Flood and Waters Subsiding* at Santa Maria Novella and Cimabue's *Crucifix* at Santa Croce, which were among the 14,000 works of art damaged or destroyed by the 1966 flood of the Arno River in Florence. Many organizers rose to that occasion, most famously Franco Zeffirelli, whose short documentary, *Florence: Days of Destruction*, helped raised millions of dollars for the reconstruction efforts. The film also popularized the term "mud angels": volunteers who cleaned the city of refuse, mud, and oil, and who retrieved numerous works of art, books, and other priceless Florentine artifacts. I relate to what then-mayor of Florence, Mario Primicerio, remarked at the thirty-year anniversary of that event in 1996:

What we were doing was dictated by the desire to give back the traces of the history of the past to future generations, so that it could be used for the spiritual growth of peo-

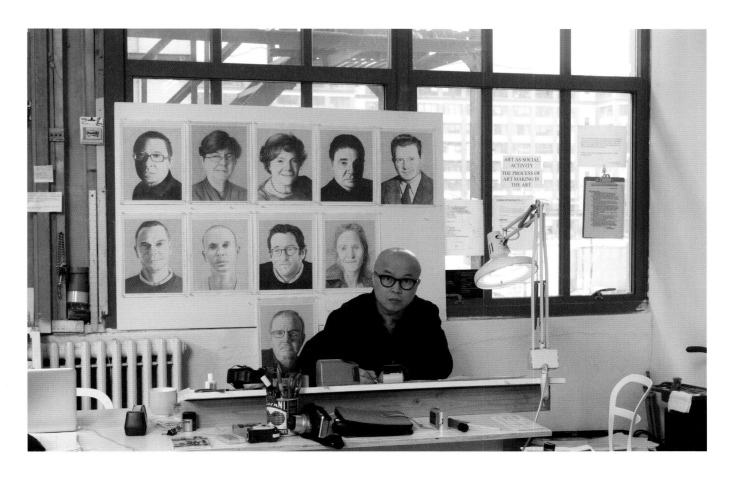

ple who perhaps had yet to be born . . . It was the international community that worked to try to save Florence, this unique patrimony which belonged to the whole world.

In the end, *Come Together: Surviving Sandy, Year 1* offered all of us—the people involved with *The Brooklyn Rail*, the Dedalus Foundation, Industry City, the Jamestown Charitable Trust, the participant artists, writers, poets, dancers, musicians who were involved in the event from beginning to end, and the viewers who came to experience it—a concrete manifestation of collaboration, where everyone is in service to the same cause. This is when we all understand, along with John Keats, that "the excellency of every art is its intensity, capable of making all disagreeables evaporate."[9] As one of my favorite philosophers, Johann Gottlieb Fichte, once said, "We do not act because we know. We know because we are called upon to act."[10]

28. Phong Bui at work on monthly portraits, to be published in
The Brooklyn Rail
Photo by Brian Buckley

Following pages
29. Installation of Nari Ward's
We the People, October 2013
Photo by Taylor Dafoe

[1] Original: "Certains souvenirs sont comme des amis communs, ils savent faire des réconciliations." Marcel Proust, *In Remembrance of Things Past*. New York: Random House, 1981. Trans. C. K. Scott Moncrieff, Terence Kilmartin, and Andreas Mayor.
[2] According to Dr. Lillian Milgram Schapiro, her husband Meyer Schapiro related this story to her in the fall of 1990. It was also in reference to Paul Tillich's popular volume *The Courage to Be* (1952), which I had just read a month before.
[3] It was Jack Flam who, in the course of a recent discussion, commented on my constant reference to oppositions, and casually brought up the term "call and response," which I am grateful for. It is fitting to put it to use in this essay.
[4] I first learned the proverb from my grandmother at the age of six or seven.
[5] Dustin said this to me during the VIP reception on October 17, 2013, for having convinced him to show his *Triptych* in the *Come Together: Surviving Sandy, Year 1* exhibition.
[6] Lucy Lippard, *Andrea Robbins & Max Becher: The Transportation of Place*. New York: Aperture, 2006.
[7] "Constance Lewallen in Conversation with Phong Bui," *The Brooklyn Rail*, July/August 2013.
[8] Meyer Schapiro, *Worldview in Painting–Art and Society*, Selected Papers. New York: George Braziller, 1999.
[9] John Keats, "On Negative Capability: Letter to George and Tom Keats, 21, 27 December 1817," in Grant F. Scott (ed.) *Selected Letters of John Keats*. Cambridge: Harvard University Press, 2005.
[10] Original: "Wir handeln nicht, weil wir erkennen, sondern wir erkennen, weil wir zu handeln bestimmt sind." *Johann Gottlieb Fichte's Popular Works* (London: Trubner & Co: 1873). Trans. William Smith.

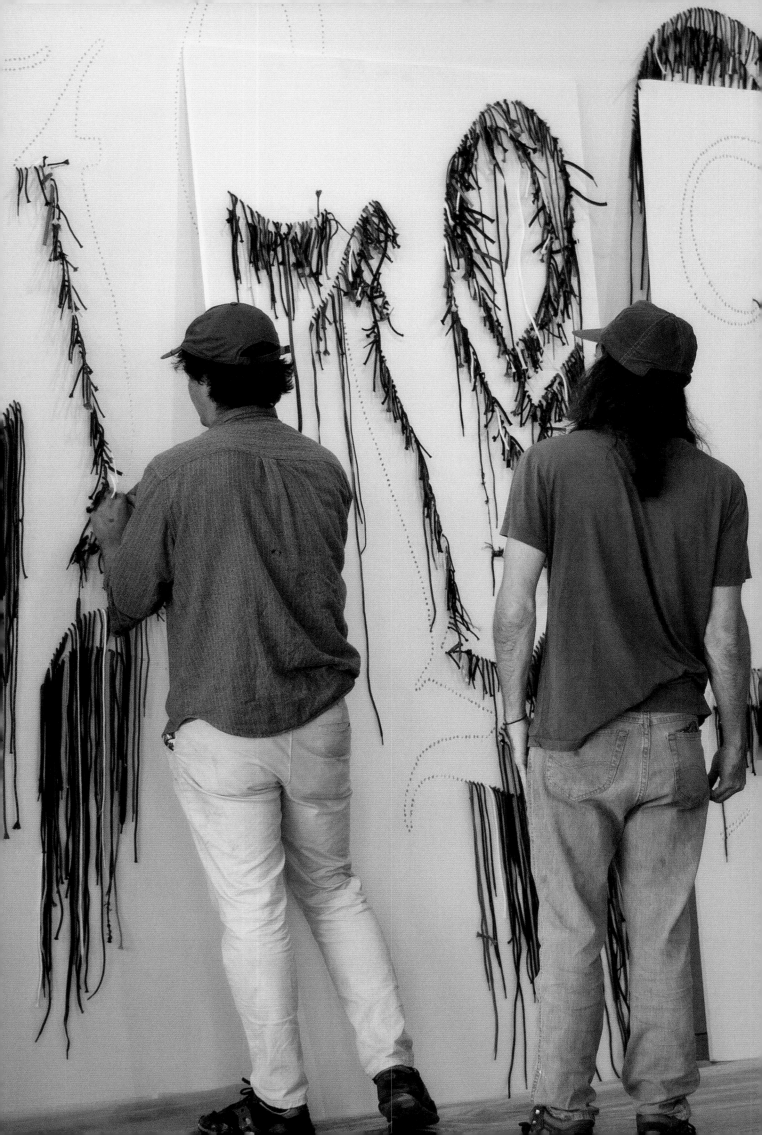

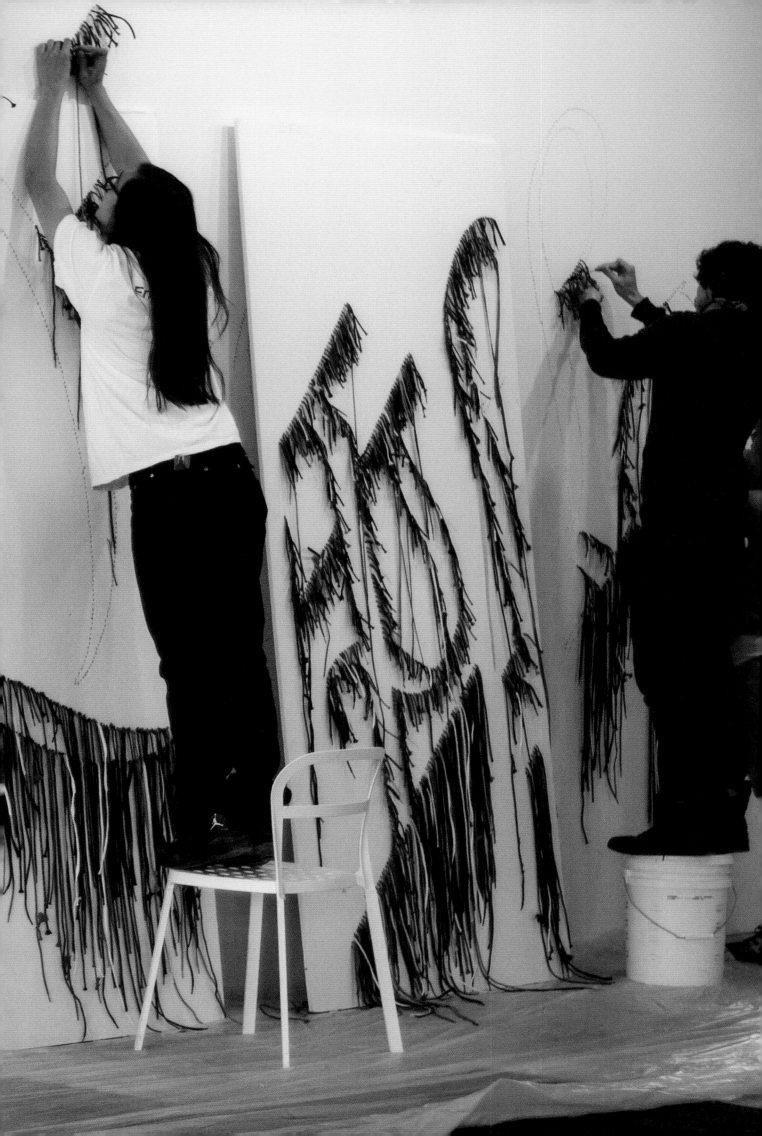

The Poetry of Space

Katy Rogers

"As the waters rise and rising keep on
Coming closer and then topping as winds
Swirl and the concoction pulls the children
Out of your arms and into the whale of air
The sky can break in your basement, the burglar
Alarm is not taking any more messages. Sweet
Pacific of Atlantic, the siren song salsas into
Your Lover's arms. You will rise again, Brooklyn."[1]
Bob Holman

Come Together: Surviving Sandy, Year 1 was never meant to be only an exhibition of visual art. From the first days of planning, everyone involved at both the Dedalus Foundation and *The Brooklyn Rail* wanted the galleries to serve as a forum for an expansive dialogue between the works on display and a variety of performances, literary readings, film screenings, and panel discussions. All of the organizers were deeply involved with all of the arts: this kind of broad engagement is one of the hallmarks of Phong Bui's work, and for Dedalus it was an engagement that went all the way back to its founder, Robert Motherwell, who was deeply involved with poetry, music, and dance, as well as with the visual arts. So our decision to have the exhibition accompanied by varied programs of dance, music, and poetry reflected not only our personal interests but also a continuity of well-established traditions at both Dedalus and the *Rail*.

A number of questions became immediately apparent. How might a large and diverse community come together after tragedy, and what form might its expression of recovery take? How could we, the organizers of the exhibition, provide a creative support network for those who were affected? Expanding outward from the core idea of solidarity within both the art community and the greater community of New York City, *Come Together* became a stage for both artistic experimentation and exploration of how everyone affected by the experience of the storm might continue to grow stronger from this tragedy.

All of the events mounted during the exhibition were held in the galleries, surrounded by sculptures, paintings, installations, and videos. This lent a new dimension to the physical exhibition by activating the works and the spaces between works

in new ways. The events were not only interesting in themselves but also gave rise to new interpretations and inspirations. This began as soon as the opening night, with performances of Josiah McElheny's *Walking Mirrors* (figs. 30–31) and Matthew Lange's *Archeology of the Plummet Machine Vol. 1* (fig. 32)—very different kinds of interventions, both of which simultaneously reaffirmed the physical presence of the exhibition spaces and called into question their stability.

The large, high-ceilinged industrial spaces of Industry City gave viewers a relationship to the work that was different from what might be experienced in the polished white cube of more traditional galleries and museums. The exhibition was infused with a sense of freedom and accessibility, which was enhanced by the unfinished floors and peeling concrete ceilings. Artists in all mediums connected strongly to the environment, creating works that, like the spaces, were at once intimate and vast, and which gave rise to very particular kinds of performances.

One of the most striking instances of this was Danspace Project's presentation, *Performing the Precarious*, a two-part intervention into the galleries. The second part of this program was a series of dance events performed over several hours, in the changing light of a winter afternoon, on December 7. Conceived as "poems in space" by curator Judy Hussie-Taylor, this event included a number of different performances that were staged at the same time in different parts of the exhibition, and which were repeated in such a way that viewers could see most of them one after another and then go back and see repeat performances (several repeated three times during the course of that single day). Some were new works, created in specific response to the themes of the works in *Come Together*. Others were reinterpretations of earlier works, reconfigured in response to the new context. Rebecca Davis's excerpts from *will however happen* (fig. 33), and Cori Olinghouse's *The Animal Suite: Experiments in Vaudeville and Shapeshifting* (fig. 34), were excellent examples of works that had been created earlier and had been revised, and even transformed, for the new context in which they would be seen.

Michelle Boulé's radiant performance, *White*, was a compelling example of a work that had been created earlier but which was dynamically altered by the gallery spaces. In *White*, three dancers dressed in diaphanous white dresses raced and weaved and spun through a very long and spacious gallery filled with sculptures by Rachel Beach, Ursula von Rydingsvard, Arthur Simms, Donald Moffett, and others (figs. 35–36). The space quite literally came alive: the inanimate works themselves seemed to dance from their bases and walls in response to the energy of the live dancers. Michelle Boulé has noted that she was "inspired by the life of the work in the galleries . . . The layout of the pieces created an already existing movement pattern that we could follow . . . We used various pieces as landmarks for the choreography . . . The choreography was very specific to that space."[2]

Will Rawls's solo performance *decumulation*, which was staged around and underneath Michael Joo's sculptural works, offered a more self-contained and introverted response to the exhibition spaces (fig. 37). Using many different colors of chalk, Rawls drew on the wood floors, while at the same time rolling around slowly on the floor, gymnastically at times, as he coated himself with more and more layers of colored chalk dust. This accretion and transfer of materials and gestures created a kind of call and response not only with Joo's works, but also—by extension—with the whole exhibition.

In a very different vein, Rebecca Brooks's three-hour long, continuous dance performance, *YALA*, delicately engaged very different surroundings. On the wall behind her was a series of austere black and white Richard Serra prints which she responded to with her own sensual, curvilinear movements, which in turn were echoed in a more direct way by the proximity of Ray Smith's sculptures (fig. 38). Both dancer and sculptures seemed to roll and undulate throughout the space, which was in a sense "framed" by Serra's rectilinear forms. Here, as elsewhere in the performances, movement was infused into the still spaces between the stationary artworks in such a way that both the dancers and the artworks came to be seen differently. The in-

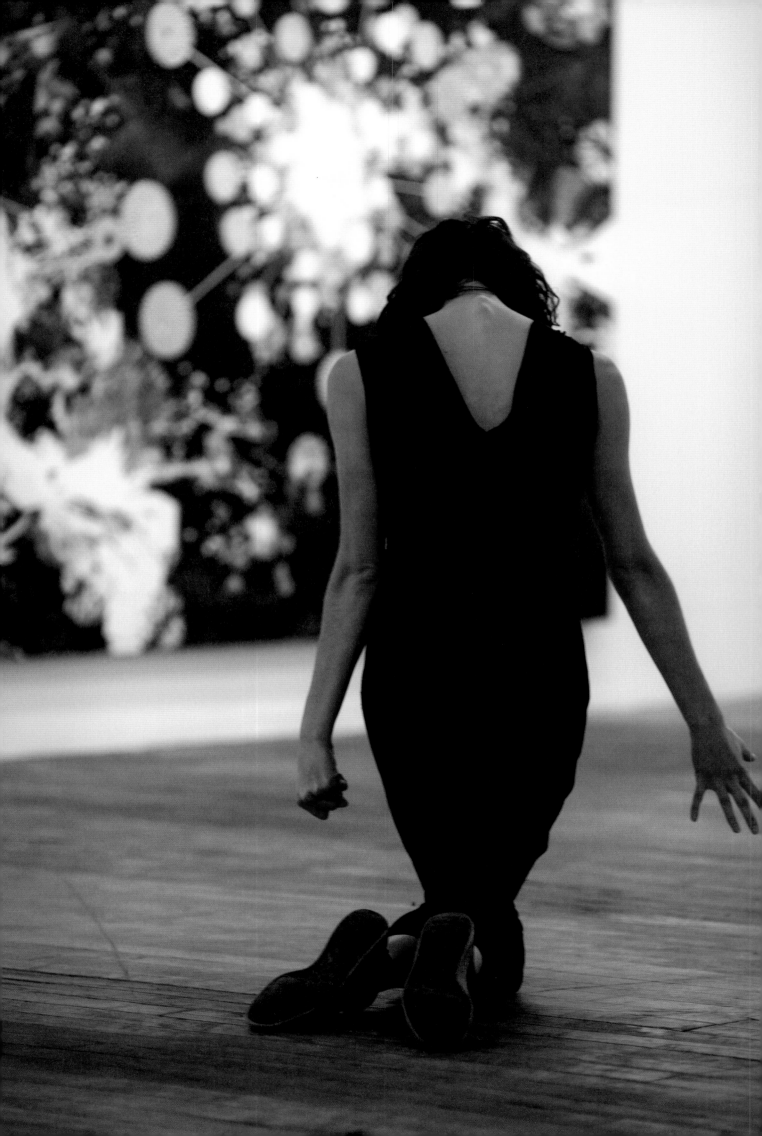

terplay between them became a kind of physical manifestation of the kind of artistic dialogue that underlay the conception of the exhibition itself.

Vast as they were, the exhibition spaces also allowed for warmth and intimacy—both for the works and for the performers. Xaviera Simmons's performance of Yoko Ono's riveting *Cut Piece* (fig. 39), the first part of *Performing the Precarious*, was an especially memorable example of what could be done with this kind of intimacy. Simmons had performed the piece before, but in larger, more traditional, stage-like settings. For *Come Together* she chose simply to sit on the floor in front of a windowed wall, on the same plane as the audience, dressed in a flowing brown dress. She and performance curator Lydia Bell of Danspace had selected *Cut Piece* as a response to the "devastation of Sandy and the vulnerability of humans and cities everywhere."[3] In this performance, members of the audience come forward at their own pace—often slowly, but sometimes decisively—and cut off pieces of the performer's clothing. The austere and yet emotional way in which Simmons performed this piece made vividly tangible the deep intimacy that vulnerability can create between people. It explored something deeper as well: how human beings can make themselves less vulnerable by banding together, especially in moments of great stress or tragedy.

Many artists found themselves either devastated or in extremely vulnerable situations in the aftermath of Sandy, which ruined studios, materials, and years worth of stored work. In the days immediately following the storm, a number of conservators came together to help artists salvage what they could. But the question remained, even a year later, of what preparations might have mitigated the losses suffered by artists. Many of those same conservators teamed up with the Craft Emergency Relief Fund (CERF+) to generate materials outlining how to prepare and protect a studio before a disaster strikes. CERF+ hosted a panel discussion on these matters in the *Come Together* galleries, highlighting the need to invest in thoughtful studio design, proper emergency procedures, adequate insurance, and relationships with conservators (fig. 40), which could provide artists with the means for navigating their way through catastrophic situations.

Although some might find it hard to address such issues after the fact, *Come Together* created a platform in which artists could learn from the tragedy and also grow more resilient. The International Network for the Conservation of Contemporary Art-North America (INCCA-NA) took on the difficult task of asking artists to speak openly and candidly about their losses and about how their vulnerability may have changed (or not changed) their studio practice.

Beginning on the opening night of the exhibition, and continuing every Saturday for the next two months, conservators affiliated with INCCA-NA conducted oral history interviews with artists who had been directly affected by Sandy. Even a full year later, some artists had not yet fully recovered, and at times bursts of raw emotion—even sobs—broke through the veneer of the interview format. It was instructive to see how varied the responses were. Some artists lingered on past losses. Others had chosen to push forward and not look back.

The wide range of emotional responses in these oral history interviews reflected the different ways in which various artists were able to explore the complex new realities that they had to face in their studio practices. The conservators, some independent and some from major institutions such as the Brooklyn Museum of Art and the Hirshhorn Museum and Sculpture Garden, subtly and sensitively inquired as to how the artists had dealt with the trauma of lost and damaged work. The hope was that by working together, artists could be better prepared, and conservators better equipped, to help artists deal with the next disaster. The best way to move forward and recover, they realized, was to learn from each other and to expand the support network, individual by individual.

33. *will however happen*, choreographed by Rebecca Davis, in *Performing the Precarious: Day into Night*, presented by Danspace Project. December 7, 2013 Photo by Ted Roeder

Following pages
34. Neal Beasley, *The Animal Suite: Experiments in Vaudeville and Shapeshifting*, choreographed by Cori Olinghouse, in *Performing the Precarious: Day into Night*, presented by Danspace Project. December 7, 2013 Photo by Ted Roeder

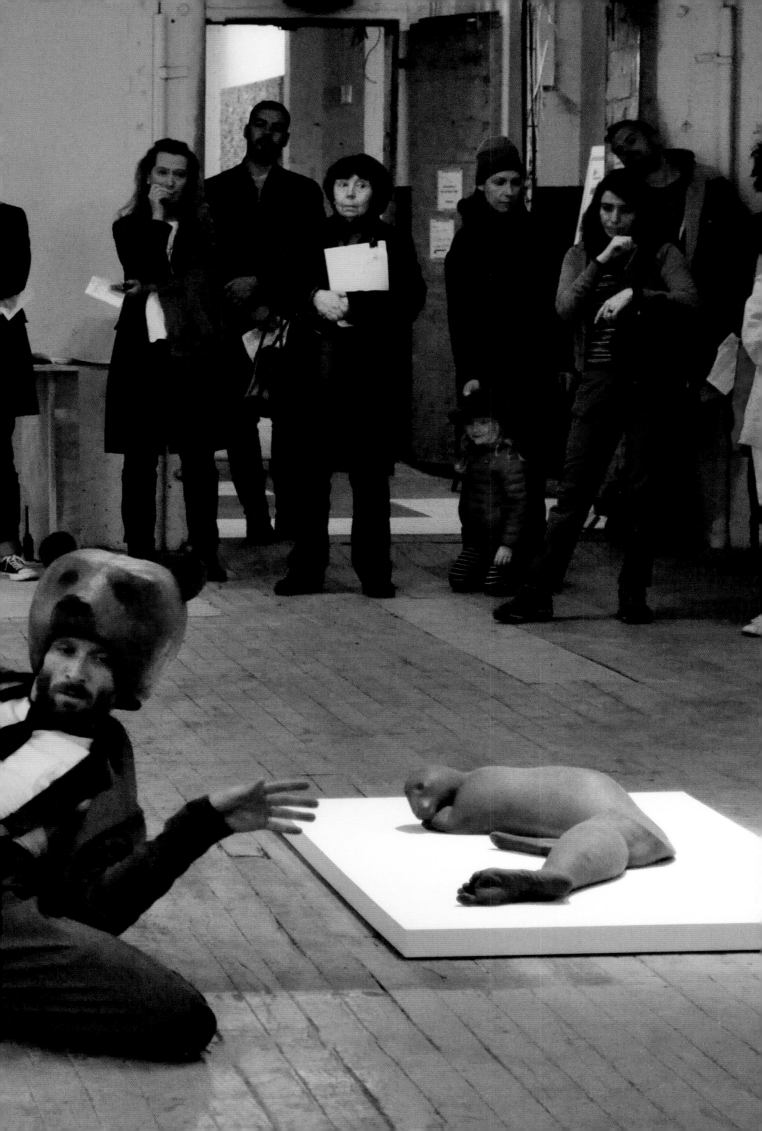

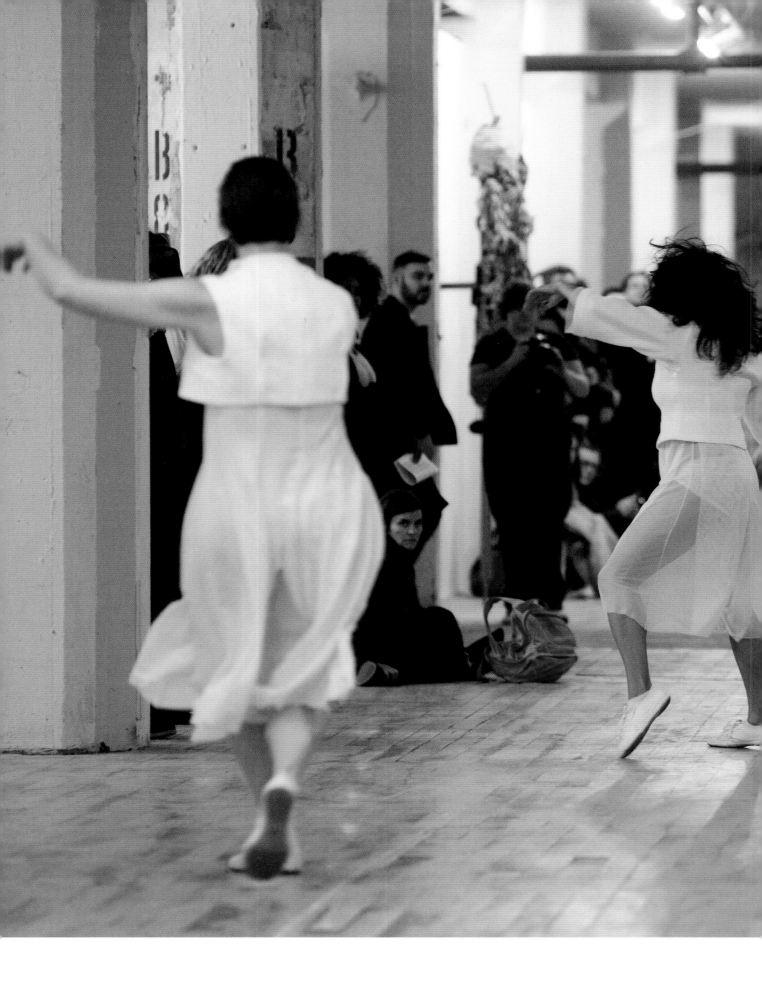

35. *White,* choreographed by Michelle
Boulé in *Performing the Precarious:*
Day into Night, presented by
Danspace Project. December 7, 2013
Photo by Ted Roeder

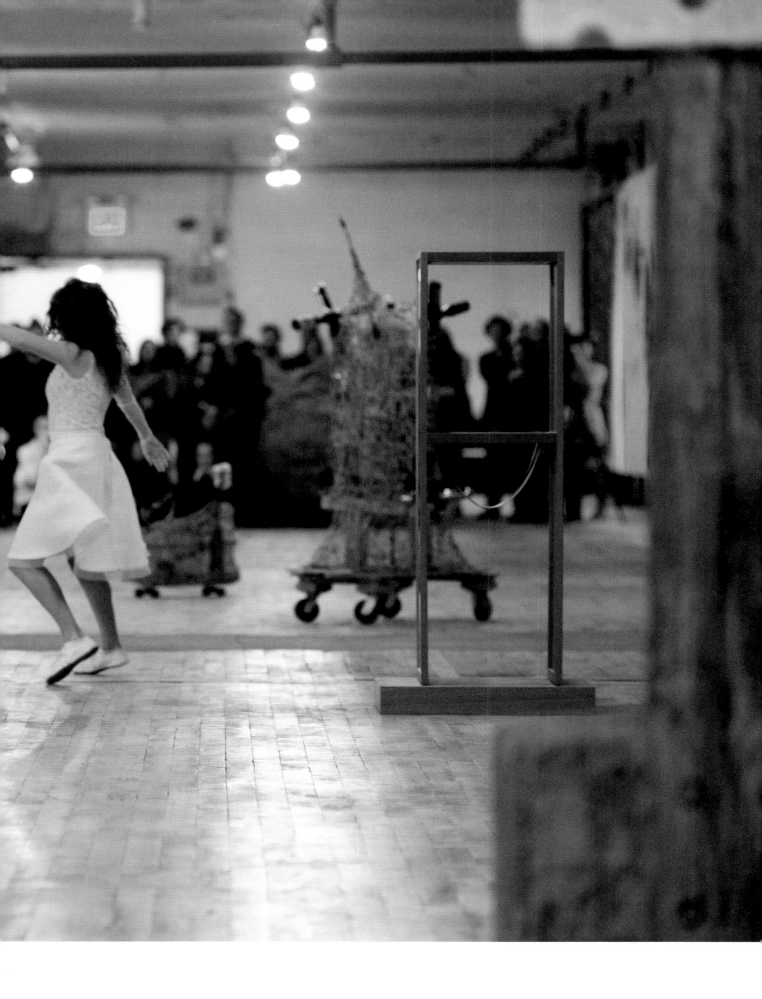

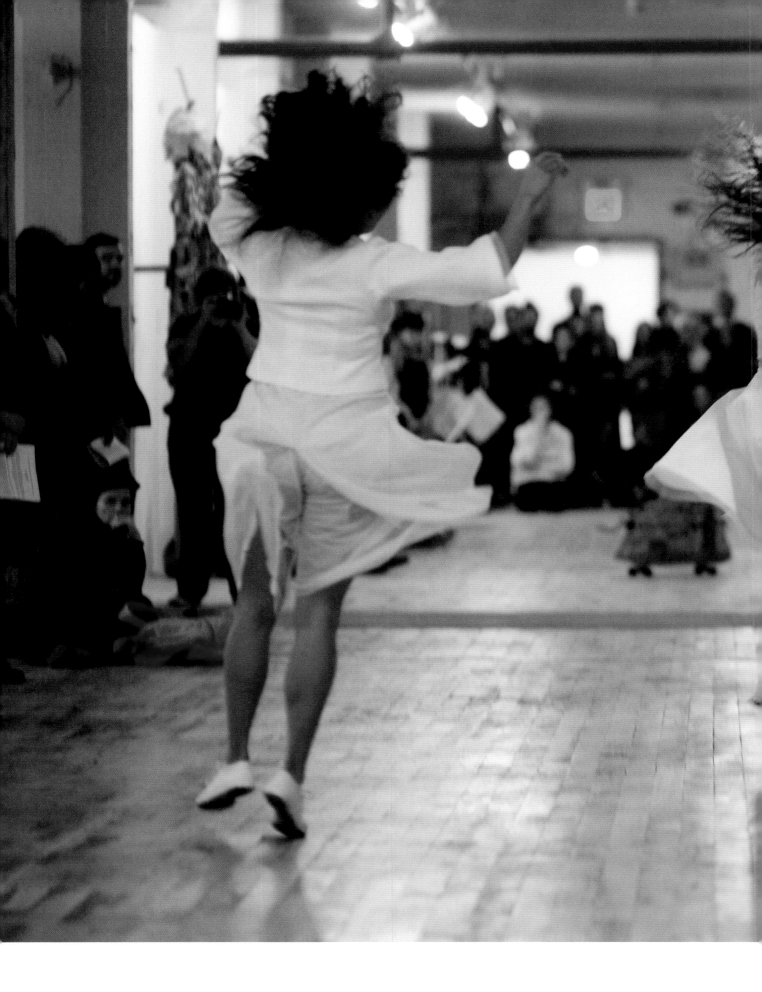

36. *White*, choreographed by Michelle
Boulé in *Performing the Precarious:
Day into Night*, presented by
Danspace Project. December 7, 2013
Photo by Ted Roeder

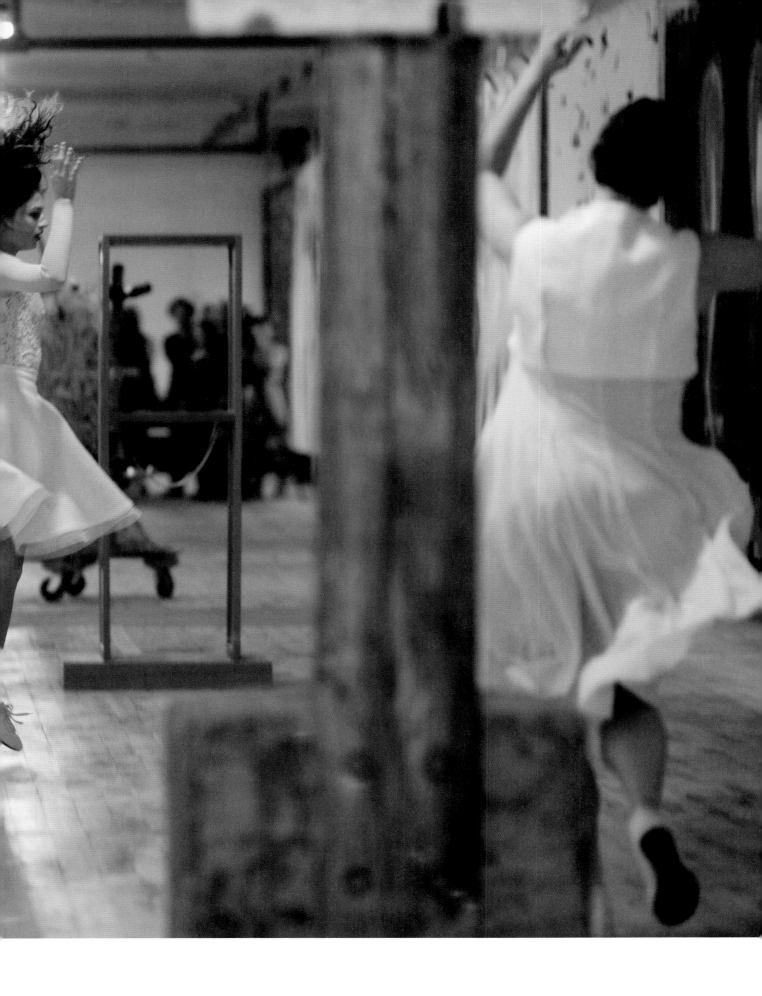

Giving voice to the experience of Sandy did not always entail strict factual discussions and interviews. Some of the most powerful responses came through poetry. The Dedalus Foundation and *The Brooklyn Rail* commissioned a number of poets to respond either directly or indirectly to their experience of Sandy. The poems, which were read in the second floor gallery space, have been gathered together for a chapbook that is being published at the same time as this catalogue, as *Oh! Sandy: A Remembrance* (figs. 41–44). This particular act of commemoration was a vivid instance of the ways in which beautiful and moving things may be born out of our darkest moments, and of the ways in which inspiration often comes from unexpected places. Some poets spoke plainly and directly of the storm while others evoked a sense of the personal, political, and social storms of our times. Perhaps most poignant were the poems that spoke directly to the loss of both life and art, as in Anne Waldman's "If/Then: All Hallow's Eve":

> if what we see if what we fear if what we inhabit the jealous gods
> the master narratives
> the misplaced funds, the allocated ruins, prophetic ignorance. then what.
> waves of detritus. the overturned house. the dismembered car. then, what.
> the torn
> clothing. panicked mother. dead lines. then dead lines. dead lines.
> and some lives, dead.
>
> if what we see we taste we touch the ransacked clothing. the destroyed
> archive, the
> destroyed canvas, the plans awry. the rotting food. lights out for what
> message earth
> might be telling us. then stop. then stop. shore of our city enfolded in
> thematic detail:
> mask you wear, ghost you wear, fear you wear, edges you wear, the work you
> wear
>
> if and then the art you make the poetry you stir up, could it be "gone" "lost"
> never return?
> if, and then. if/then. what. value. what value. inestimable. "get over it."
> if you are not prepared. civic safety not there sanctuary not there,
> not there, but
> foreshadow there then: what? where. and turn. where. loss is the discovery.
> safety,
> what?[4]

The theme of disaster as generative force was explored further in the panel *Beyond Backdrop: Fiction in the Wake of History*, where authors Joseph O'Neill, Lucy Alibar, and Alex Gilvarry discussed how they incorporated traumatic events into their fictionalized narratives. The organizers of the panel, co-editors of the *Rail*'s Books section, Katie Rolnick and Joseph Salvatore, chose the writers because their "work and process could provide context for the fictional stories that would inevitably arise in Sandy's wake."[5] Each of the authors described how fact could play an important role in fiction, by adding depth and nuance through context, and by challenging readers to reassess their own personal experiences in relation to specific traumas.

Each of the events that were mounted during the course of the exhibition explored ways in which it might be possible to move beyond the uncertainties of living a creative life in a city like New York, where the unpredictable is constantly oc-

37. Will Rawls, *decumulation* in *Performing the Precarious: Day into Night*, presented by Danspace Project. December 7, 2013 Photo by Taylor Dafoe

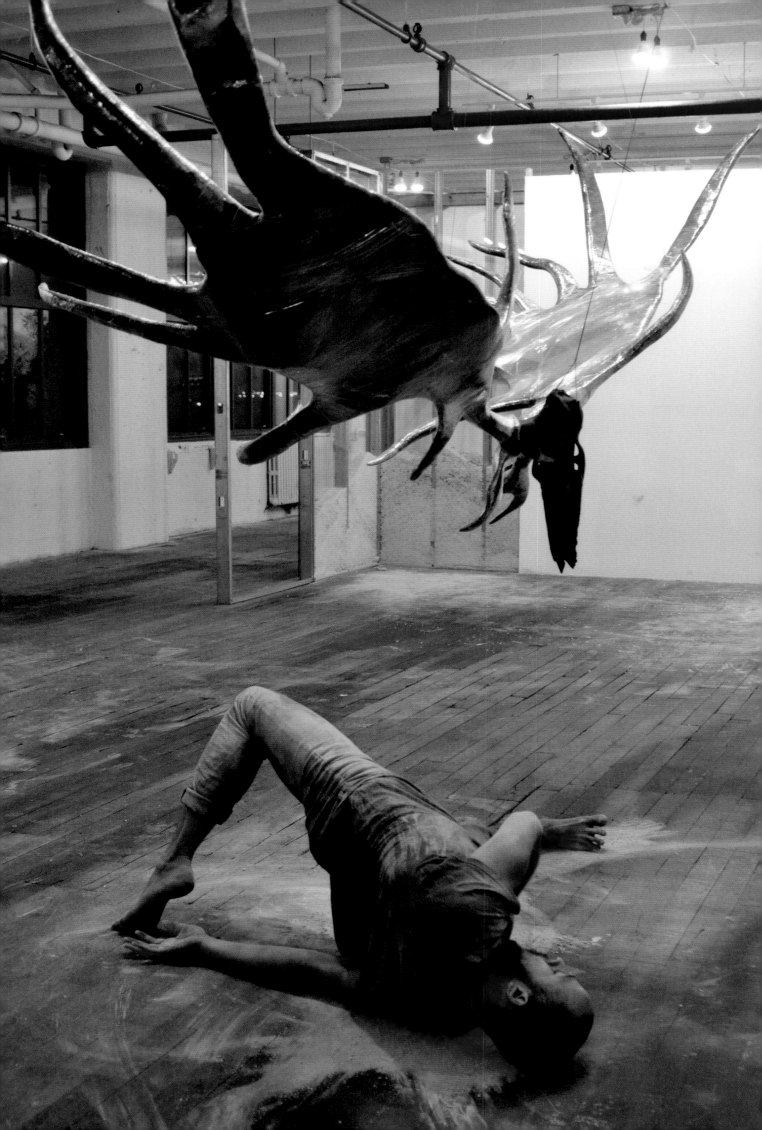

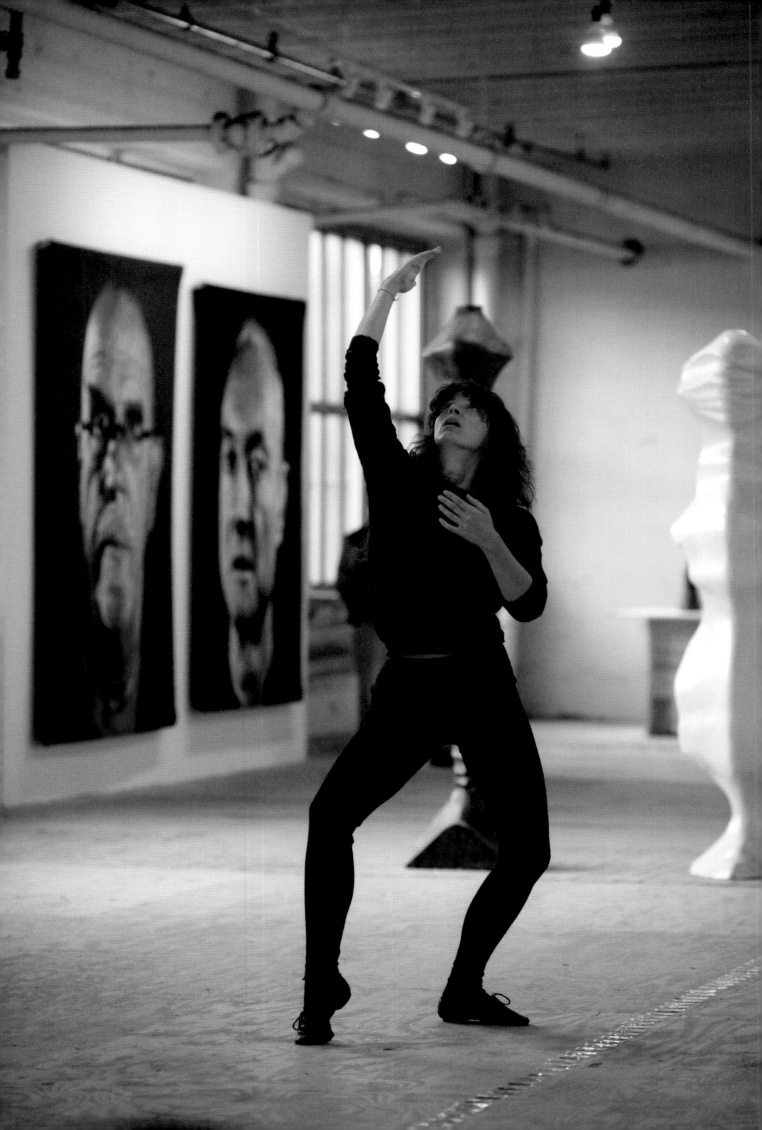

curring, and where coping with the constantly changing physical, economic, and human landscapes is both a challenge and a source of inspiration to artists. Hurricane Sandy taught us that there is no one way to overcome disaster or even to prepare for it. But there are nonetheless many ways to learn from all sorts of disasters, large and small.

Over the course of the exhibition and all of its related events *Come Together* made it clear that community and dialogue lie at the heart of both surviving and thriving, and that, in the end, the sense of community is one of the most valuable assets that anyone in any city has to depend on. Beauty may emerge from catastrophe, and inspiration from trauma, but the strength to overcome and move forward emanates from coming together, as we prepare to face whatever may befall us in the future.

38. Rebecca Brooks, *YALA* in *Performing the Precarious: Day into Night*, presented by Danspace Project. December 7, 2013
Photo by Ted Roeder

39. Xaviera Simmons, performance of Yoko Ono's *Cut Piece*, presented by Danspace Project. November 17, 2013
Photo courtesy of Xaviera Simmons

[1] Excerpt from *For Sandy* by Bob Holman. Commissioned for *Oh! Sandy: A Remembrance.*
[2] Michelle Boulé email to the author, June 24, 2014.
[3] November 7, 2013 Danspace press release.

[4] Excerpt from *If/Then: All Hallow's Eve* by Anne Waldman. Commissioned for *Oh! Sandy: A Remembrance.*
[5] Katie Rolnick email to the author, June 25, 2014.

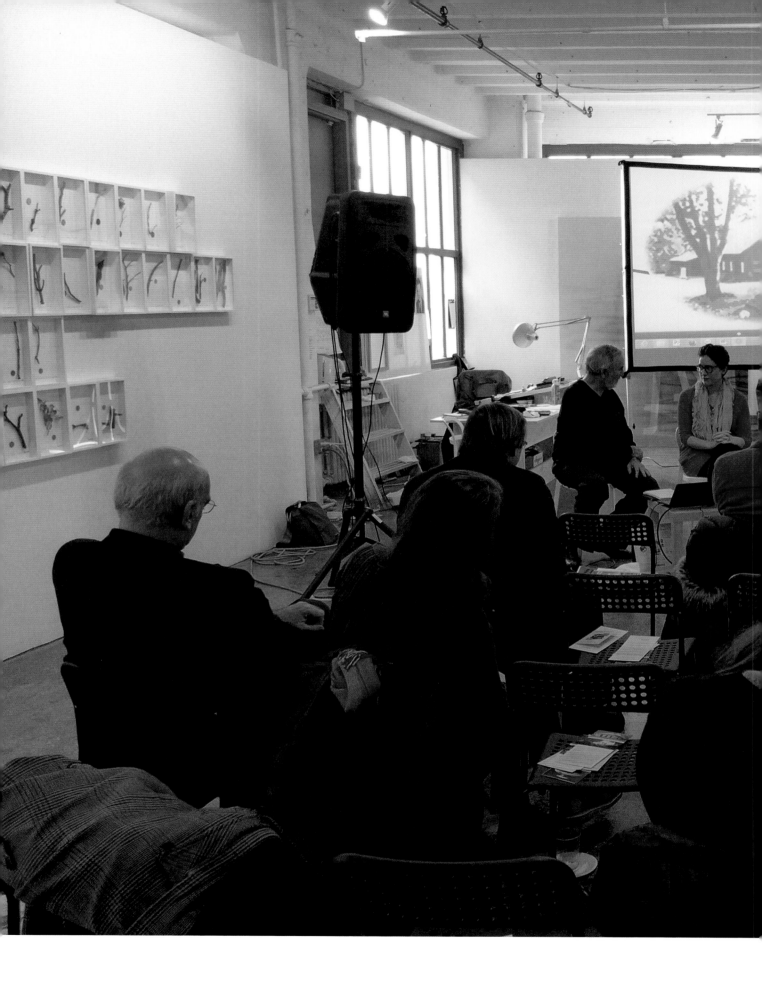

40. Craig Nutt, Jean Ann Douglas,
and Anna Studebaker speak
on the CERF+ Panel, "Keeping it
Together: Surviving After Sandy,"
November 23, 2013

Following pages
41. Anne Waldman reading in
Oh! Sandy: A Remembrance.
November 10, 2013
Photo by Zack Garlitos

42. Charles Bernstein reading in
Oh! Sandy: A Remembrance.
November 10, 2013
Photo by Zack Garlitos

43. Tonya Foster reading in *Oh! Sandy:
A Remembrance.* November 10, 2013
Photo by Zack Garlitos

44. Audience members, *Oh! Sandy:
A Remembrance.* November 10, 2013
Photo by Zack Garlitos

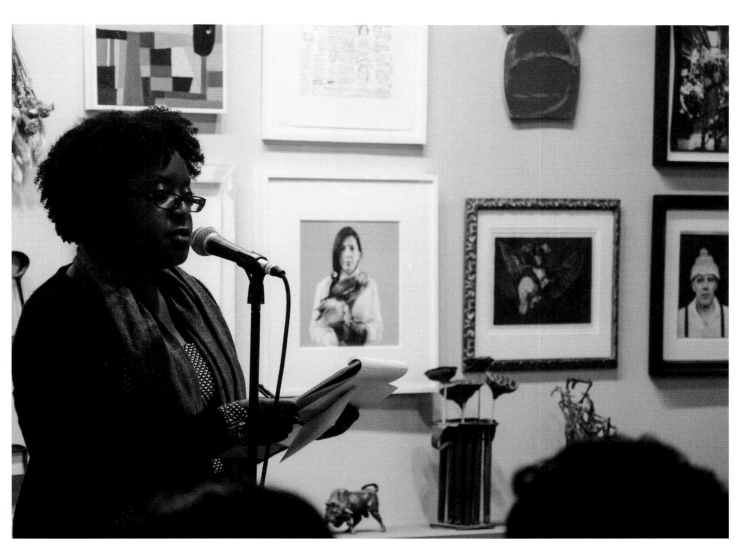

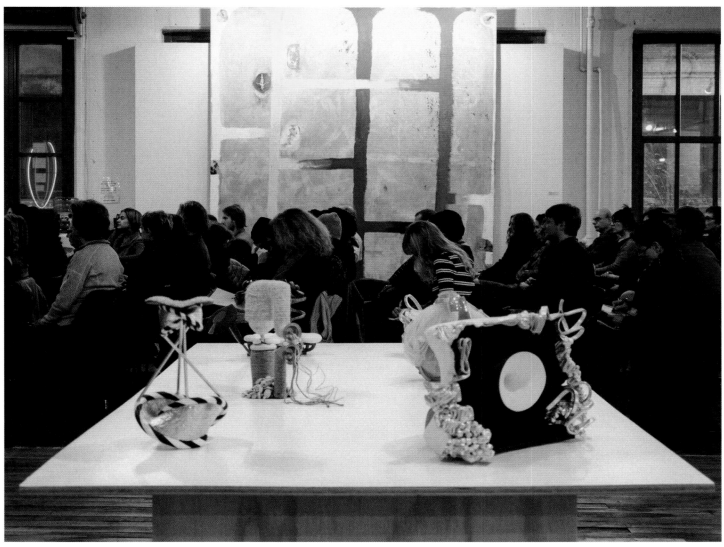

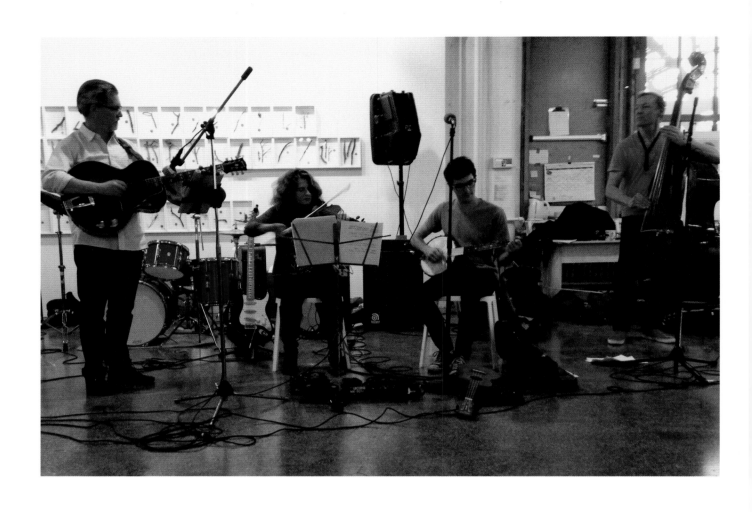

45. *Battle of the Artists' Bands.*
November 24, 2013

Events

Thursday, October 17
Various performances at the Opening Reception

• *Red Head*
Site-specific performance by Nathaniel Lieb (also performed at the closing reception on December 15)
• *Node: Within the Space of 7 Breaths III*
Performance by Shawn Upton
• *Archeology of the Plummet Machine Vol. I*
Site-specific performance by Matthew Lange (also performed at the closing reception on December 15)
• *Walking Mirrors*
Josiah McElheny pieces activated by dancers (also performed at the closing reception on December 15 and at other times over the course of the exhibition)

Thursday, October 24
Screening of *Beach 119* documentary

• Directors: Marcie Allen and Jessica Beutler
Discussion with the directors and selected film subjects

Saturday, November 9
Screening of *The Rider and the Storm* and *Shored Up* documentaries

• Directors of *The Rider and the Storm*: David Darg and Bryn Mooser
Q & A with director of *Shored Up*: Ben Kalina

Sunday, November 10
Children's Poetry Workshop

• Led by Christie Ann Reynolds

Sunday, November 10
Oh! Sandy: A Remembrance

• Readings by poets commissioned to write about their experiences during Hurricane Sandy. Published as a chapbook by *The Brooklyn Rail* in 2014.
Poets: Charles Bernstein, Anselm Berrigan, LaTasha N. Nevada Diggs, Tonya Foster, Nada Gordon, Bob Holman, Erica Hunt, Paolo Javier, Pierre Joris, Vincent Katz, Erica Kaufman, Rachel Levitsky, Tan Lin, Tracie D. Morris, Anna Moschovakis, Bob Perelman, Anne Waldman, Elizabeth Willis, Matvei Yankelevich.

Thursday, November 14
Bedsport Fan Breathe

• Performers: Dachi Dreaa, Candice Williams, and Whitney Vangrin

Sunday, November 17
Performing the Precarious, Part I: Cut Piece

• Created by Yoko Ono and performed by Xaviera Simmons
Curator: Lydia Bell

Saturday, November 23
***Keeping it Together: Thriving After Sandy* (CERF+ Panel)**

• Panelists: Illya Azaroff, Jean Ann Douglas, and Anna Studebaker
Moderator: Craig Nutt

Sunday, November 24
Battle of the Artist Bands

• Performers:
• *Ham* with Steve Dibenedetto, David Humphrey, Michele Segre, and Jennifer Coates
• *Gospel of Barb* with Steve Dibenedetto, David Humphrey, and Jon Kessler
• *Jeanne Get Around* with Jennifer Coates, Stephen Ellis, David Humphrey, and Terry Dignan
• *Slip N' Slide* with Stephen Ellis, Ron Baron, and Scott Williams
• *Red* with David Ross and Patrick Jones

Saturday, December 7
Children's Dance Workshop

• Led by Rebeca Medina and Tatyana Tenebaum

Saturday, December 7
Performing the Precarious, Part II: Day into Night

• Curator: Judy Hussie-Taylor
• *YALA* created and performed by Rebecca Brooks (6th floor)
• *will however happen* (excerpts) created by Rebecca Davis and performed by Erin Cairns, Lydia Chrisman, Carolyn Hall, and Kay Ottinger (3rd floor)
• *decumulation* performed by Will Rawls (3rd floor)
• *The Animal Suite: Experiments in Vaudeville and Shapeshifting* (excerpt) created by Cori Olinghouse and performed by Neal Beasley (3rd floor)
• *Find Yourself Here* created by Joanna Kotze and performed by Jonathan Allen and Joanna Kotze (6th floor)
• *White* created by Michelle Boulé and performed by Michelle Boulé, Lauren Bakst, and Lindsay Clark (3rd floor)
• *Study for 13 Love Songs* created and performed by Ishmael Houston-Jones and Emily Wexler (3rd floor)

Sunday, December 8
***Hurricane Sandy and Damaged Artwork: The Artist's Experience* (INCCA-NA Panel)**

• Panelists: Rachel Beach, Diana Cooper, Magdalena Sawon, and Linda Serrone Rolon
Moderator: Elizabeth Nunan

Sunday, December 8
***Beyond Backdrop: Fiction in the Wake of History* (Fiction Writers Panel)**

• Panelists: Joseph O'Neill (author of *Netherland*), Lucy Alibar (screenwriter for *Beasts of the Southern Wild*), and Alex Gilvarry (author of *Memoires of A Non-Enemy Combatant*)
Moderators: Katie Rolnick and Joseph Salvatore

Every Saturday during the entire course of the exhibition, INCCA-NA conducted *Oral Histories* with artists who were victims of Sandy. Excerpts from these interviews are available on the website cometogethersurvivingsandy.org

The Beauty of Friends Coming Together

Sara Christoph

The Beauty of Friends Coming Together I & II was a group show of Herculean proportions: nearly 200 artists on twelve walls. Within the already massive exhibition *Come Together: Surviving Sandy, Year 1*, it was not merely the logistical challenges that filled these rooms with vitality. It was the message, heard loud and clear across the two floors, that art making in New York City remains full of eclecticism and passion. In retrospect, it seems that perhaps only a tragedy of such proportions as Hurricane Sandy could have brought about such a joyous and varied surge of creative renewal.

The concept for *The Beauty of Friends* was simple: one hundred artists, the majority of whom had been affected by the storm, were invited to submit a single, self-selected work. Each artist was then instructed to invite a friend, doubling the total count of participants. If a chosen artist was *not* directly affected by Sandy, he or she had to find a partner with a Sandy story, and vice versa. The exercise was a bit like finding a buddy in grade school, and became yet another way of building a sense of community. Bushwick artists found partners in Queens, veteran artists with stories of heartbreaking loss paired up with those fresh to the city's landscape. Such an intertwining web across the boroughs generated an infectious exuberance, visible in the hanging of the show upon shimmering, silver walls. In gathering together the many artists for *The Beauty of Friends*, a second, regenerative, wave of Sandy stories was created. Stories that, we now hope, might enrich and outlast the initial accounts of great ruin.

Creating expansive networks of people and their art is a drive that runs through Phong Bui's veins. His way of "networking" differs from the business or career-building connotation of the word, with its notions of upward mobility. Phong's networks are strictly horizontal. Exchanges are interdisciplinary and intergenerational; barriers of personal history are left in rubble. Indeed, this sort of network building is his lifeblood—his "social sculpture" as he would say. In its collective diversity, *The Beauty of Friends* was the manifestation of this spirit of exponential interconnectivity.

The work was split between two floors, and the range of media, style, subject matter, and maturity would have presented any experienced curator with a formidable challenge. But this was the brilliance of the show, because to walk through the galleries was to witness the multiple and varied voices that conveyed so much about

Following pages
46. *The Beauty of Friends Coming Together I.* Installation view
Photo by Rachel Styer

47. *The Beauty of Friends Coming Together I.* Installation view
Photo by Rachel Styer

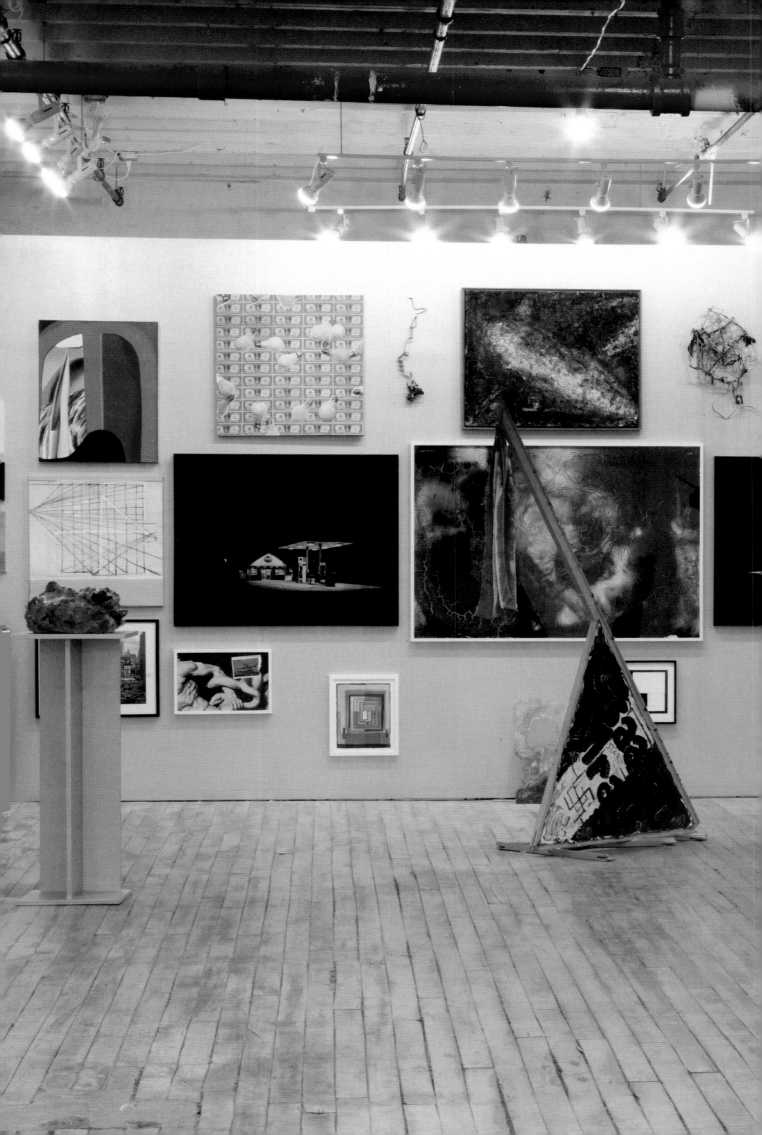

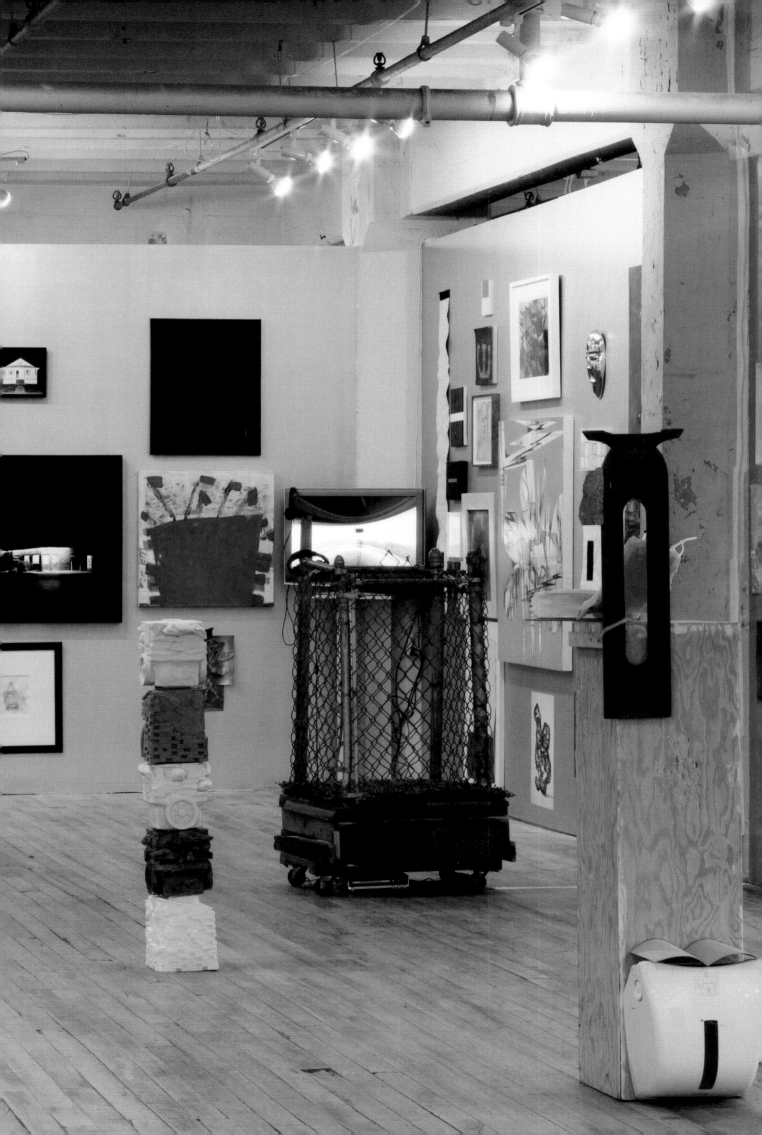

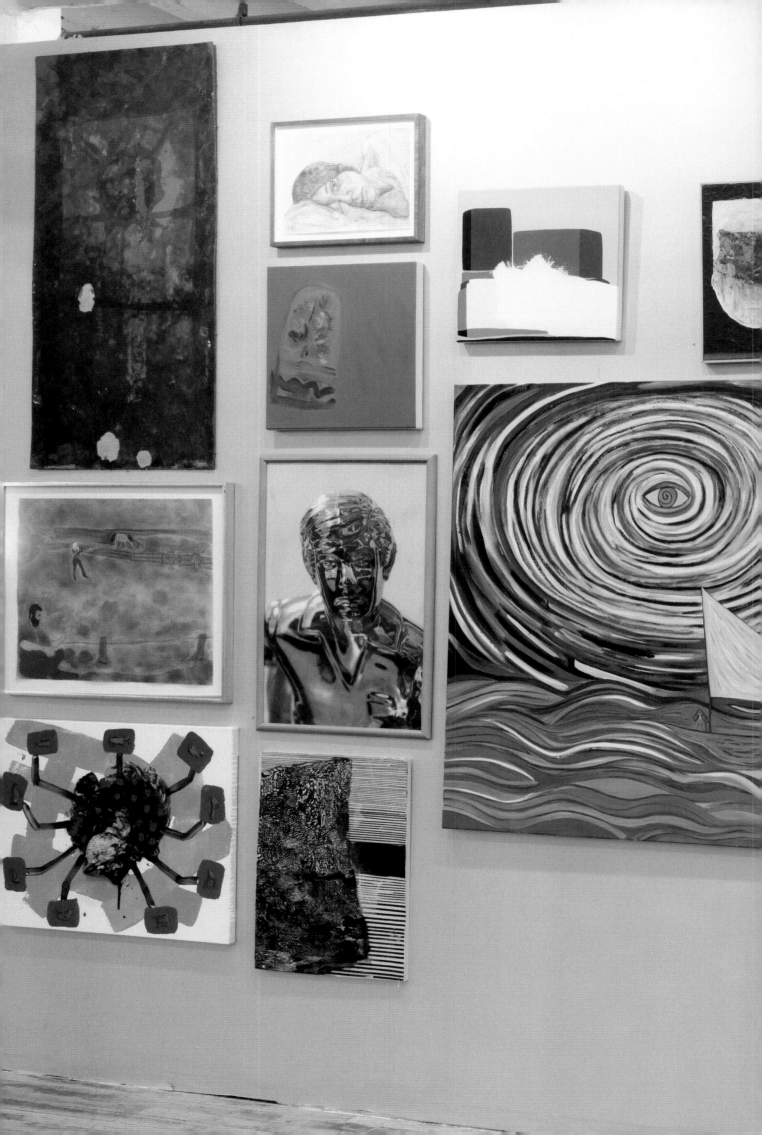

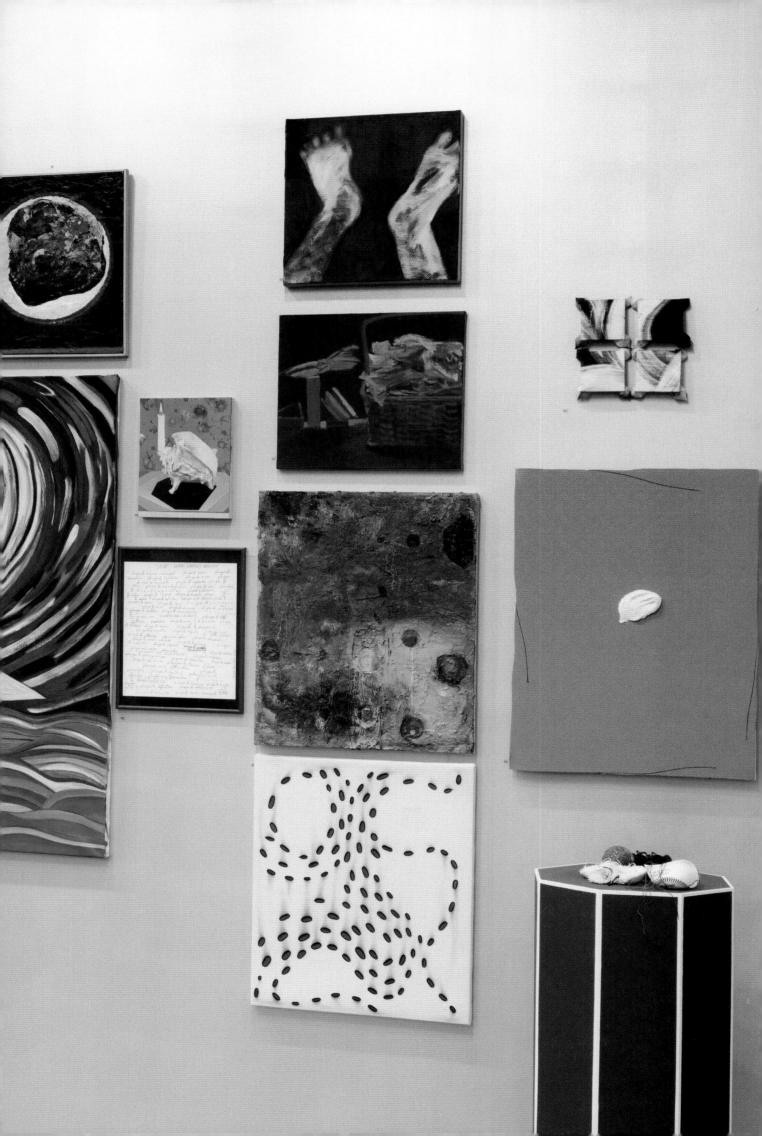

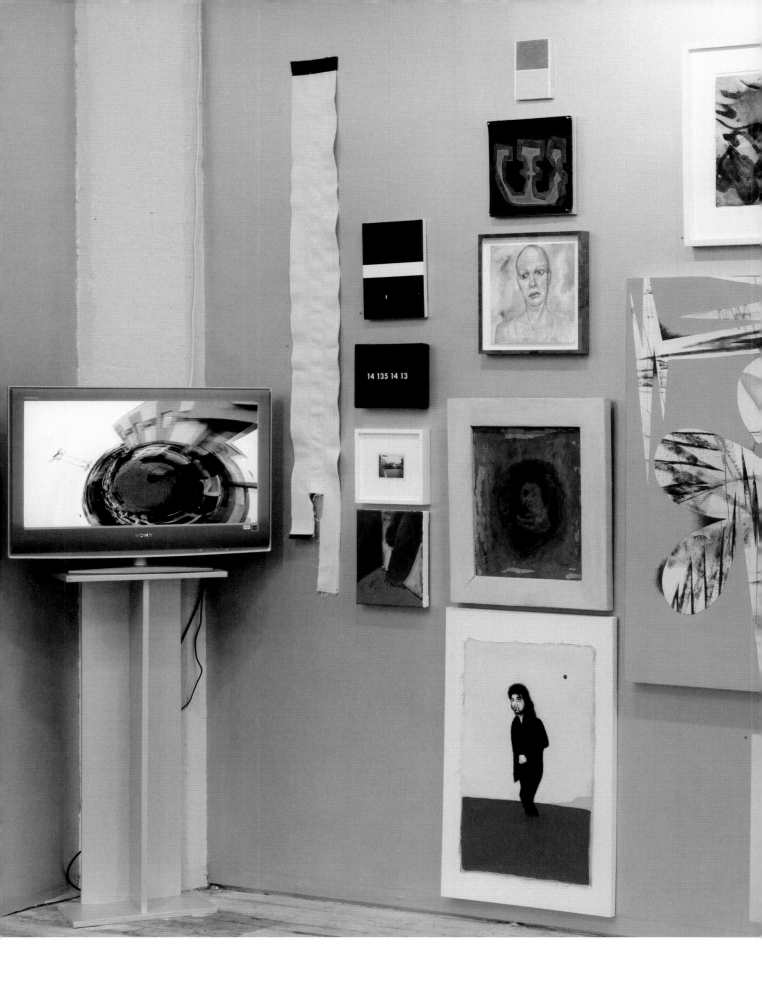

48. *The Beauty of Friends Coming
Together I.* Installation view
Photo by Rachel Styer

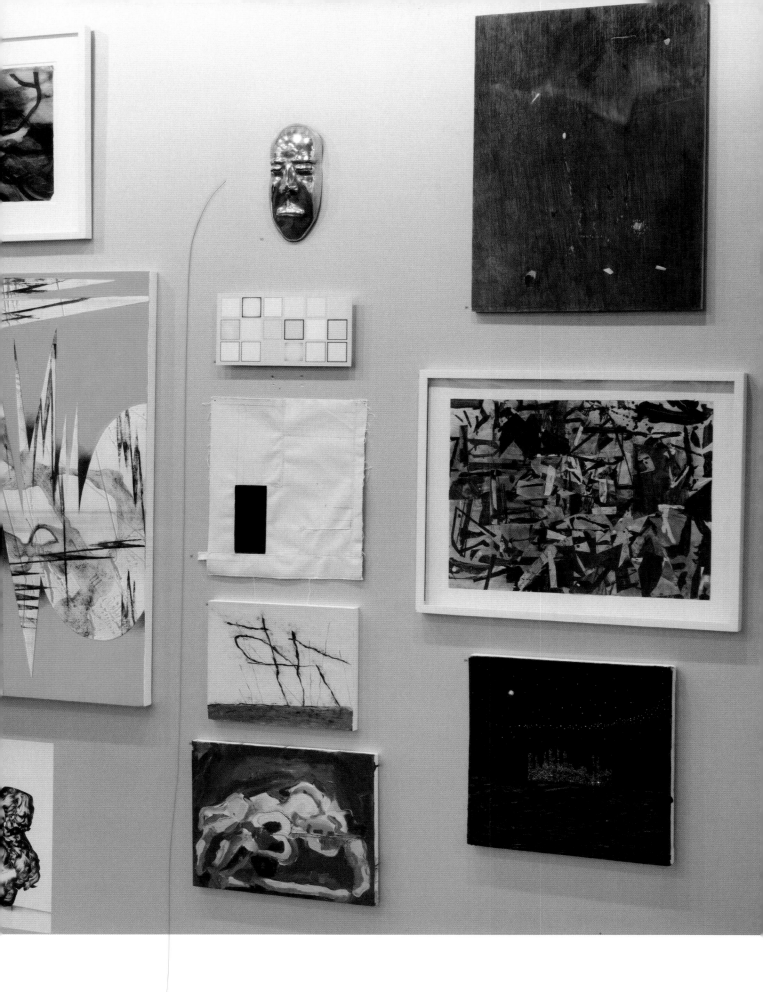

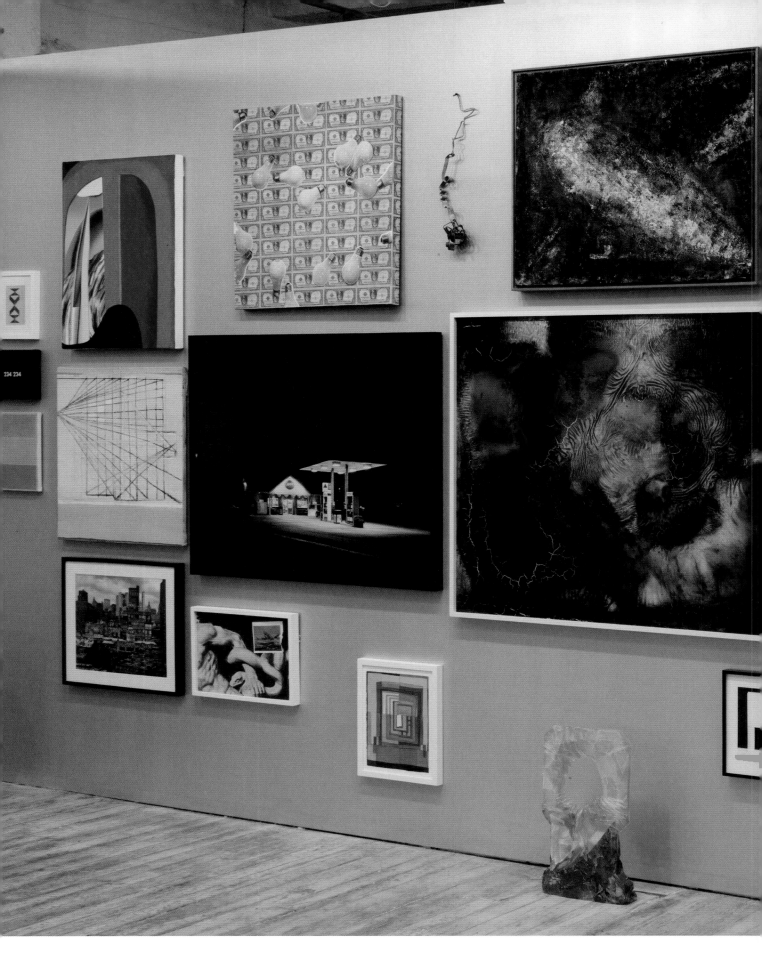

49. *The Beauty of Friends Coming*
Together I. Installation view
Photo by Rachel Styer

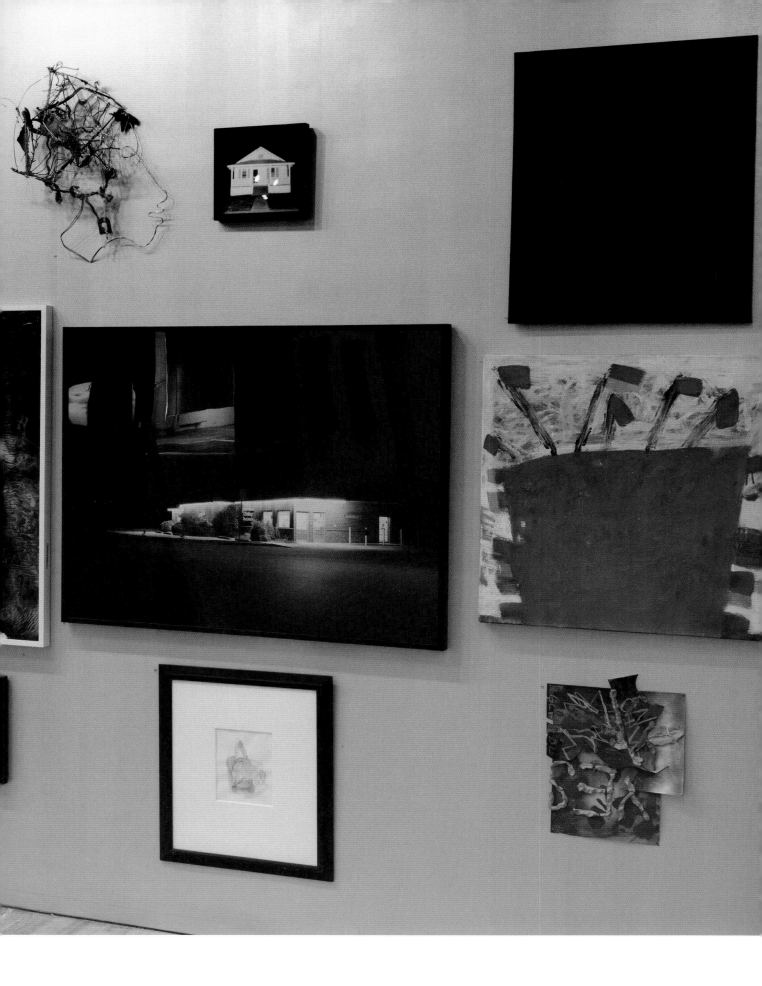

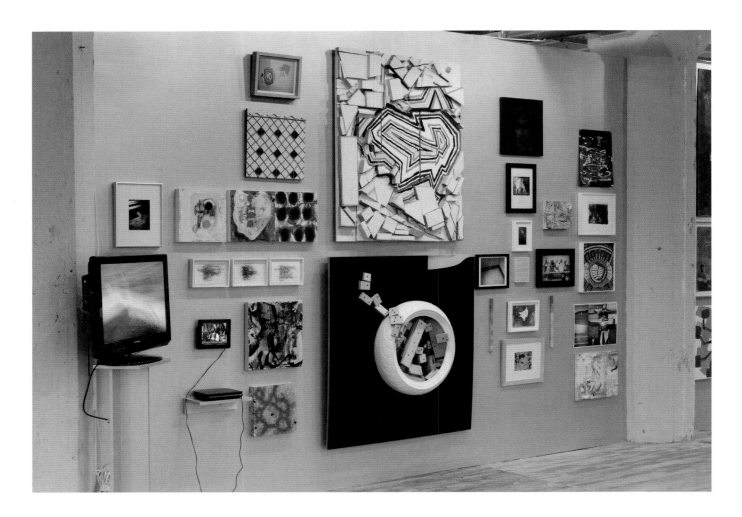

what it means to live as an artist in this great city. Painted works representational and abstract, photography digital and analog, video choreographed and spontaneous, sculpture found and composed, and even site-specific installations were all merged into conversations both effusive and subtle.

Despite the cacophony of voices, moments of harmony emerged in the closely knit, salon style installation. While not all participant artists selected work that specifically dealt with Sandy's aftermath, many chose work that alluded to the age-old struggle of humanity in the face of nature's omnipotence. In *Eye of the Storm*, a painting by Susan Bee, a ravenous, centrifugal sky stares with an unblinking eye upon a single figure alone, drifting on ribbon-like waves (fig. 47). The painting was hung next to a handwritten poem by her husband, Charles Bernstein, commissioned for the occasion:

> plunges & remains submerged
> plunges & expires
> plunges & resurfaces
> plunges & liquidates
> plunges & flips
> plunges & fails to accelerate

Here, the two partners in life became poles on the wall: one a mythical, jewel-toned telling of a soul adrift, the other, factoids of bare-knuckled perpetuity.

Next door was Kristie Hirten's *Float*, in which a closely cropped orange life preserver hovers near the painting's surface, beneath a layer of dried hurricane detritus. The painting, which was lost for months after Hirten's Long Island studio was submerged in the flood, was miraculously discovered a year later when the canvas washed up from the bay behind her family's home, like weathered driftwood. In *The Beauty*

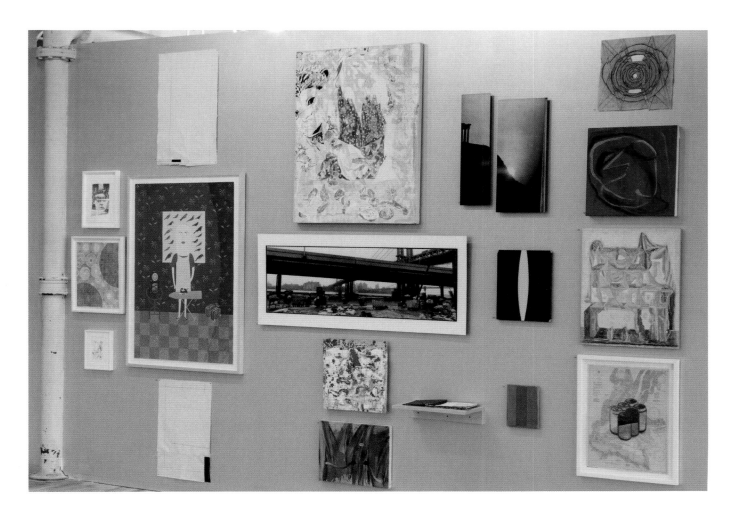

51. *The Beauty of Friends Coming Together I*. Installation view
Photo by Rachel Styer

Following pages
52. *The Beauty of Friends Coming Together I*. Installation view
Photo by Rachel Styer

53. Johnson Sarkissian, *Moving through the Water of Other Bodies*, 2012
20 inkjet photographs on museo silver rag fine art paper, 12' 6 x 7' 4"
As part of *The Beauty of Friends Coming Together I*
Courtesy of the artist. Photo by Brian Buckley

of Friends, the painting hung valiantly on the wall with battle scars intact, still carrying the salty stench of the Atlantic.

Another Sandy story could be gleaned from the work of Arnold Wechsler, an eighty-four-year-old artist whose commitment to the show was steadfast. Wechsler, who has lived in the Westbeth Aritsts Community since the 1970s, lost a substantial portion of his life's work when the waters of the Hudson rushed into the basement of the building. In spite of it all, Wechsler was a regular visitor to the exhibition, wandering the galleries and spreading his ebullient spirit.

When joining the show, Wechsler found a partner in Zack Garlitos, a photographer whose association with *The Brooklyn Rail* goes back to his days as a high school-aged volunteer. Previously unknown to each other, the two became "buddies" when Wechsler's cousin, the filmmaker Lynne Sachs, serendipitously stopped by *Rail* headquarters and shared Wechsler's story of loss. For the exhibition, Garlitos submitted *Abstraction #1*, a piercing, black-and-white image of a shadow's edge splayed across concrete steps—a quiet nod to Wechsler's frenetic abstraction. Though far apart in age and practice, the two have since foraged a friendship, Garlitos profiling Wechsler in his ongoing photographic series of artists in their studios.

Across the gallery hung the series *Moving through the Water of Other Bodies* (fig. 53), by the photographic team Johnson Sarkissian (Robert Johnson and Katherine Sarkissian). Right after Hurricane Sandy hit, the two traveled to the New Jersey shore to document the destruction, but stayed for months when they saw the scale of the desolation. Their camera, the team explained, "became a platform from which the residents could release their anger, despair and disbelief." All twenty images were saturated with rich color and exquisite, unforgiving details—details that revealed moments of individual tragedy that were, in the end, monumental in scale.

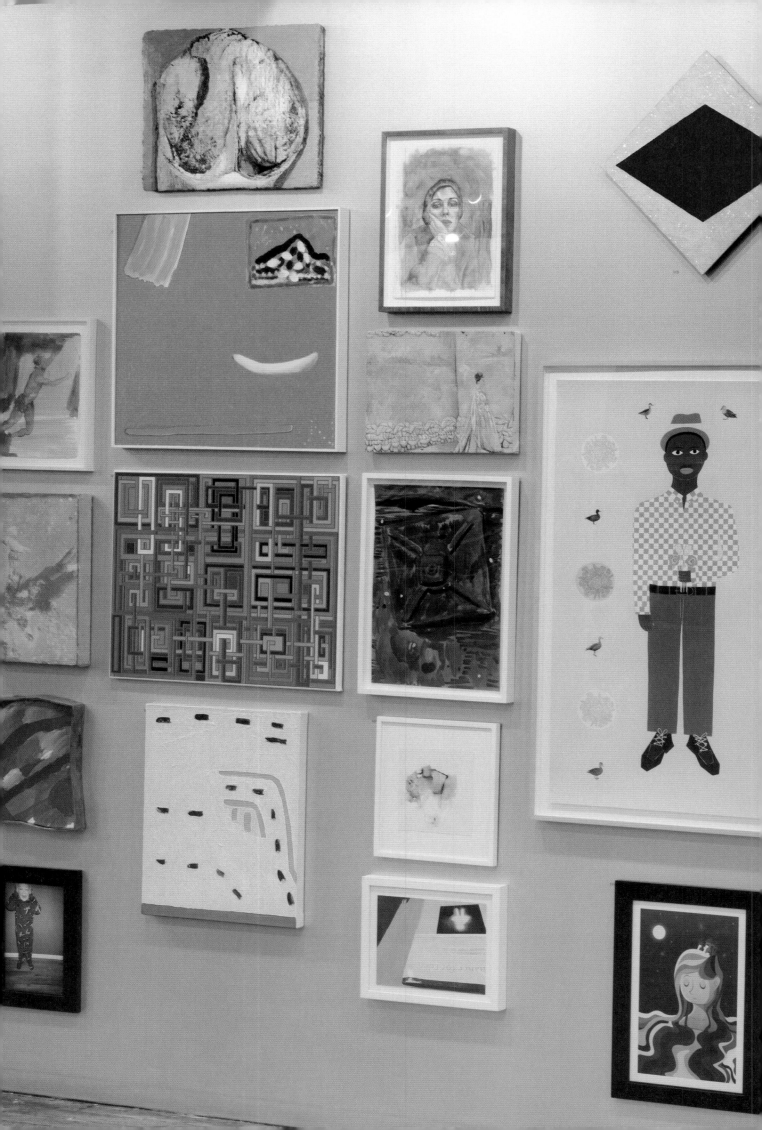

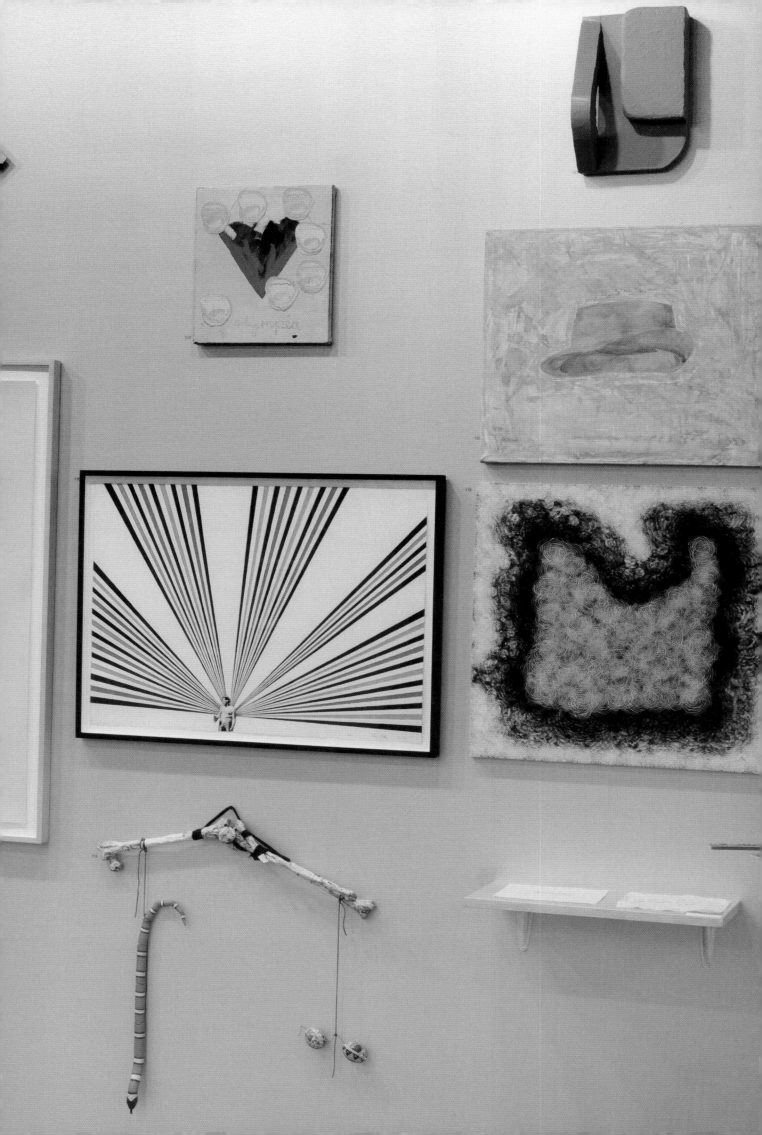

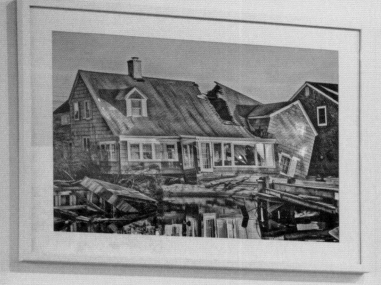
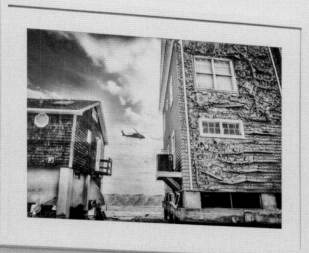

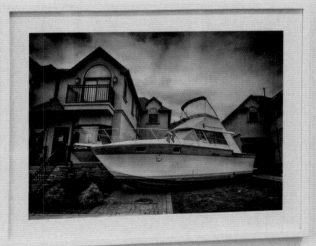

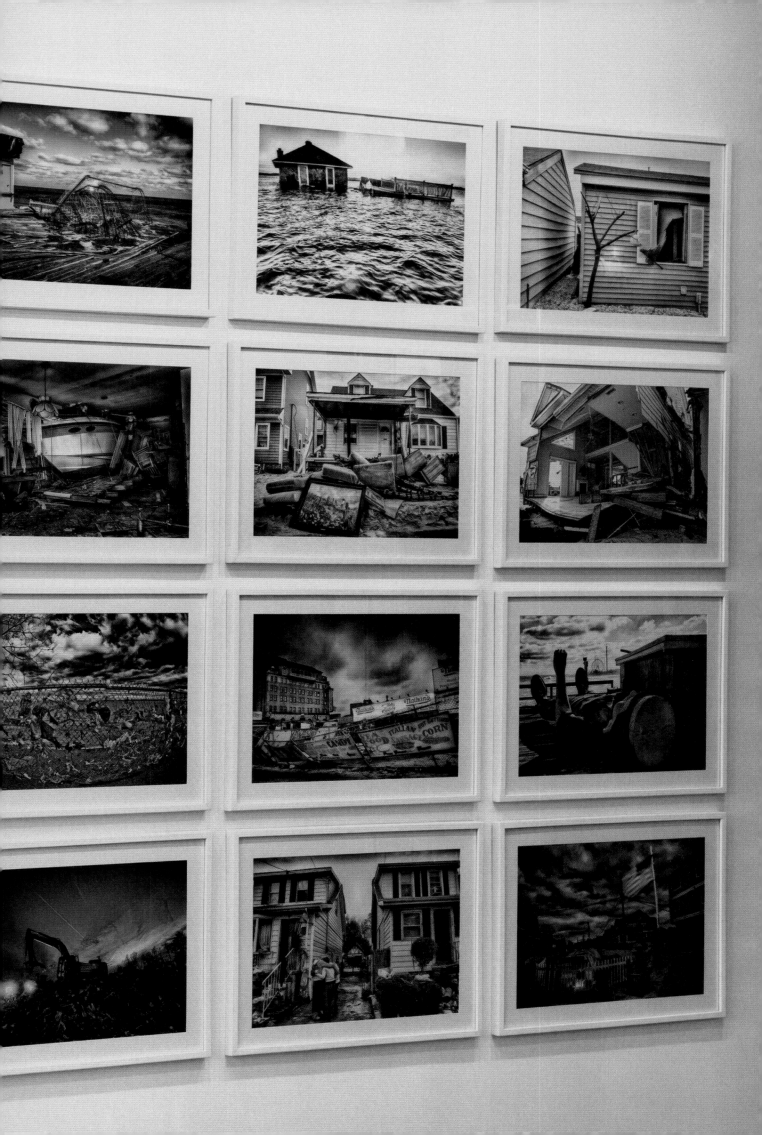

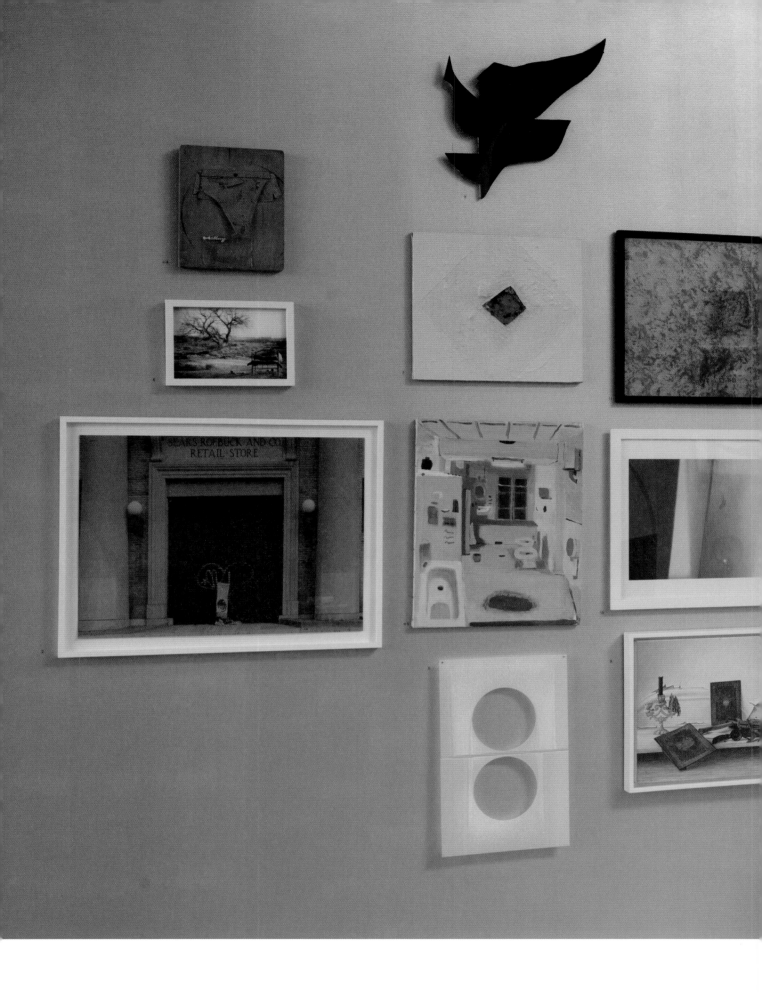

54. *The Beauty of Friends Coming
Together II.* Installation view
Photo by Brian Buckley

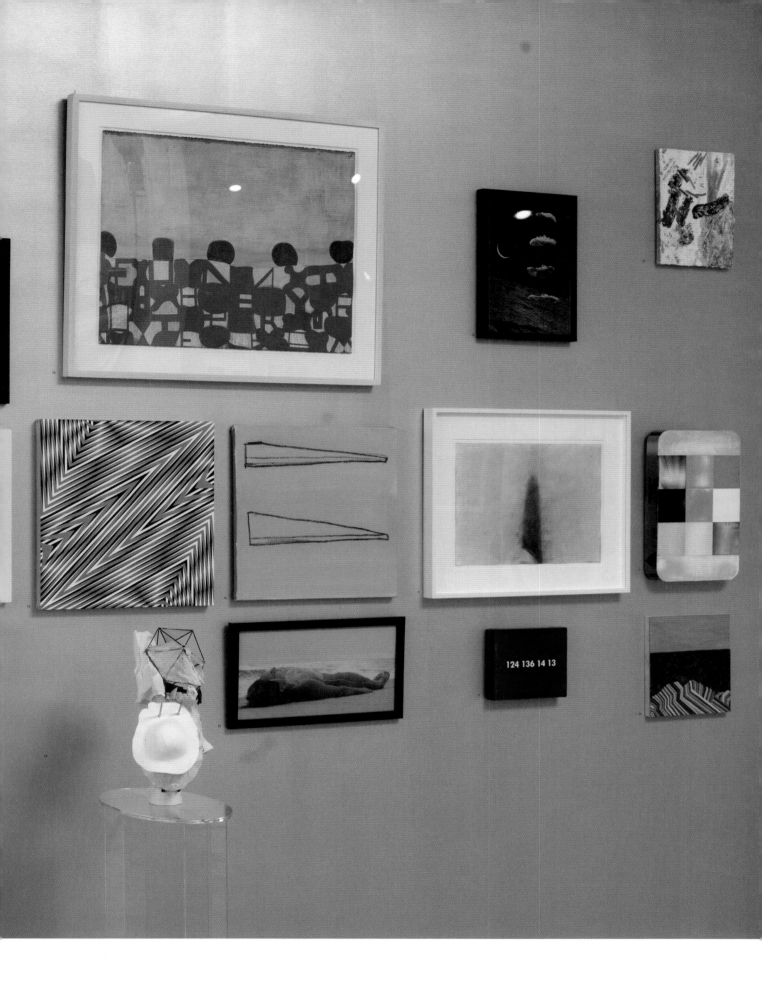

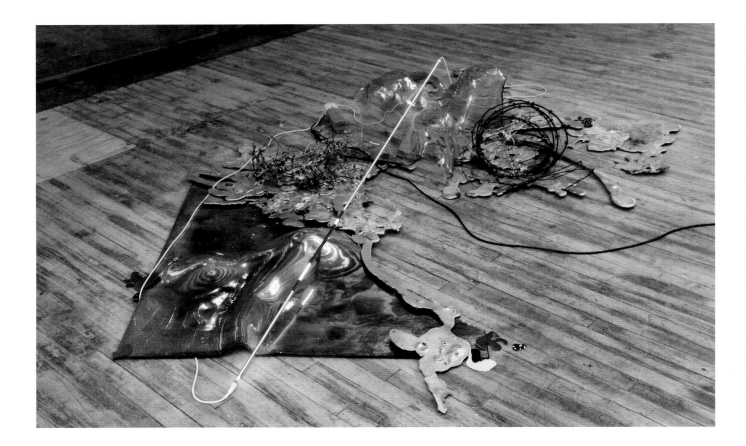

For the artist Caroline Sun, when the electric power finally returned after nine days of bitter cold in her home in Queens, the surge caused a fire that destroyed much of the building and incinerated a large portion of her artwork. One piece that survived, *Feline Relativity*, was included in the show, and later mentioned in a luminous review by *The New York Times* art critic Roberta Smith. Sun, like Wechsler, was invited to participate in the exhibition through a chain of "good Samaritan art people." She was astonished, Sun recently wrote, "to realize that there is a *real* community of artists who actually care, connect, and support one another." And once she saw her name in the *Times*, such encouragement became a jolt of energy that "remains with her still."

Next to Sun's painting was a video work by Joey Frank, initially submitted as *Documentation of the Trains Finger Playing Cards Table* (fig. 59). During installation, the flat screen television plummeted from the wall and smashed the screen into a web-like pattern of cracked crystallizations. When the artist came to see the damage, he declared the piece complete as it was, and left the television exactly at the spot it had fallen. "The whole accident felt like the most fitting way to see Hurricane Sandy," explained Frank, "such a sudden, unexpected turn of events, like a playing card dropped on a table."

Some artists chose to use material culled from the storm's wreckage, picking up on nature's push toward rebirth. Kevin Marin, a resident of Queens, gathered the wood and wire from his neighbor's toppled fence and created *Acre*, a free-standing sculpture that encloses a small television screen (fig. 46). Looking over and down into the fenced-in square, a deceptive infomercial loops on the screen promising prepackaged land out West, riffing on the games that real estate prospectors play with rising water lines.

What I am describing, of course, is only a miniscule portion of the work that was included in *The Beauty of Friends*. The abstract paintings of Williamson Brasfield, Gaby Collins-Fernandez, Nathlie Provosty, Joan Waltemath, and Benjamin Weber introduced a more formal, meditative element to the collection of works. Meanwhile, the videos of Michael Marfione, Lucy Cottrell, and Kara Rooney spun narra-

55. Gandalf Gavan, *Breach*, 2013
Aluminum, neon, dimensions variable
As part of *The Beauty of Friends Coming Together II*
Courtesy of the artist. Photo by Brian Buckley

110

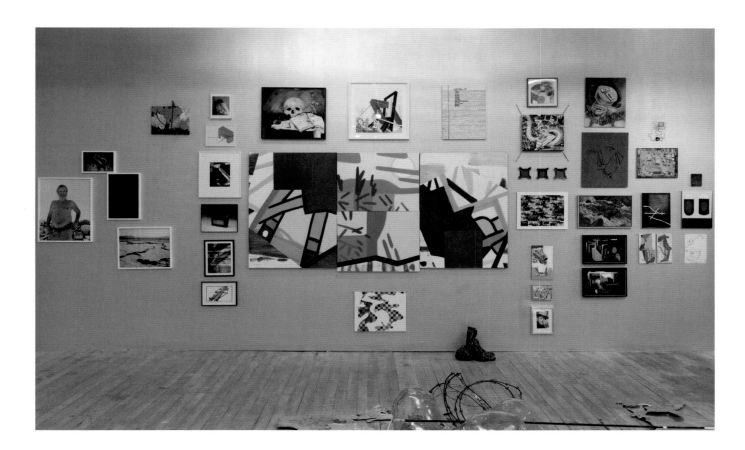

tives in entirely new, fantastical directions. The digital drawings of Nyeema Morgan scrambled words and traditions until obscured edits were all that remained, while the eerie, lustrous photographs of Wilmot Kidd reminded us that nostalgia always adds its own layer of glossy desire (fig. 46).

Reflecting on the experience now, after the show has closed, I still remember arriving at Industry City early one September morning and hearing for the first time that we were adding another 200 artists to the show. (Naturally, I thought this was a joke.) Though involved with the *Rail* for years, I had joined the team only recently as the Managing Director—just as the exhibition barreled ahead. But as I saw time and again, the curatorial vision did not bend to difficult logistics, quite the opposite. Insurmountable tasks were navigated largely, if not entirely, because of a collective belief in this momentous opportunity. Phong Bui, and all the partners involved in the exhibition, believed that this was the time to reclaim Sandy's legacy of devastation, our time to embody this moment of rebuilding. ("Refuse to use the word *stress*," Phong would remind us in our morning meetings, "we must refer to such details simply as *challenges*.") This sort of unflagging zeal, which began with the artists who picked themselves up after losing so much (Phong Bui being one himself), and trickled down from curator to staff, and later, to the thousands of visitors who traveled to witness the exhibition, is now, looking back, the most vivid manifestation of the resiliency Sandy inspired.

It is not often that you find instances of extreme democracy in the art world; rarely does establishing connections with other people—specifically with those different from you—ever seem to be the goal of an exhibition. But here, in this show, it was about nothing else. It was about *people*, the relationships they form, and the things they make in response to this inexplicable life. It was about solidarity actualized through art.

56. *The Beauty of Friends Coming Together II*. Installation view
Photo by Brian Buckley

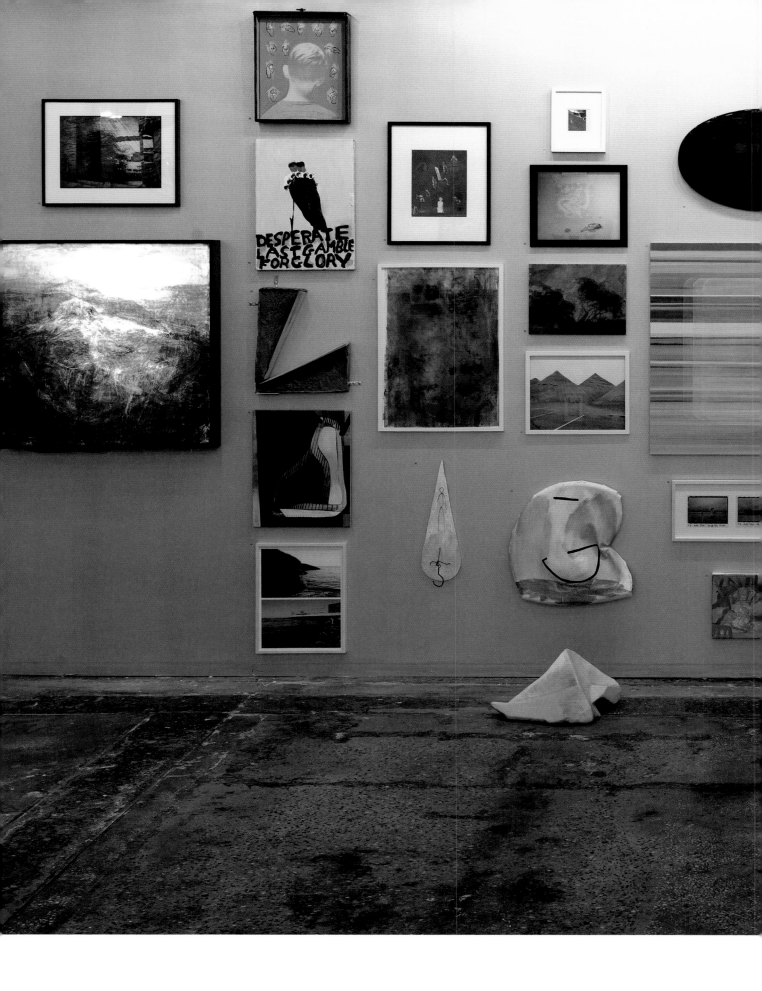

57. *The Beauty of Friends Coming Together II*. Installation view
Photo by Brian Buckley

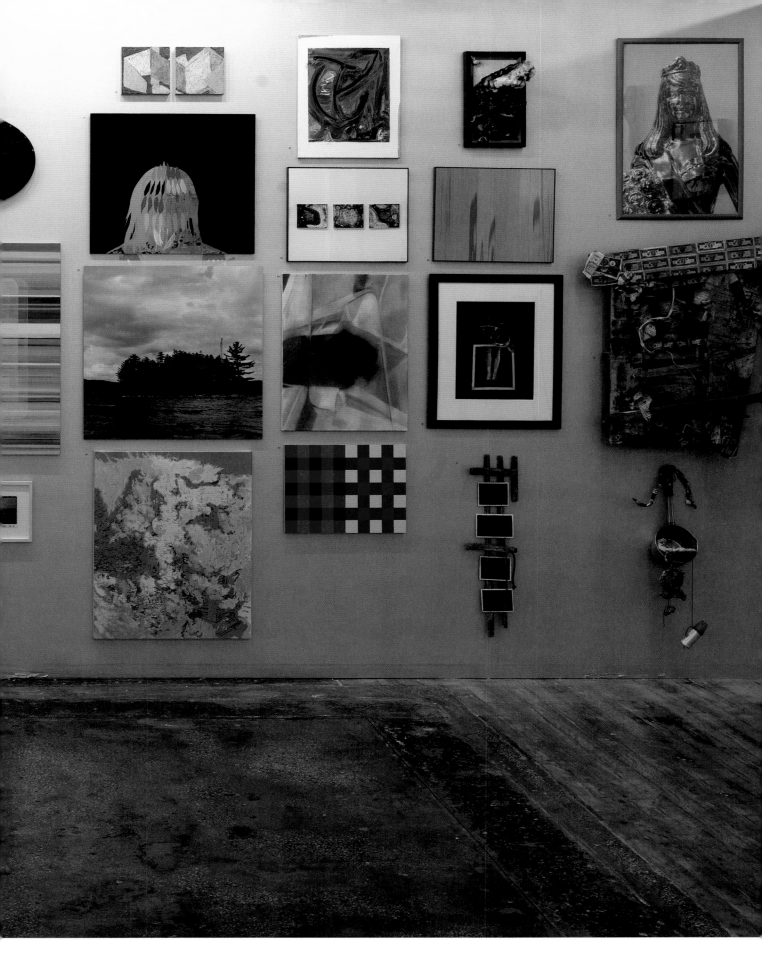

Following pages
58. *The Beauty of Friends Coming Together II*. Installation view
Photo by Brian Buckley

59. *The Beauty of Friends Coming Together II*. Installation view
Photo by Brian Buckley

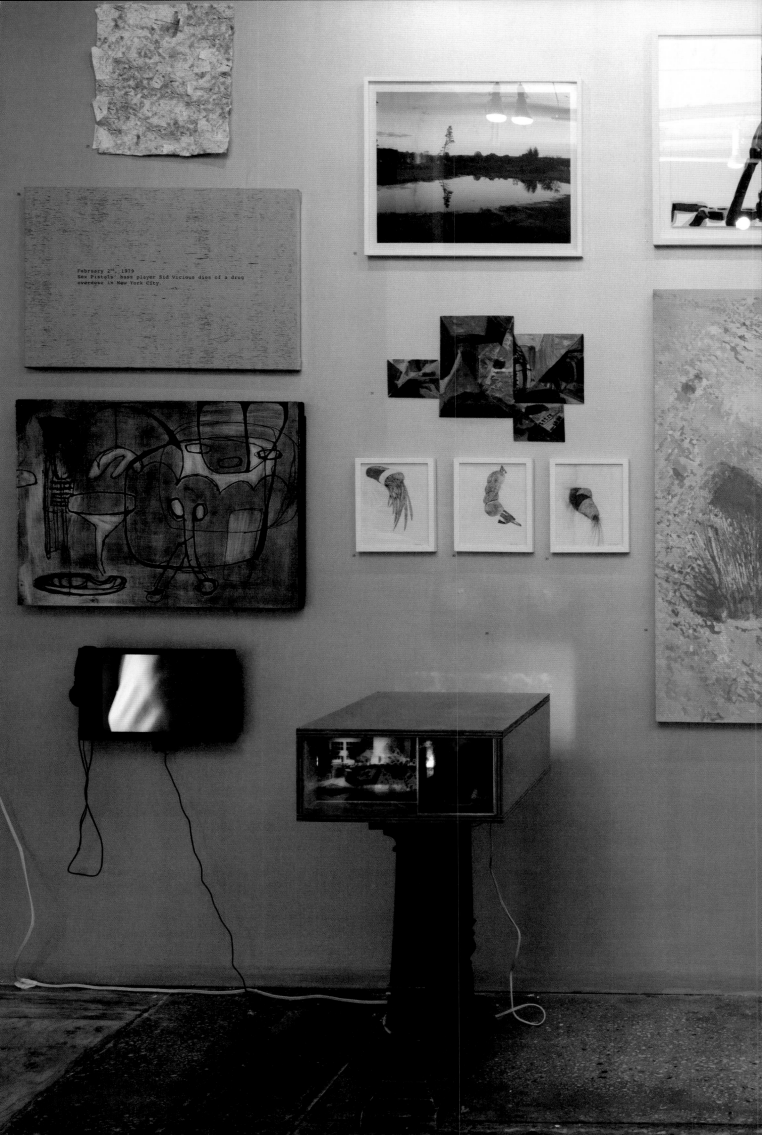

February 2nd, 1979
Sex Pistols' bass player Sid Vicious dies of a drug
overdose in New York City.

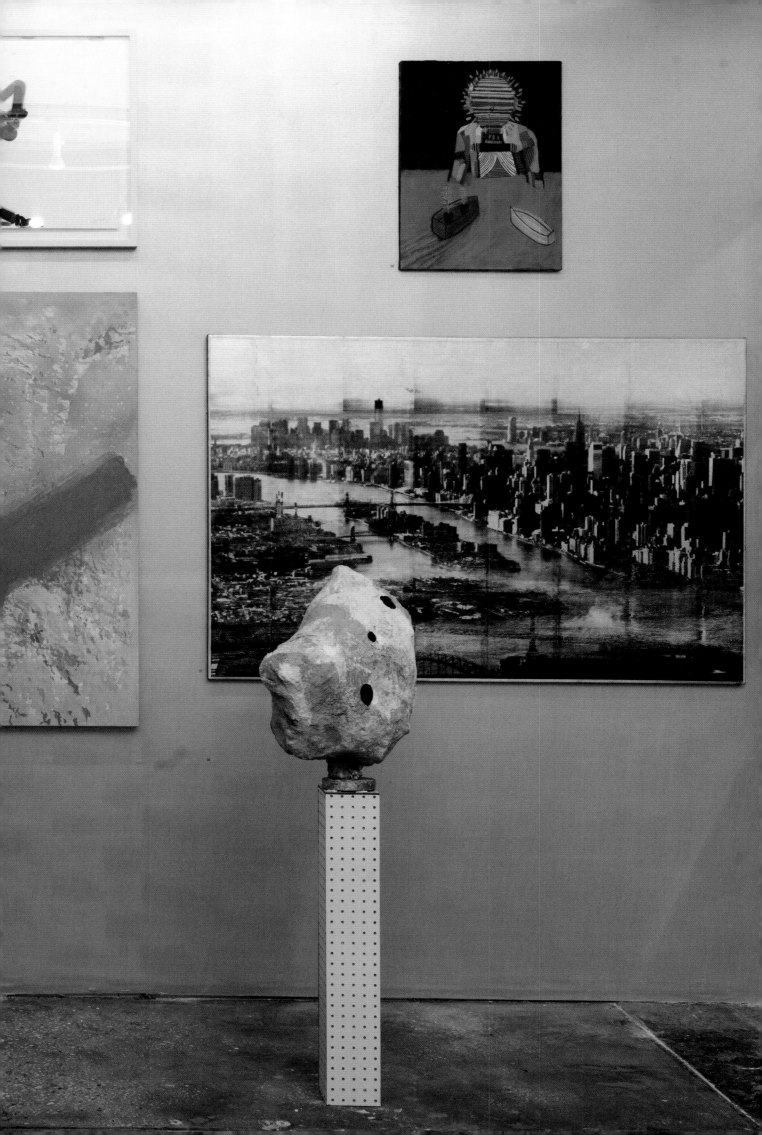

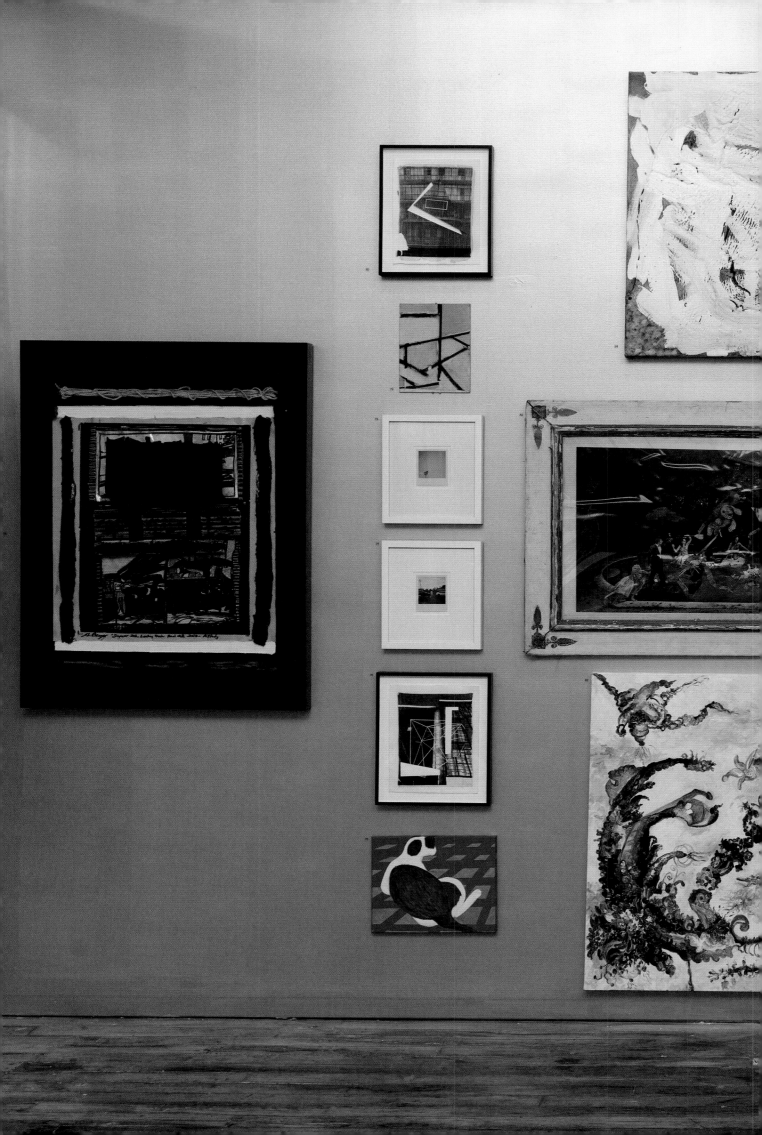

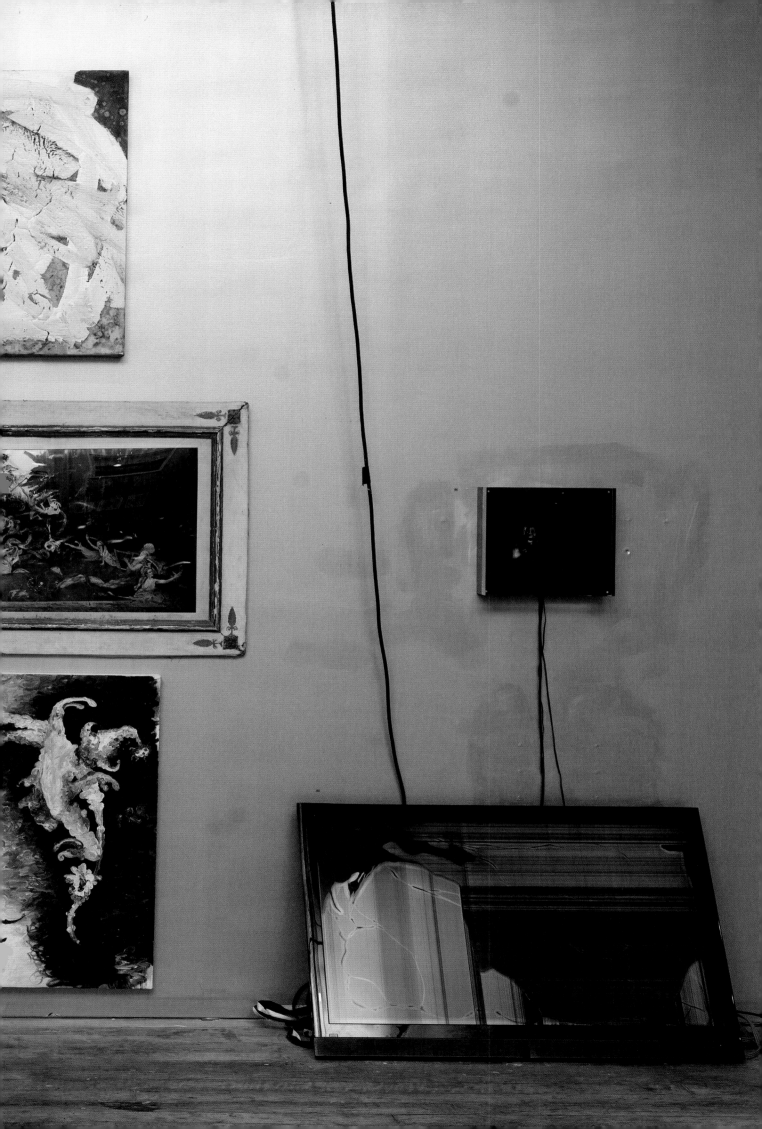

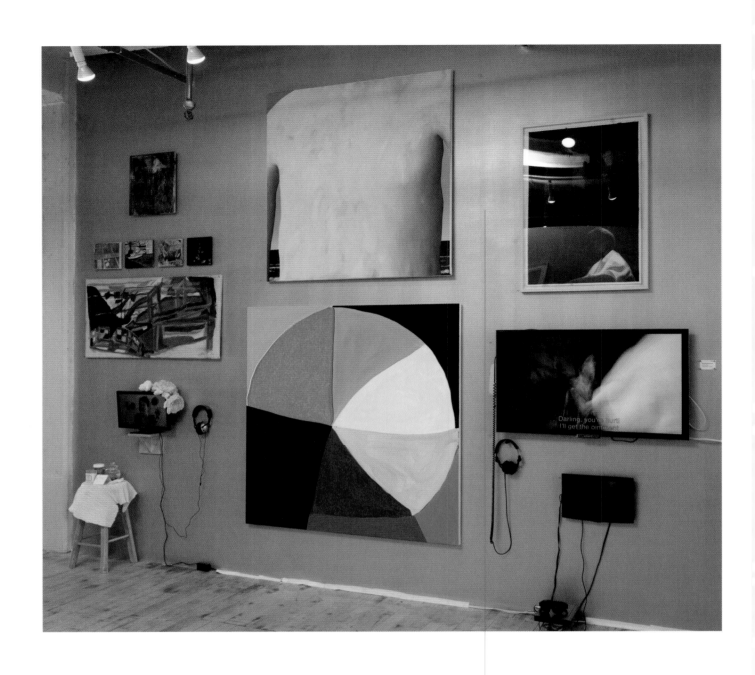

60. *The Beauty of Friends Coming Together II*. Installation view
Photo by Brian Buckley

The Beauty of Friends Coming
Together I & II

Bill Abbott
Marina Adams
Mira Aldridge
Barbara Asch
Adriana Atema
Eric Banks
Paul Baumann
Rachel Beach
Susan Bee
Z Behl
Louise Belcourt
Adam Bell
Jesus Benavente
Matt Benedetto
Michael Benedetto
Leon Benn
Meryl Bennett &
Matt Taber
Sallie Benton
Susan Berger
Robert Berlind
Charles Bernstein
Michael Berryhill
Gregg Biermann
Antonio Bilotta
Jeffrey Bishop
Julia Bland
Gregory Botts
Katherine Bradford
Kim Brandt &
Walsh Hansen
Williamson Brasfield
Amy Brener
Michael Brennan
Rick Briggs
Becky Brown
Elle Burchill
Melissa Carroll
Kathleen Casey
Alex Casso
Lea Cetera
Kris Chatterson
Jesse Chun
Donna Cleary
Mike Cloud
Cora Cohen
Lucille Colin
Gaby Collins-Fernandez
Lucy Cottrell
Jon D'Orazio
Jamie Dalglish
Amy Davis
Blane de St. Croix
Jean-Jaques du Plessis
Yael Eban
Eve Eisenstadt
James English Leary
Nick Etre
Julie Evanoff
Franklin Evans
Lisa Fairstein
Matthew Farina
Salvatore Farina
Adriana Farmiga
Maximiliano Ferro
Nils Folke Anderson
Gerald Förster
Lucy Fradkin
Joey Frank
Scott Fulmer
Daniel G Hill
John Ganz
Zack Garlitos
Rico Gatson
Gandalf Gavan
Clara Genard-Claus
Jackie Gendel
Alicia Gibson
Allison Ginsberg

Marilyn Gold
Anders Goldfarb
Nancy Goldring
Juan Gomez
Dana Gordon
John Gordon Gauld
Nora Griffin
Jeremy Haik
Everest Hall
Josephine Halvorson
Sanford Hirsch
Kristie Hirten
David Hixon
Faith Holland
Brandon Holmes
Jayne Holsinger
William Holton
Kevin Horton
Heidi Howard
Gilbert Hsiao
Paul Hunter
Baptiste Ibar
Bill Jensen
Katarina Jerinic
Jody Joyner
Joanna Karatzas
Nils Karsten
Jordan Kasey
Owen Keogh
Wilmot Kidd
Peter Kloehn
Linnea Kniaz
Osamu Kobayashi
Stephanie Kosinski
Kathleen Kucka
Benjamin La Rocco
Justen Ladda
Noah Landfield
Corina Larkin
Fabienne Lasserre
Abby Leigh
Don Leistman
Nathaniel Lieb
Greg Lindquist
Rick Liss
Megan Liu Kincheloe
Nicola López
Sangram Majumdar
Gabriella Mangano
Michael Marfione
Kevin Marin
Joshua Marsh
Mary Mattingly
Zony Maya
Keith Mayerson
Sam Messer
Amelia Midori Miller
Daniel Milewski
Laura Miller
Nicholas Moenich
Andrea Monti
Jaye Moon
Nyeema Morgan
N. Dash
Augustus Nazzaro
Itty Neuhaus
Tammy Nguyen
Casimir Nozkowski
Thomas Nozkowski
Patrick O'Hare
Craig Olson
Paul Pagk
Rory Parks
Matt Phillips
Eli Ping
Julie Pochron
Nickola Pottinger
James Prosek
Nathlie Provosty

Yadir Quintana
Geoff Rawling
Leon Reid IV
Carlos Reyes
Samantha Rissmeyer
Christopher Rivera
Gabriel Rizzotti
Evan Robarts
Kara Rooney
Lisa Ross
Adrianne Rubenstein
John Ryan
Michael Ryan
Cordy Ryman
Gabriela Salazar
Cecilia Salinas-Rios
George Sanders
Bill Santen
Johnson Sarkissian
Christopher Saucedo
Christopher Schade
Clayton Schiff
Mary Schiliro
Linda Serrone Rolon
Veronika Sheer
Barbara Siegel
Lauren Silva
Kyle Simon
Matt Smilardi
Sterrett Smith
Elisa Soliven
Ursula Sommer
Steel Stillman
Jason Stopa
Robert Storr
Maya Strauss
Phoebe Streblow
Caroline M. Sun
Molly Surno
Brett Swenson
Hideki Takahashi
Alina Tenser
Charlie Traub
Levent Tuncer
Shawn Upton
Ryan Vahey
Aldrin Valdez
Jessica Vaughn
Jens Veneman
Louisa Waber
Joan Waltemath
Nat Ward
Aaron Wax
Benjamin Weber
Arnold Wechsler
Ishmael Randall Weeks
Randy West
Christopher White
Coke Wisdom O'Neal
Alan Thomas Wood
Michael Wrobel
Bao Yang Chen
Rachel Youens
Robert Younger
Holly Zausner

Works

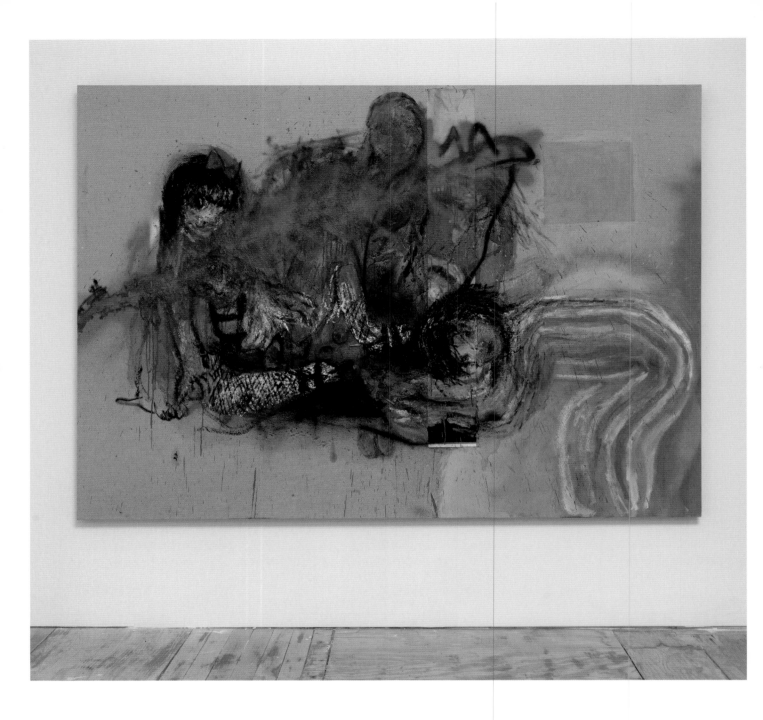

Rita Ackermann
Picnic, 2010
Acrylic, sand, spray paint, latex, oil,
tempera, printed vinyl, modeling
paste, glass on linen, 72 x 101"
Courtesy of the artist and Hauser
and Wirth, New York. Photo by
Brian Buckley

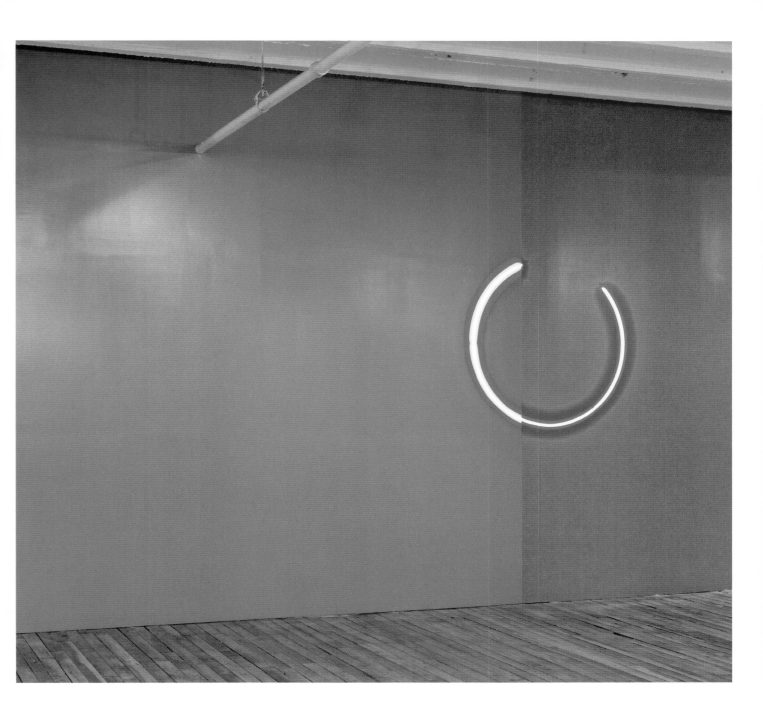

Stephen Antonakos
*Blue Incomplete Circle on Blue
and Red Wall*, 1978
Blue and red paint, blue neon tube,
12 x 18'
Courtesy of Stephen Antonakos
Studio. Photo by Brian Buckley

Shoja Azari
The Mourners (still from *The King of Black*), 2013
HD color video with sound,
TRT 24 minutes
Courtesy of the artist and
Leila Heller Gallery, New York

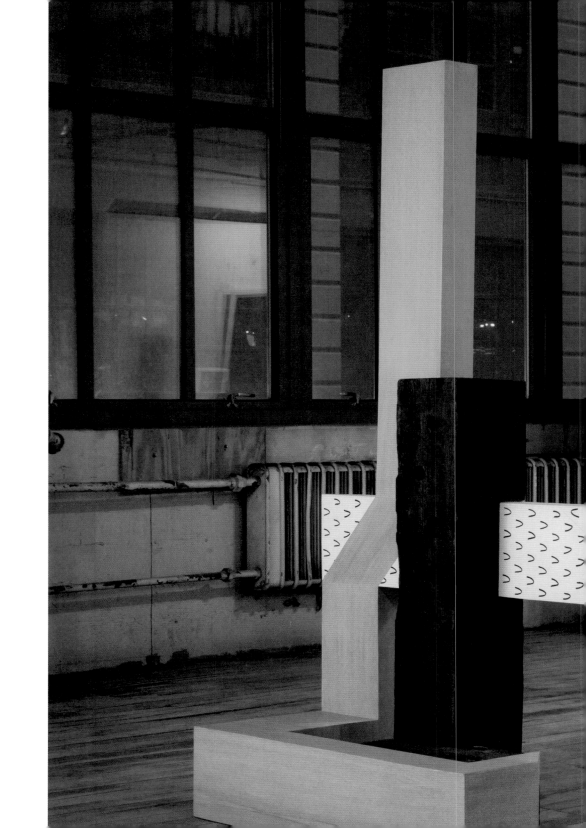

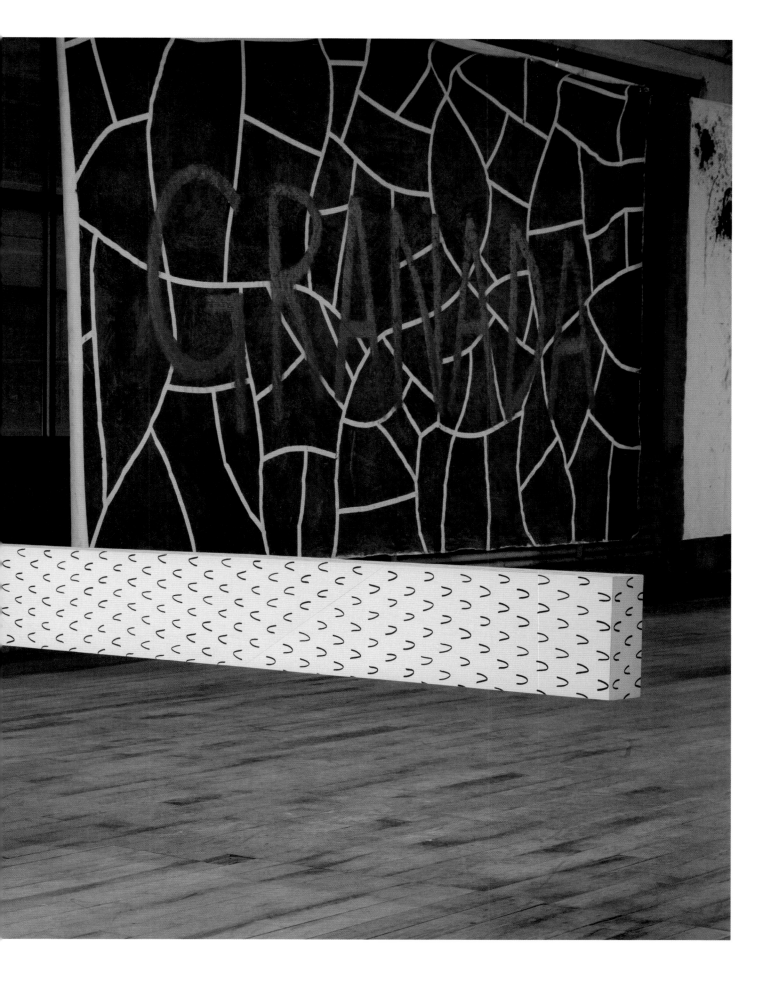

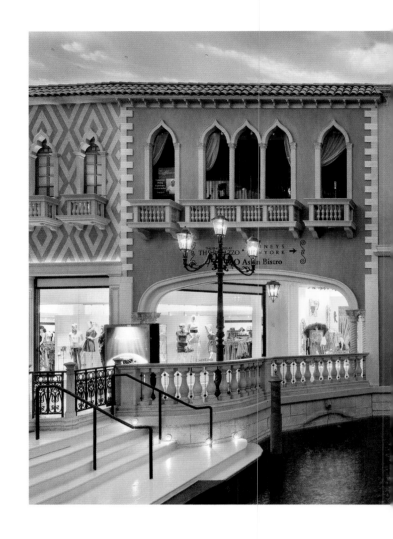

Max Becher and Andrea Robbins
Venice, Las Vegas #3, 2011
Archival digital print, 54 x 30"
Courtesy of the artist and
Sonnabend Gallery, New York

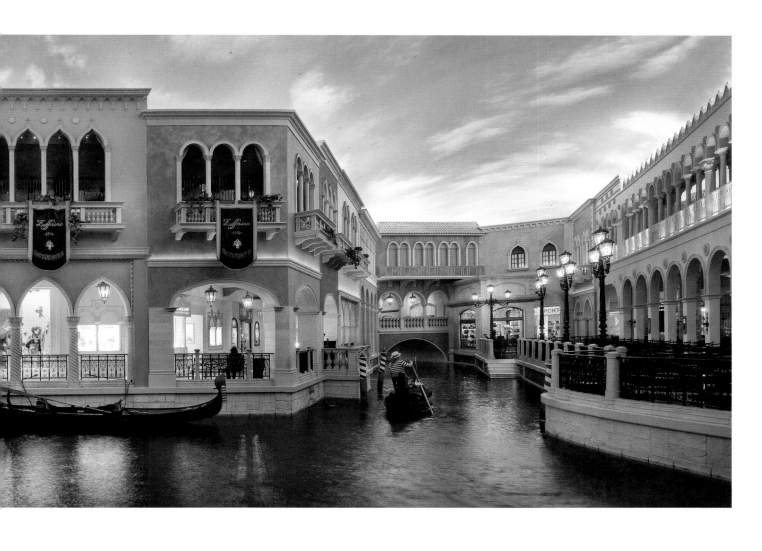

Lynda Benglis
(clockwise)
Figure 5, 2009
Aluminum, 89 x 61 x 27";
Jacks #3, 1998–1999
Cast aluminum, 39 x 34 x 37";
D'Arrest, 2009
Tinted polyurethane,
47 1/4 x 45 3/4 x 22 3/4"
Courtesy of the artist and Cheim
& Read. Photo by Brian Buckley

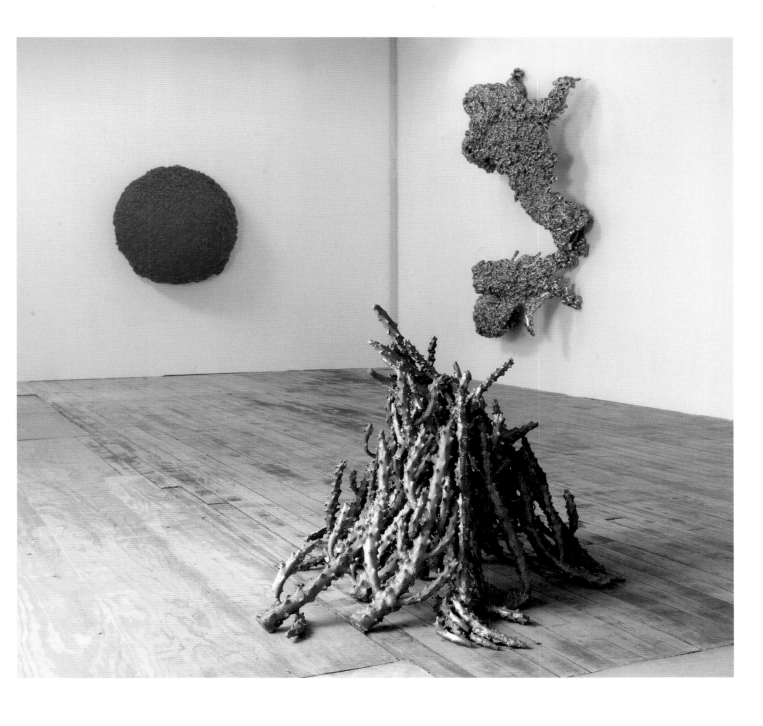

Emma Bee Bernstein
Untitled (Unique Color Polaroids),
2003–2007
Color Polaroids, 4 x 3 1/2" each
Courtesy Susan Bee and Charles
Bernstein

Vivien Bittencourt
Winter (Doria Pamphili series),
2001–2002
Fujicolor crystal archive print,
26 1/2 x 36 1/2", edition 1/9
Courtesy of the artist

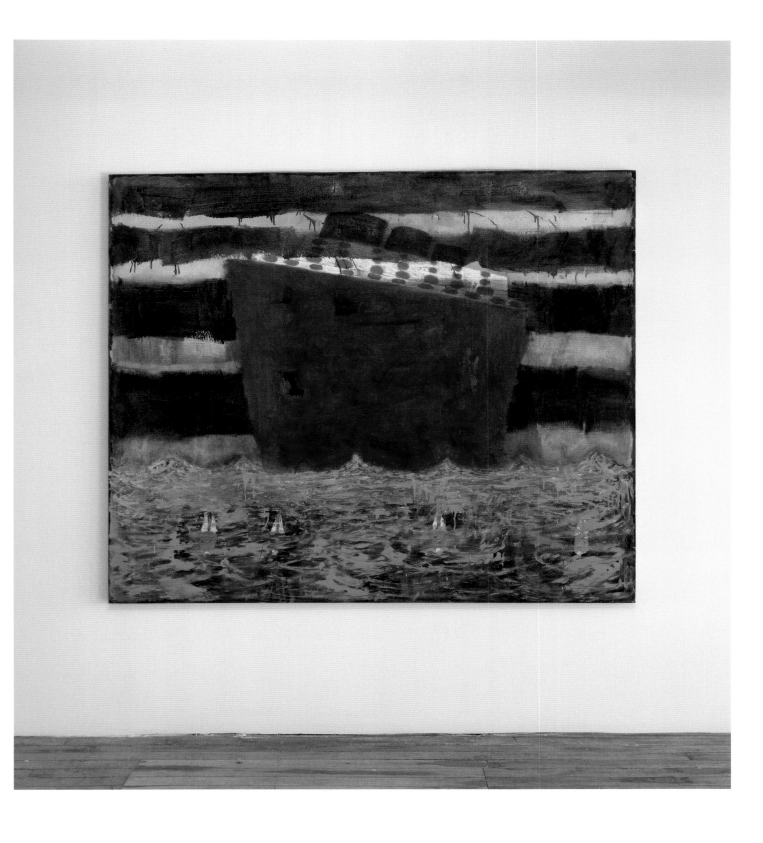

Katherine Bradford
Deep Sea Divers, 2013
Oil on canvas, 68 x 80"
Courtesy of the artist. Photo by
Brian Buckley

Bruce High Quality Foundation
Pizzatopia, 2011
Oil, flex foam, wood, plexiglass,
36 x 96";
Stay with Me, Baby, 2011
Two inflatable scab rats with
Lorraine Ellison's *Stay with Me*,
120 x 60 x 60"
Courtesy of the artist. Photo by
Brian Buckley

Beth Campbell
Crashing tables (moments
crashing...I underestimated
the consequences), 2005
Balsa, pina, china, glue, silverware,
napkin, 33 x 48 x 144"
Courtesy of the artist. Photo by
Rachel Styer

Francis Cape
Waterline (detail), 2006
Wood, paint, framed C-prints,
dimensions variable
Courtesy of the artist

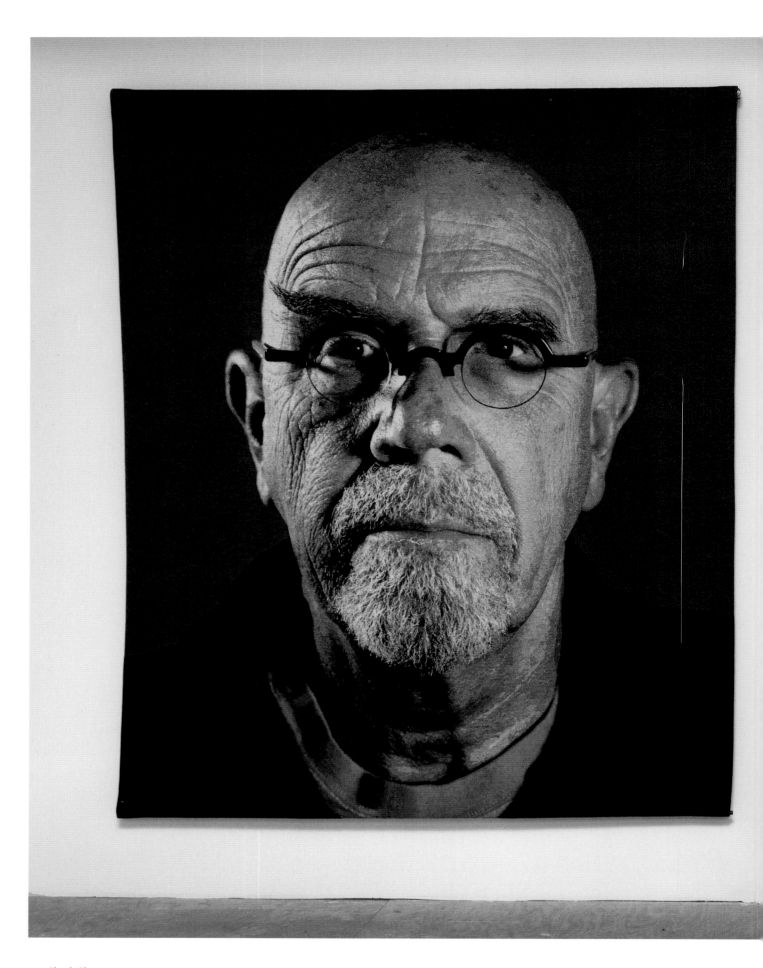

Chuck Close
(left to right)
Self Portrait (Pink T-shirt), 2013
Jacquard tapestry, 93 x 76";
Roy, 2011
Jacquard tapestry, 87 x 74"
Courtesy of the artist and Pace
Gallery. Photo by Brian Buckley

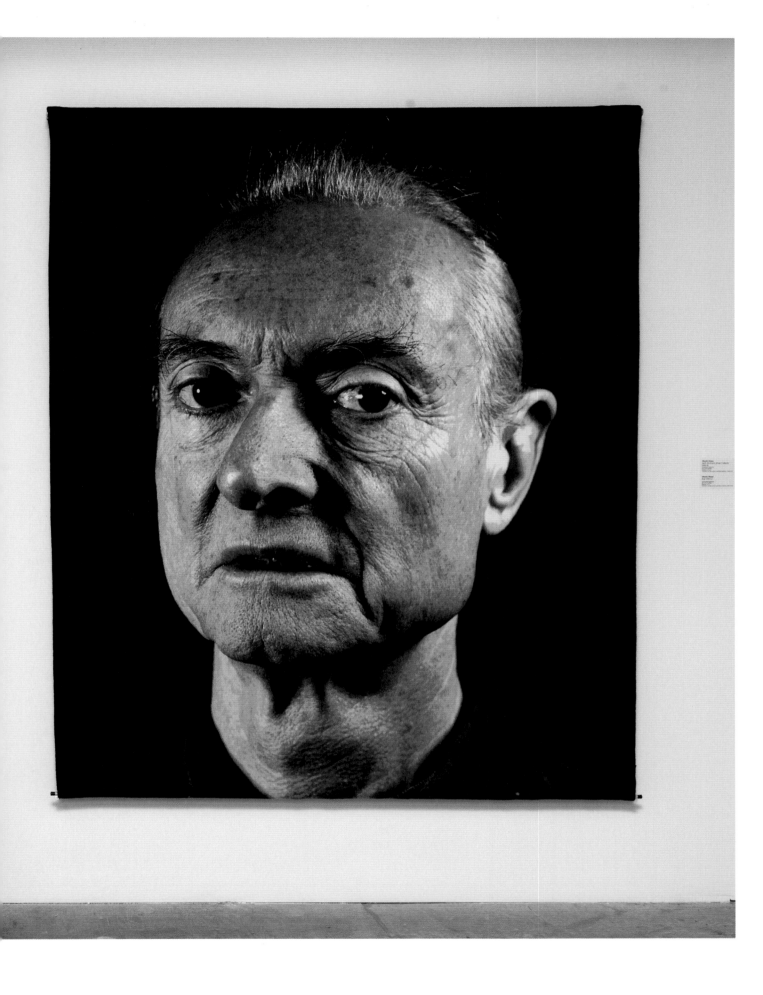

143

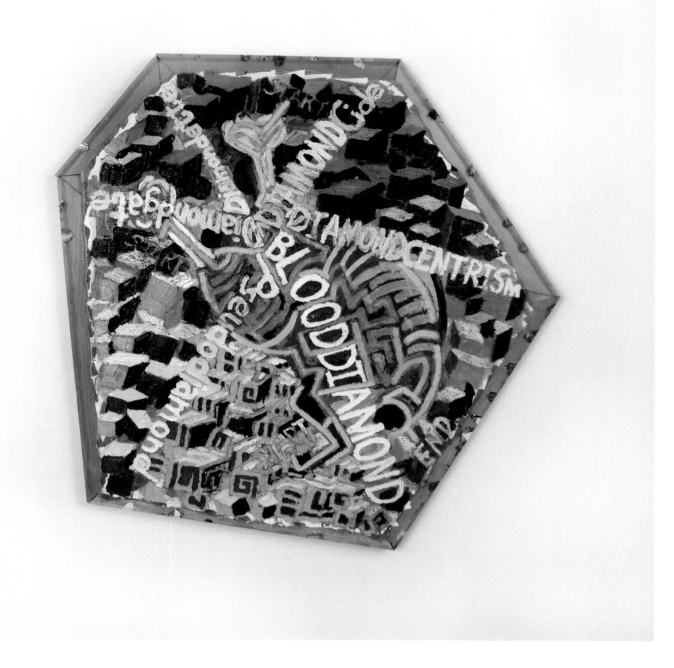

Mike Cloud
Blood Diamond, 2013
Oil on canvas, 37 x 41 1/2"
Courtesy of the artist

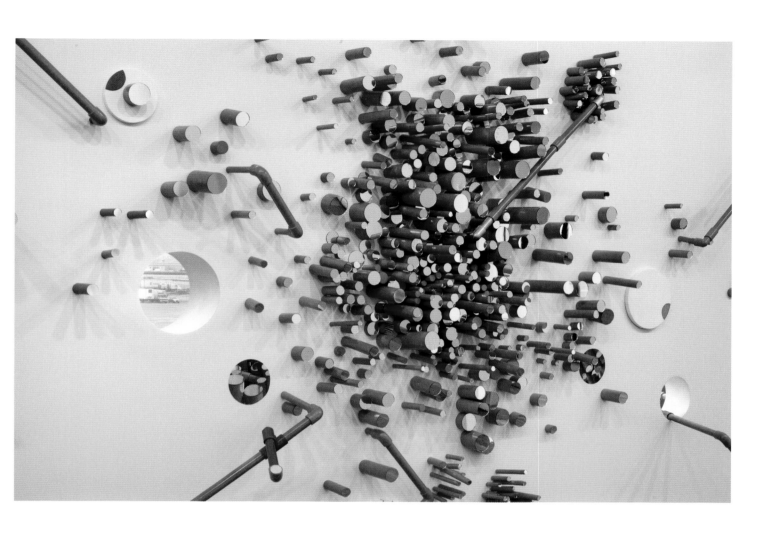

Diana Cooper
Constellation Vanity (2), 2013
Wood, mirrors, digital prints, PVC,
plexiglass, gels, sono tubes, canvas,
felt tip marker, velcro, acrylic on
walls, 9' 4 1/2" x 26' x 6' 9"
Courtesy of the artist. Photo by
Cathy Carver

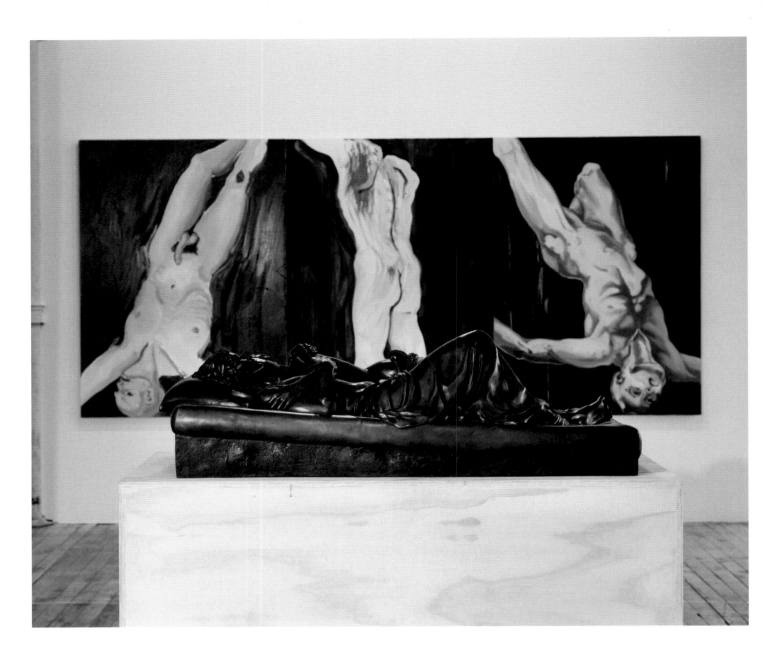

Patricia Cronin
*Canto XXXIV: Circle Nine, Complex
Fraud and Treachery, 2011–2012*
Oil on linen, 64 x 138";
Memorial to a Marriage, 2002–2012
Bronze, 17 x 26 1/2 x 52"
Courtesy of the artist. Photo by
Brian Buckley

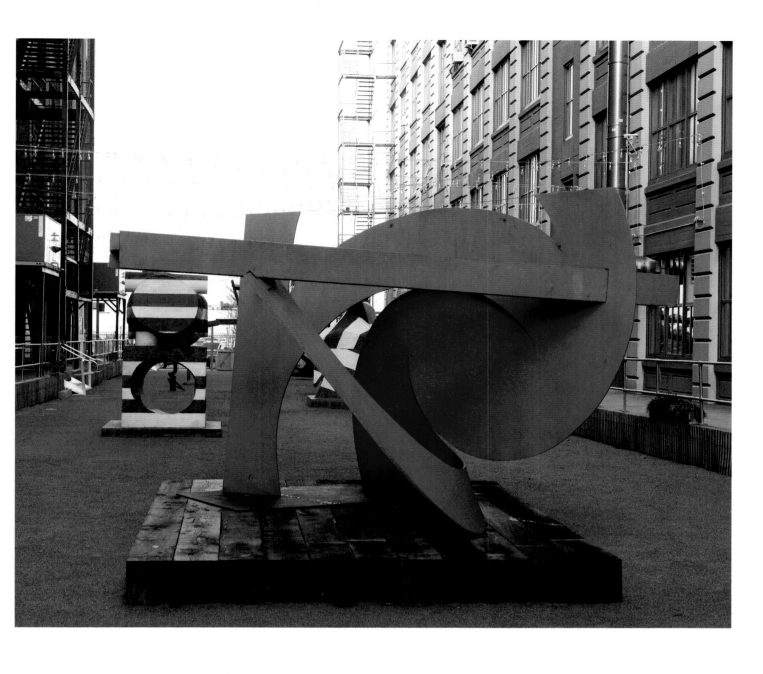

Mark di Suvero
Rust Angel, 1995
Painted steel, 8' 11" x 14' x 7' 8"
Courtesy of the artist and Paula
Cooper Gallery, New York.
Photo by Brian Buckley

Martha Diamond
Cityscape with Indian Yellow,
2001–2005
Oil on linen, 96 x 48"
Courtesy of the artist. Photo by
Brian Buckley

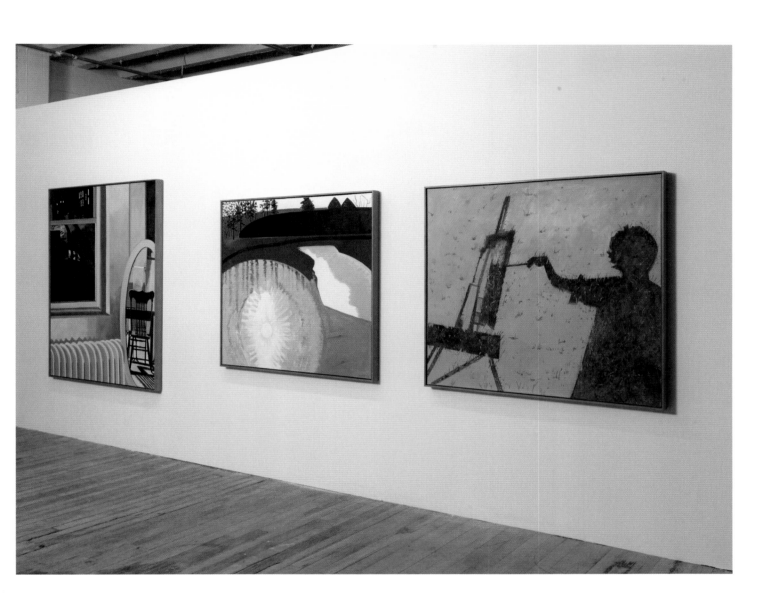

Lois Dodd
(left to right)
Night Sky Loft, 1972
Oil on linen, 66 x 54";
Winter Sunset, Blair Pond, 2008
Oil on linen, 48 x 52";
Shadow Easel, 2010
Oil on linen, 48 x 54"
Courtesy of the artist. Photo by
Brian Buckley

Rackstraw Downes
Under the J Line at Alabama
Avenue, 2007
Oil on canvas, 20 x 32"
Courtesy of the artist and Betty
Cuningham Gallery

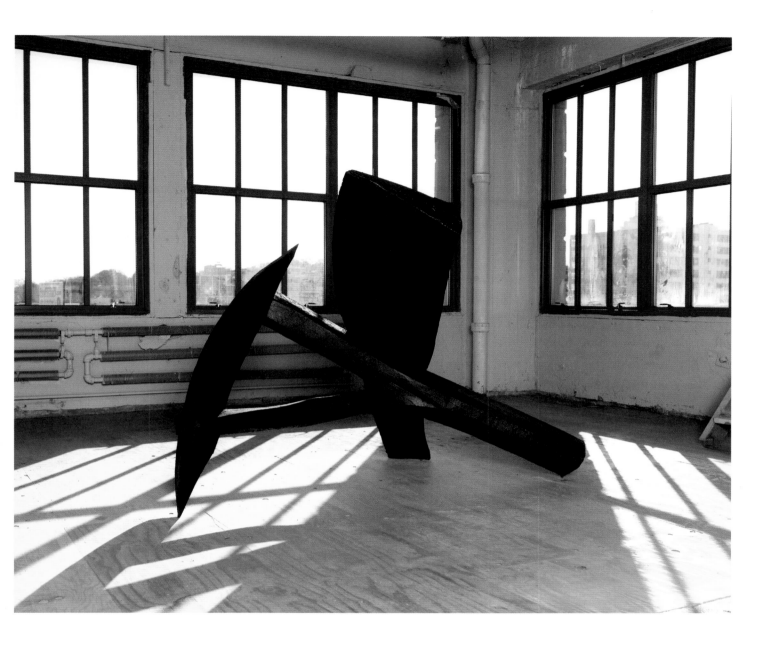

Tom Doyle
Togher, 1991
Oak, 62 x 74 x 86"
Courtesy of the artist. Photo by
Brian Buckley

Robert Feintuch
Rabble II, 2010
Polymer emulsion and oil on panel,
16 x 12"
Courtesy of the artist and
Sonnabend Gallery, New York

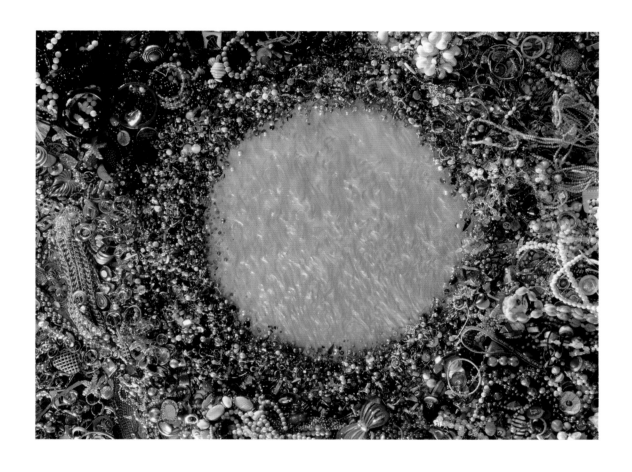

C. Finley
Mandala, 2017 (always 4 years into
the future)
Junk jewelry, wood, resin, mother
of pearl, plexiglass, 6' diameter
Courtesy of the artist

Cameron Gainer
Luna del Mar, 2012
Video with surround sound,
TRT 18:52 minutes
Courtesy of the artist

Juan Gomez
Mawinzhe, 2013
Oil on canvas, 7 x 11'
Courtesy of the artist. Photo by
Zack Garlitos

Tamara Gonzales
(left to right)
Spectral Process, 2013
Spray paint on canvas, 66 x 57";
Dawn Bringer, 2013
Spray paint on canvas, 66 x 54";
Magnetic Knight, 2013
Spray paint on canvas, 66 x 54"
Courtesy of the artist. Photo by
Brian Buckley

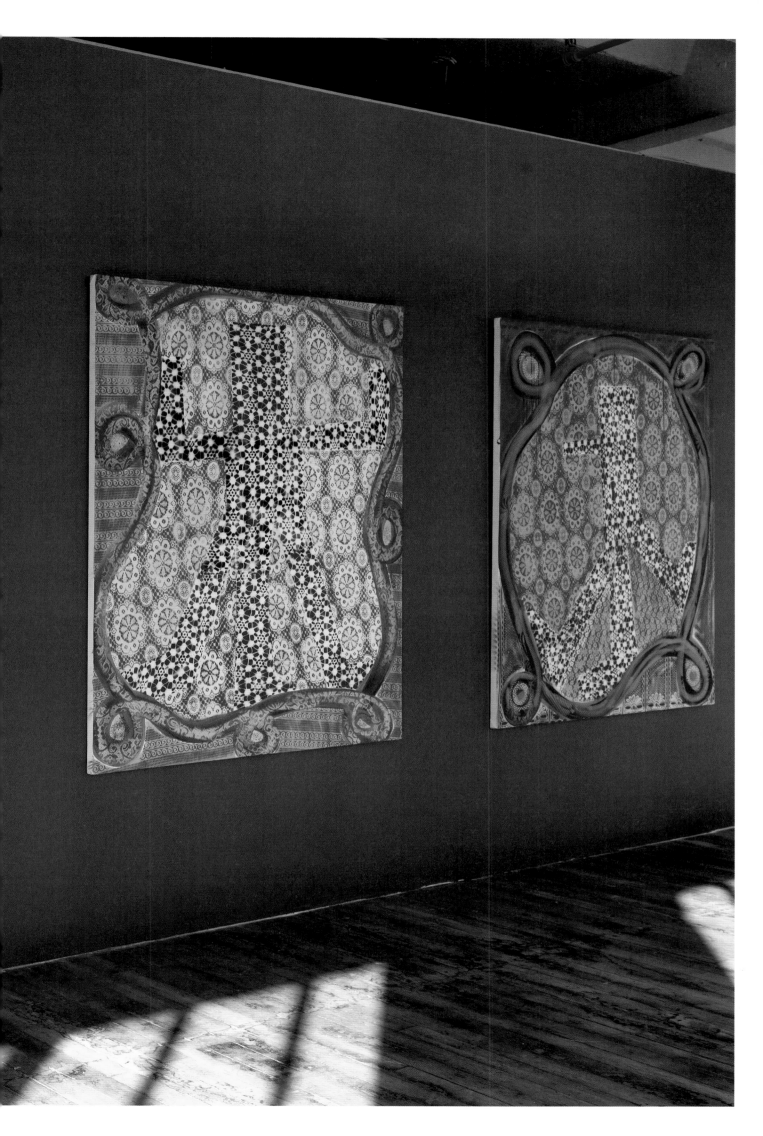

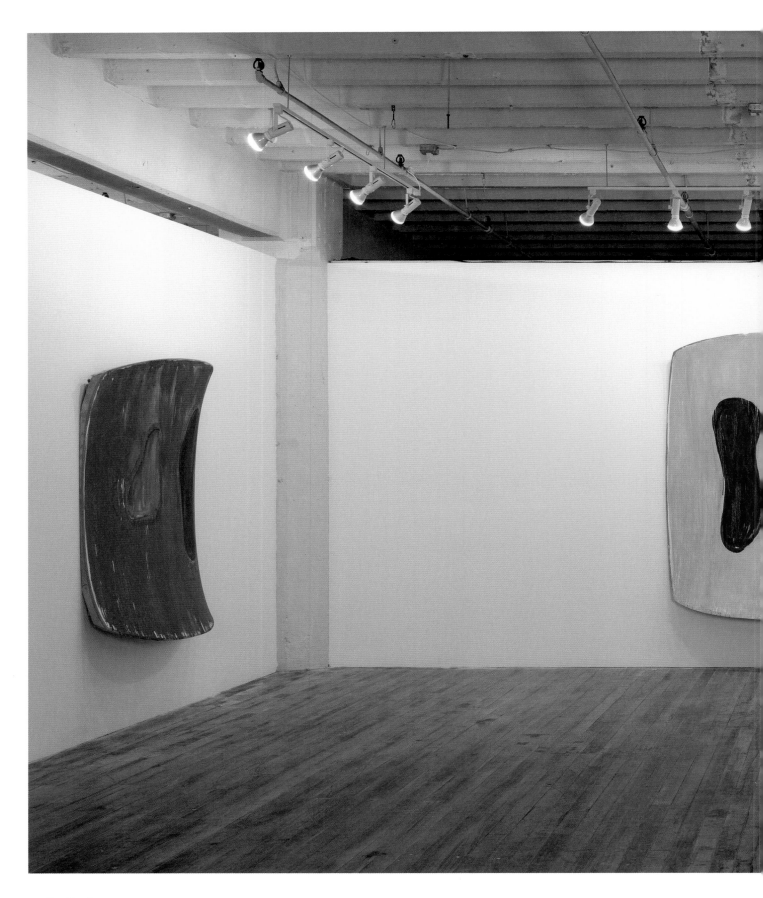

Ron Gorchov
(left to right)
Dinah, 2012
Oil on linen, 65 x 55 x 12";
Penthesilea, 2012
Oil on linen, 83 x 69 x 14";
Arrichion, 2013
Oil on linen, 45 x 39 x 9";
Morrigan, 2012
Oil on linen, 44 x 35 x 8"
Courtesy of the artist and Cheim &
Read, New York. Photo by
Brian Buckley

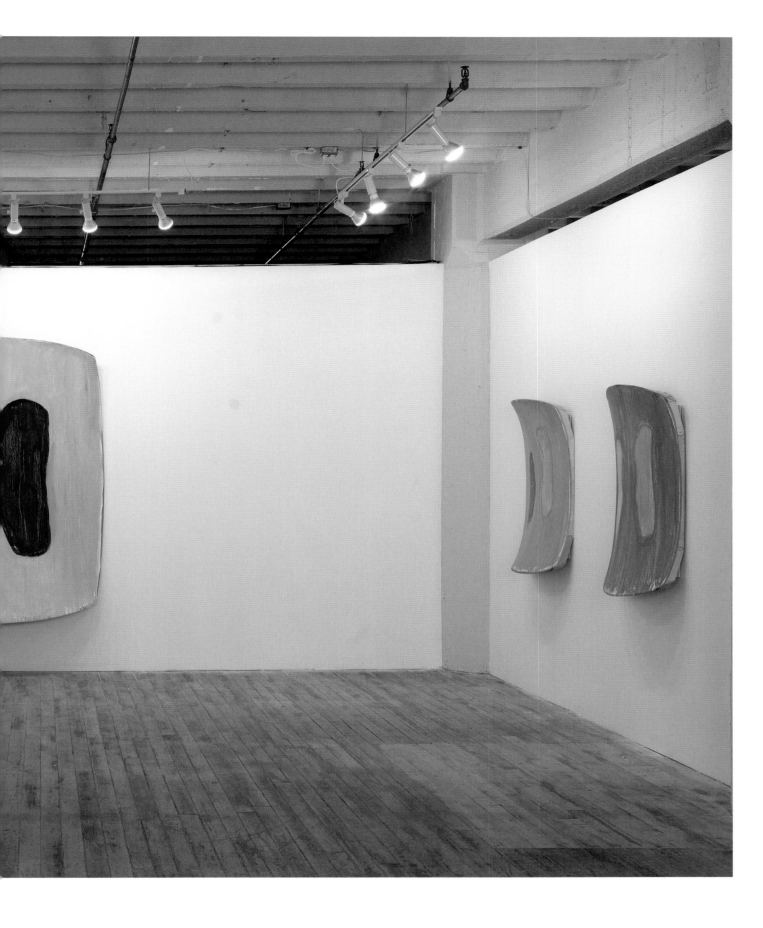

Allan & Gloria Graham
Robert Creeley, from *ADD-VERSE*,
2004
Black and white photograph,
24 x 24"
Courtesy of the artist. Photograph by
Gloria Graham

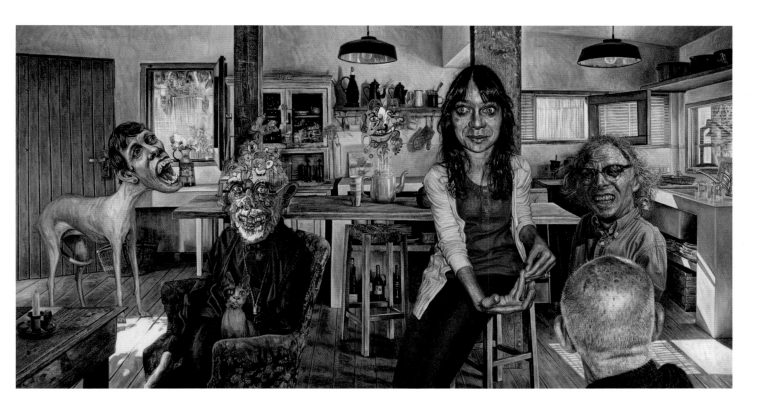

Mark Greenwold
The Banker's Daughter, 2009–2010
Oil on linen, 20 x 38"
Courtesy of the artist and Sperone
Westwater, New York

Nancy Haynes
(left to right)
Retinal Boundary, 2012
Oil on linen, 18 x 21 1/2";
Retreat, 2012–2013
Oil on linen, 18 x 21 1/2";
Rue Jacob, 2011
Oil on linen, 18 x 21 1/2";
Referent for Departure, 2012
Oil on linen, 18 x 21 1/2";
Stopping Place, 2012
Oil on linen, 18 x 21 1/2"
Courtesy of the artist. Photo by
Brian Buckley

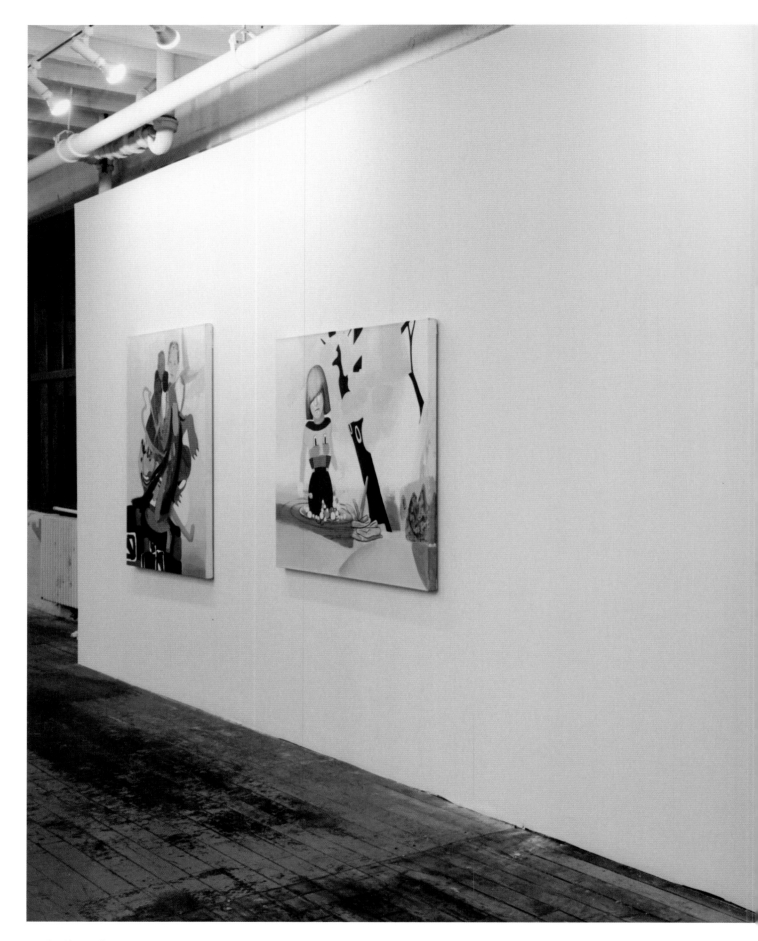

David Humphrey
meeting, 2010
Acrylic on canvas, 54 x 44"
cleaning up, 2009
Acrylic on canvas, 44 x 54"
pounder, 2008
Acrylic on canvas, 60 x 72"
Courtesy of the artist and Fredericks
and Freiser. Photo by Zack Garlitos

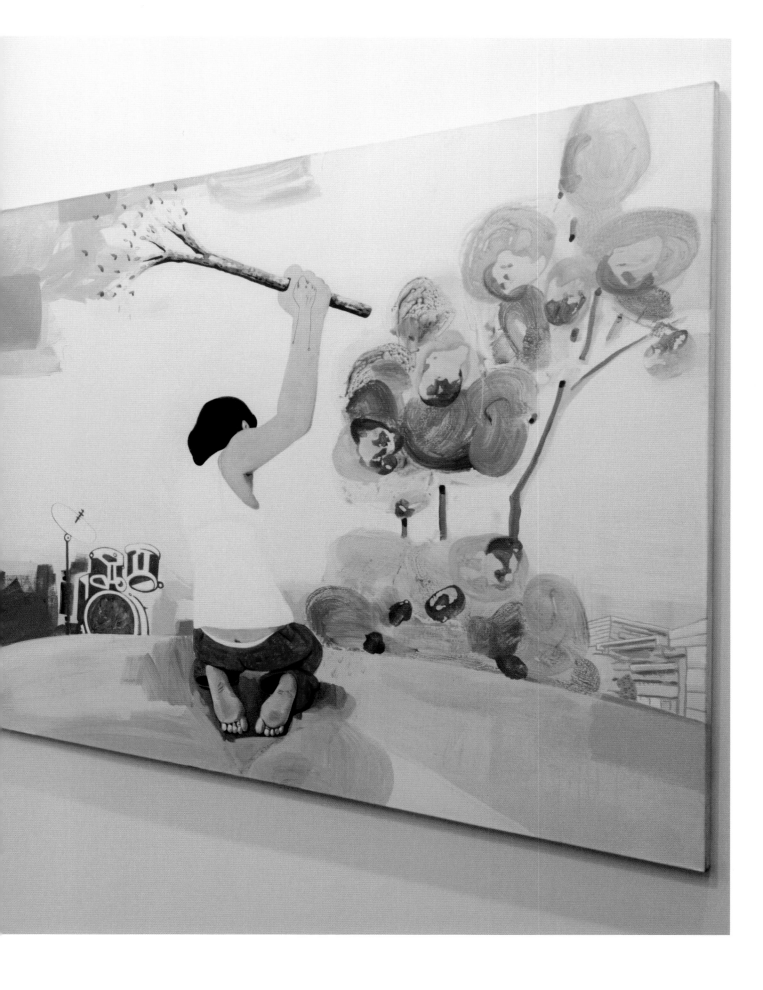

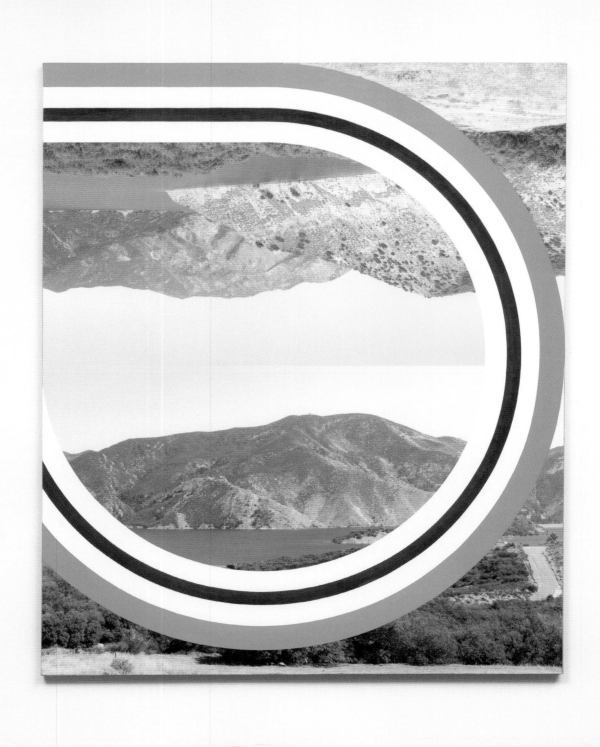

James Hyde
DOWN FOR UP, 2011
Acrylic on archival inkjet print
on stretched linen, 87 x 70"
Courtesy of the artist. Photo by
Brian Buckley

Bill Jensen
*Passions According to Andrei
(Rublev/Tarkovsky)*, 2010–2011
Oil on linen, 53 1/2 x 78 1/2"
Courtesy of the artist. Photo by
Brian Buckley

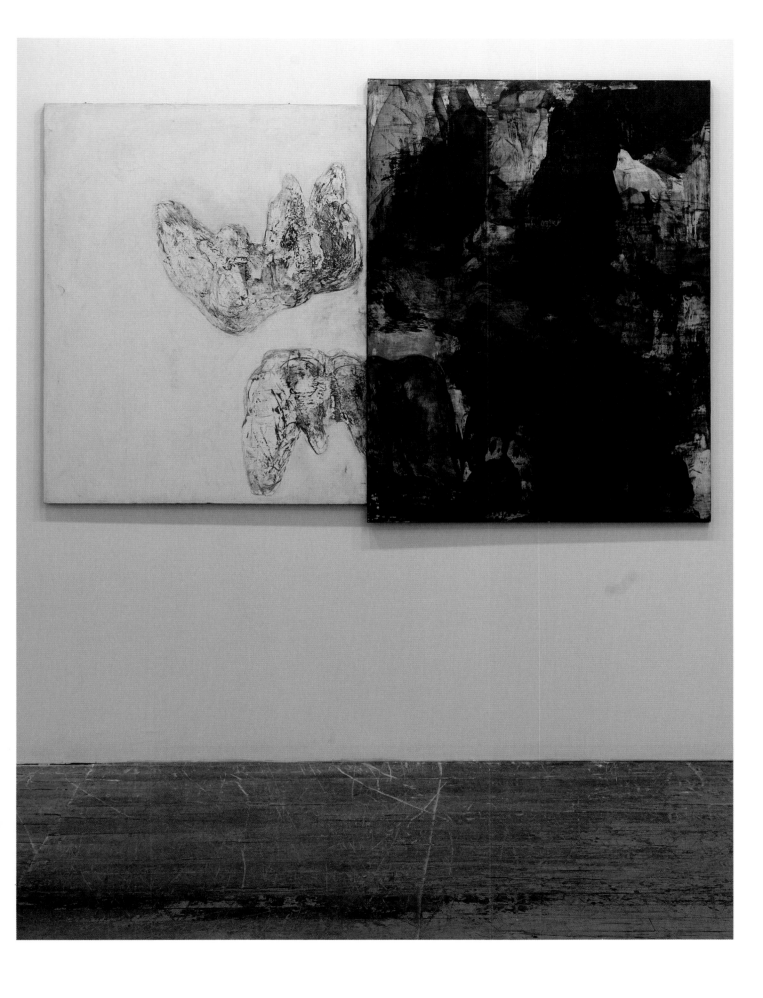

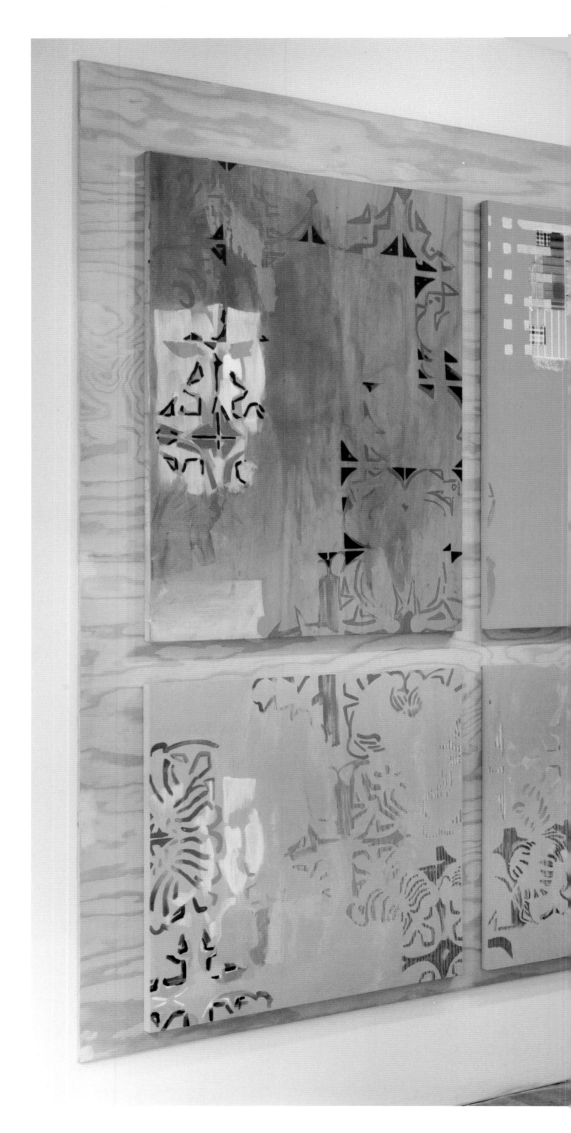

Suzanne Joelson
Rhymes with Orange, 2012
Acrylic paint, tape, wood, staples,
cotton and chiffon fabric, inkjet
photographs, 94 x 156"
Courtesy of the artist. Photo by
Rachel Styer

Darren Jones
(left to right)
Duct, 2012
Frame, paper, ocean water,
prolactin, adrenocorticotropic
hormone, leucine enkephalin,
mucin, lipids, lysozyme, lactoferrin,
lipocalin, lacritin, immunoglobulins,
glucose, urea, sodium, potassium
(tears), 5 1/2 x 3 1/2";
Anagram, 2013
Vinyl, 2 1/2 x 36";
Interregnum (History Repeating),
2013
Photographic vinyl, 120 x 78";
*Wraith: Self Portrait as a Ghost
(Fire Island Pines)*, 2012
Digital C-print, 18 x 24"
Courtesy of the artist. Photo by
Rachel Styer

Michael Joo
Untitled (Herkimer Unfolded), 2009
Silicone rubber, polyurethane,
wood, 47 x 59 x 30"
Courtesy of the artist. Photo by
Zack Garlitos

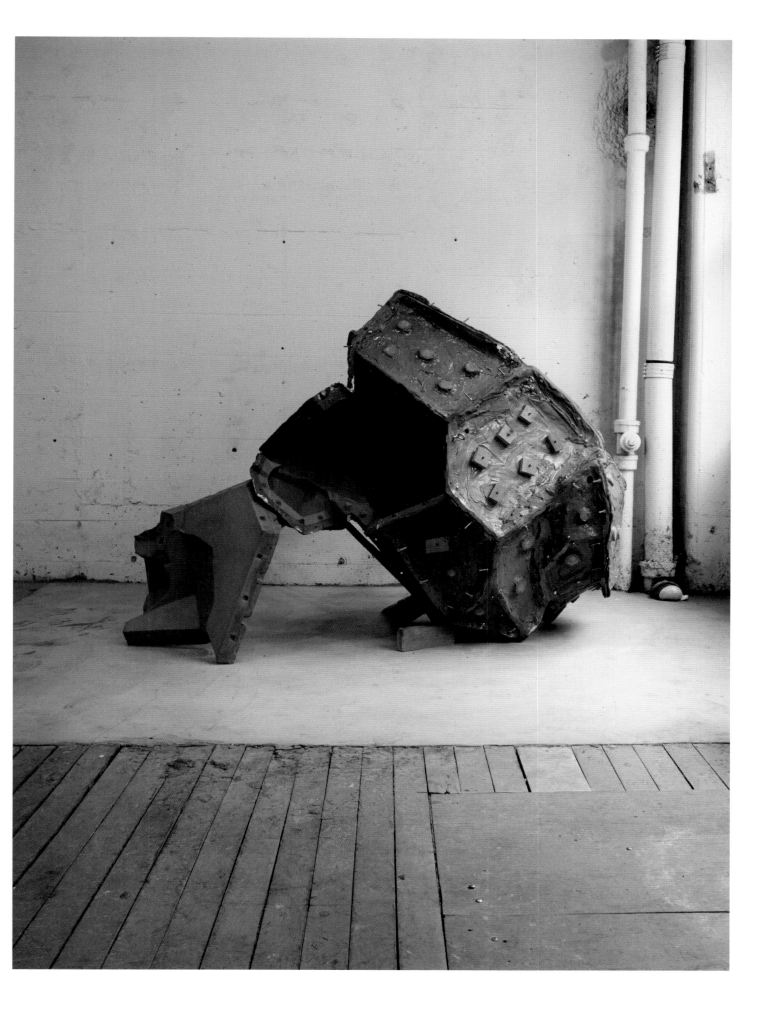

Deborah Kass
Day After Day, 2010
Oil and acrylic on canvas, 6 x 21'
Courtesy of the artist and Paul
Kasmin Gallery, New York. Photo by
Rachel Styer

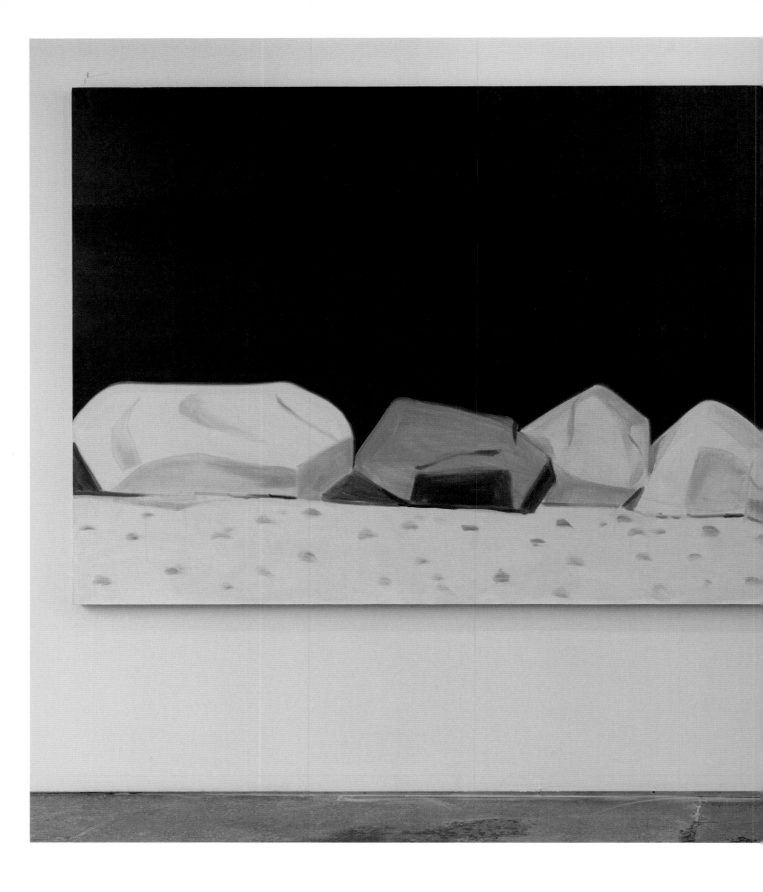

Alex Katz
Rocks, 2011
Oil on linen, 72 x 196"
Courtesy of the artist. Photo by
Brian Buckley

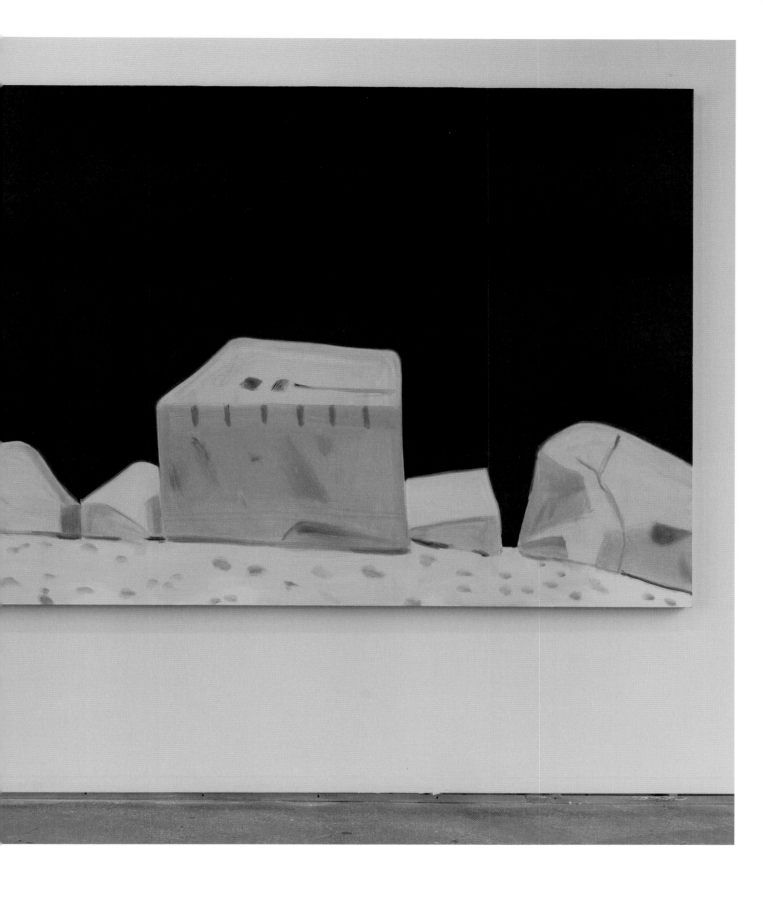

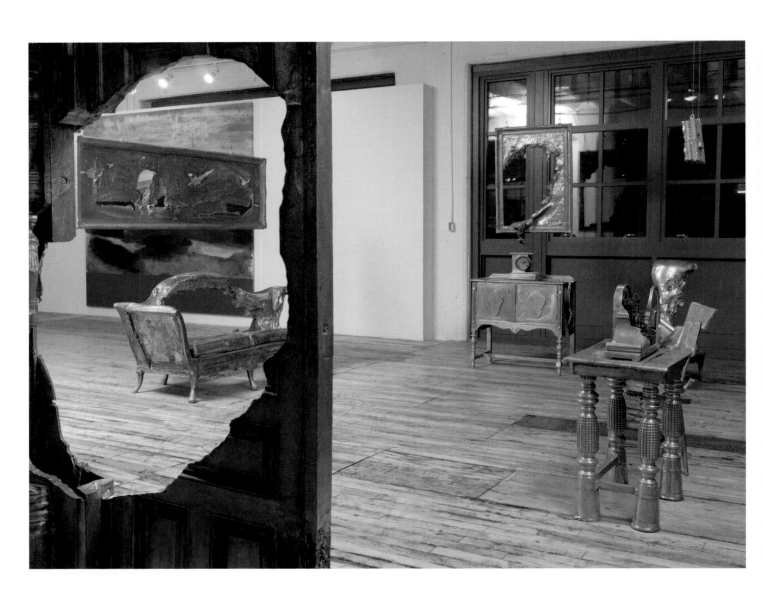

Ben Keating
(left to right)
Portrait of her by a sculptor 7:30pm,
2013
Cast aluminum, 7 x 3 x 4';
Portrait of her by a sculptor 1pm,
2013
Cast aluminum, 8 x 3 x 9';
On her time, 2013
Cast aluminum, 5 x 2 x 7'
Courtesy of the artist. Photo by
Brian Buckley

Mel Kendrick
Marker 4, 2009
Cast concrete, 116 1/2 x 61 x 51"
Courtesy of the artist and David
Nolan Gallery. Photo by Brian
Buckley

182

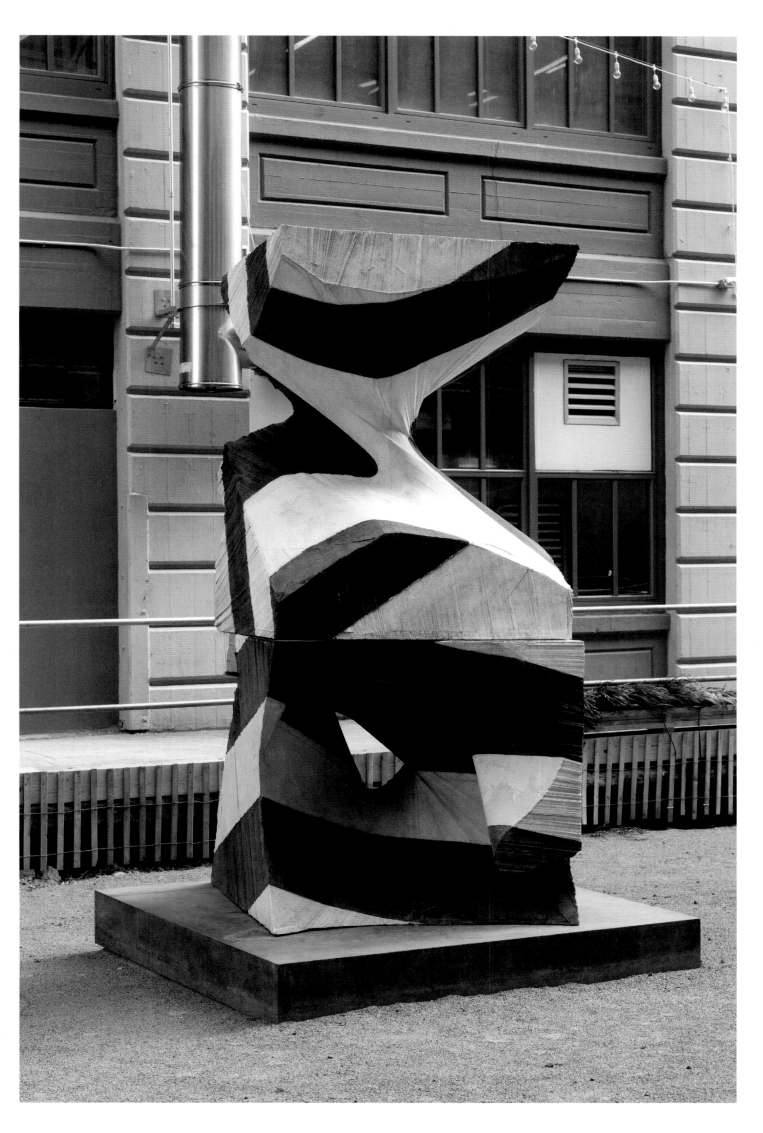

Clay Ketter
Oden Junior, Oden Senior, 2007
Diasec-mounted C-print,
39 1/4 x 47 1/4" each
Courtesy of the artist. Photo by
Zack Garlitos

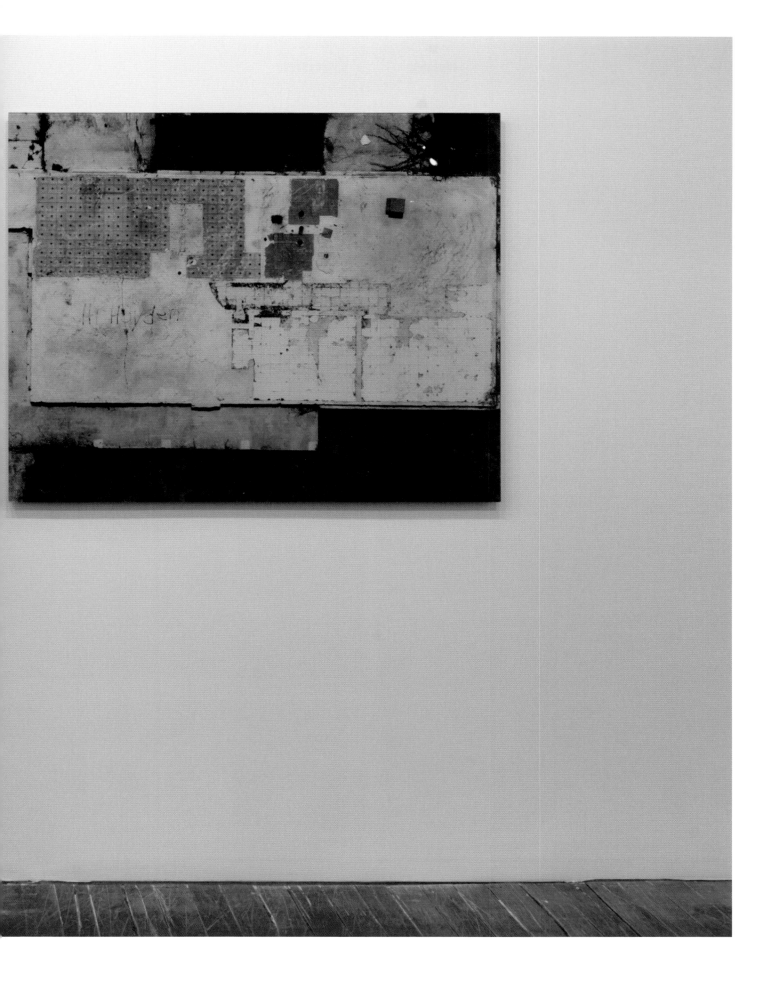

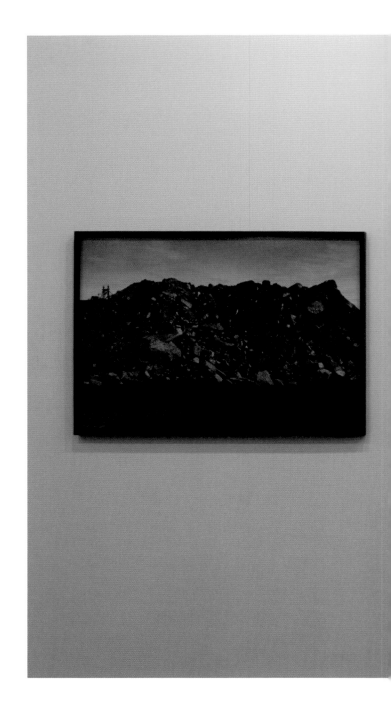

Barney Kulok
(left to right)
Untitled (Cobble Constellation),
2011
Gelatin silver print, 29 x 40";
Council Woman, 2012
Gelatin silver print, 30 x 40";
59th St Bridge, 2012
Gelatin silver print, 30 x 40"
Courtesy of the artist. Photo by
Zack Garlitos

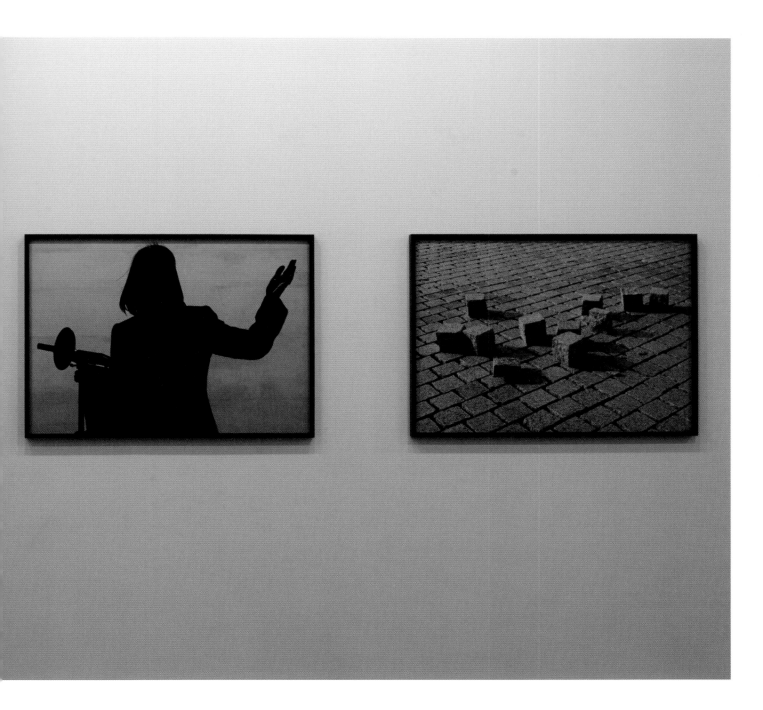

Ronnie Landfield
The Deluge, 1998
Acrylic on canvas, 108 x 120"
Courtesy of the artist. Photo by
Brian Buckley

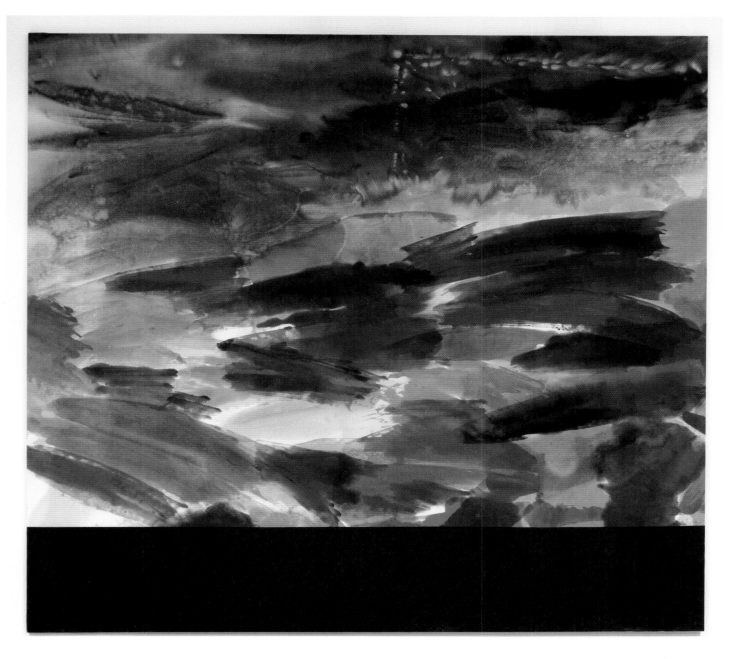

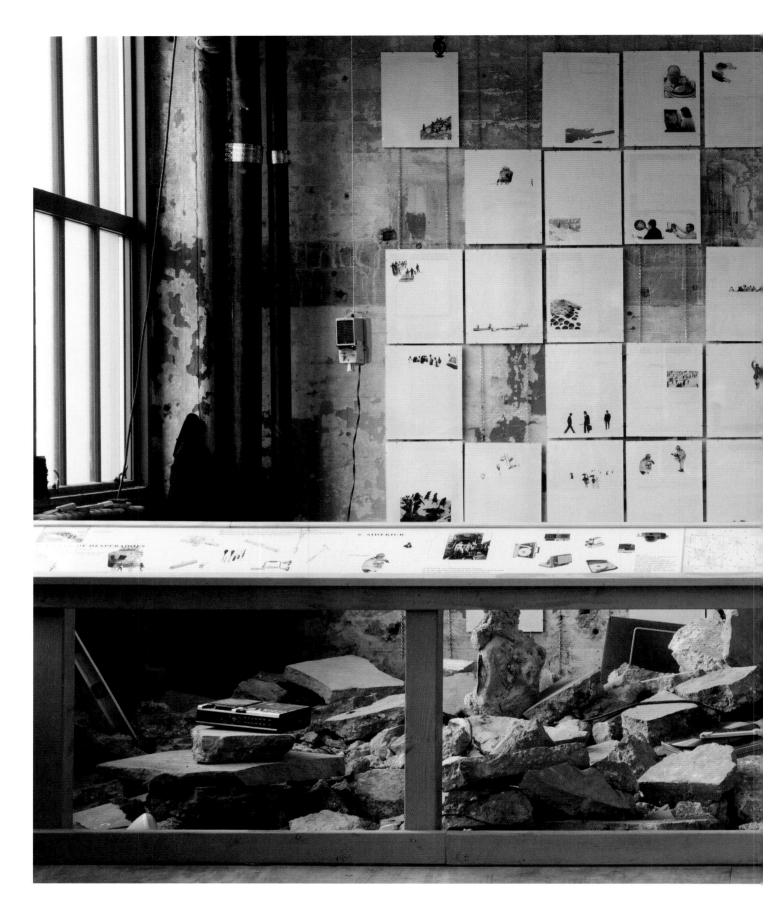

Matthew Lange
*Archeology of the Plummet
Machine Vol. 1*, 2013
Mixed media, performance,
dimensions variable;
Excerpts: Encyclophelia III,
2011–2013
Series of archival inkjet prints,
16 1/2 x 13"
Courtesy of the artist. Photo by
Rachel Styer

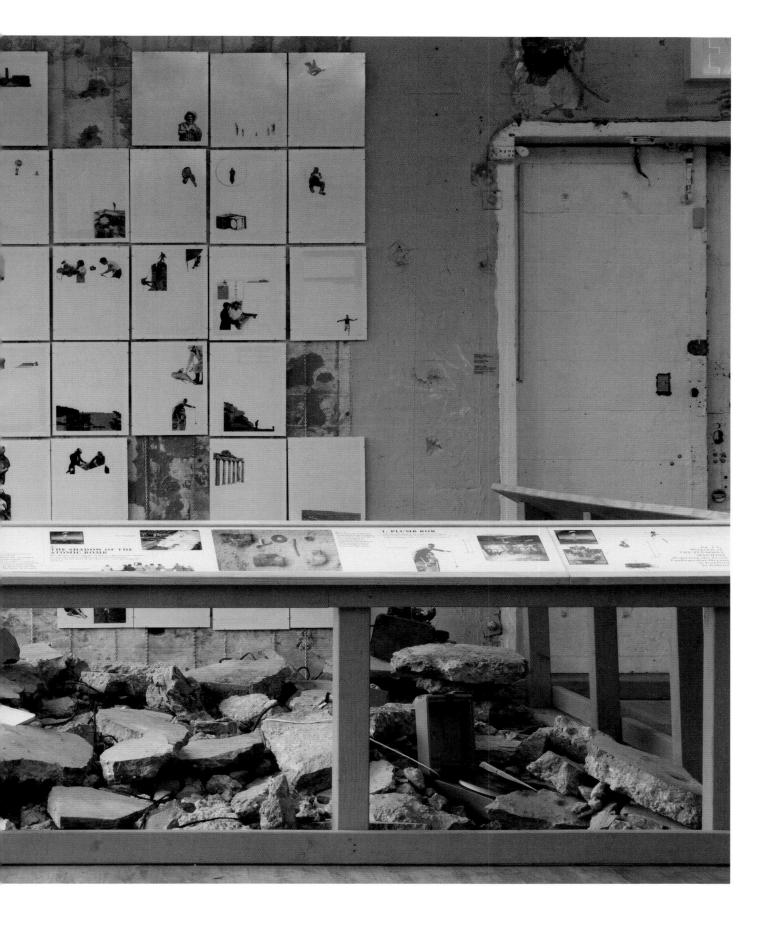

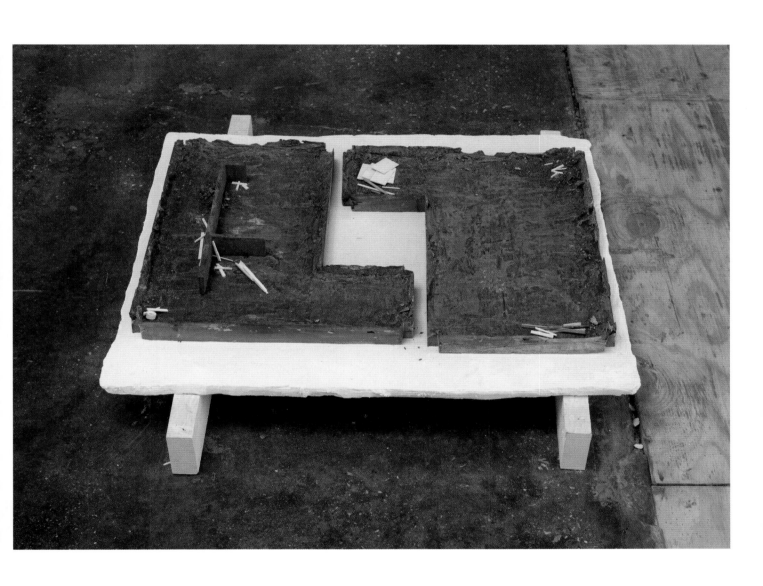

Chris Larson
Untitled (studio floor refigured and resited), 2013
Plaster, 34 x 34 x 9"
Courtesy of the artist. Photo by
Brian Buckley

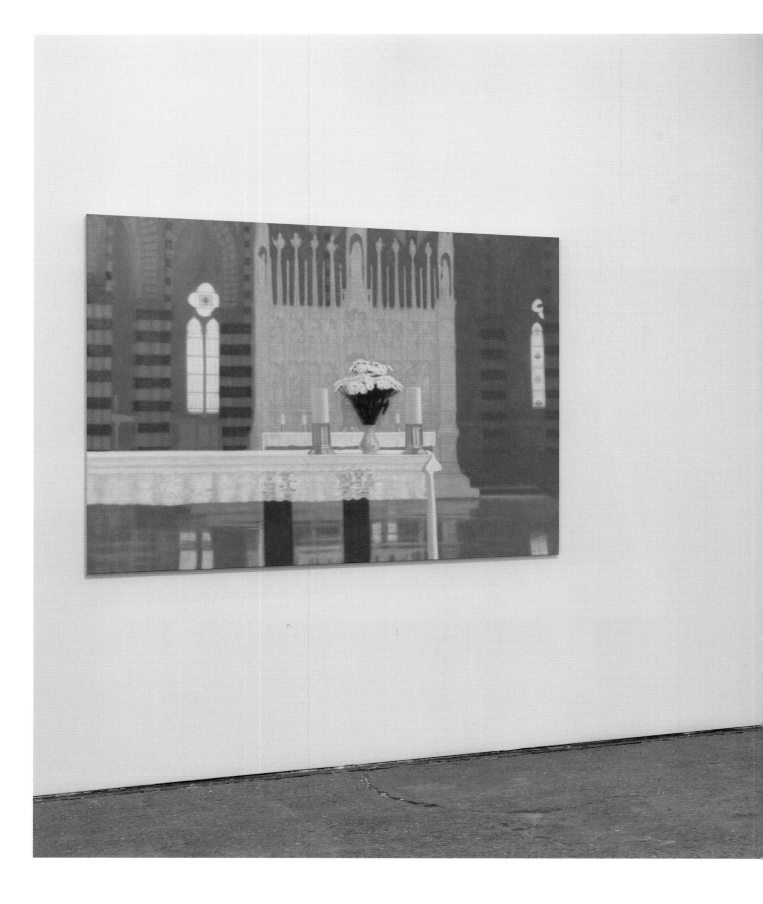

Matvey Levenstein
(left to right)
Cathedral, 2009
Oil on linen, 50 x 67";
Temple, 2010
Oil on linen, 42 x 56"
Courtesy of the artist and Larissa
Goldston Gallery. Photo by
Brian Buckley

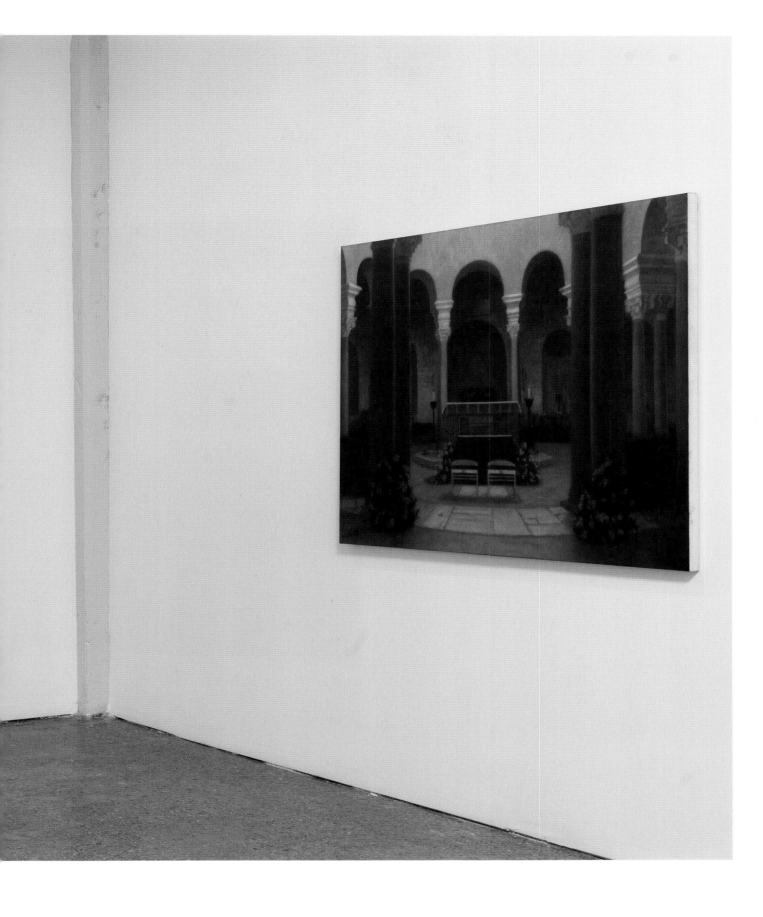

Dean Levin
(left to right)
Common Content, 2013
Rubber latex, acrylic, oil and ink
on canvas, 38 x 51";
Nothing to Hide Nothing to See,
2013
Rubber latex, acrylic, oil and ink
on canvas, 37 x 46";
Harmony and Invention, 2013
Rubber latex, acrylic, oil and ink
on canvas, 39 x 50"

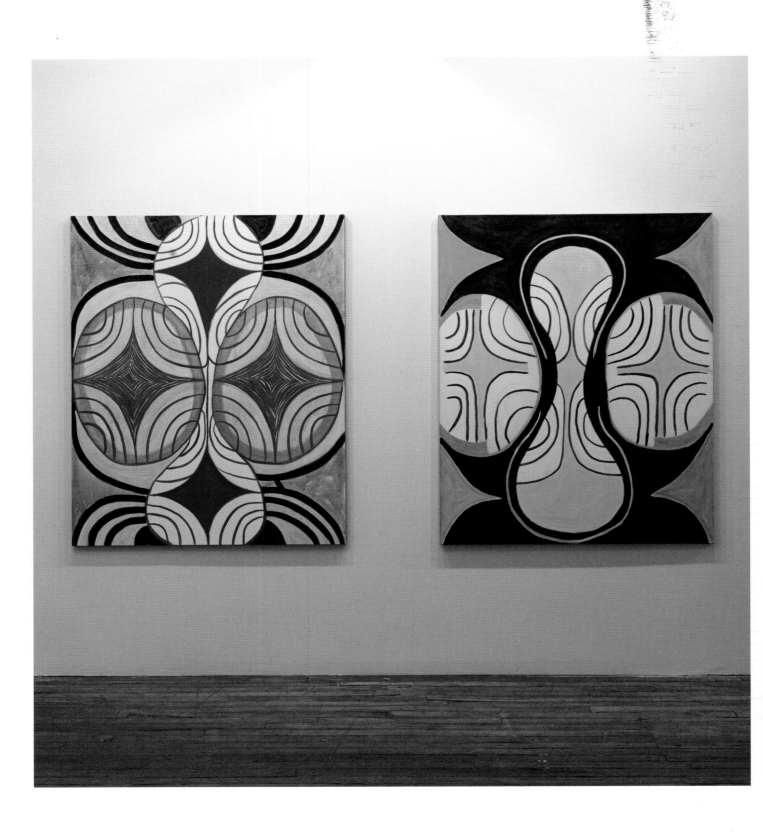

Margrit Lewczuk
Connie's Dream, 2006
Acrylic on linen, 60 x 48";
Green & Purple, 2008
Acrylic on linen, 60 x 48"
Courtesy of the artist. Photo by
Brian Buckley

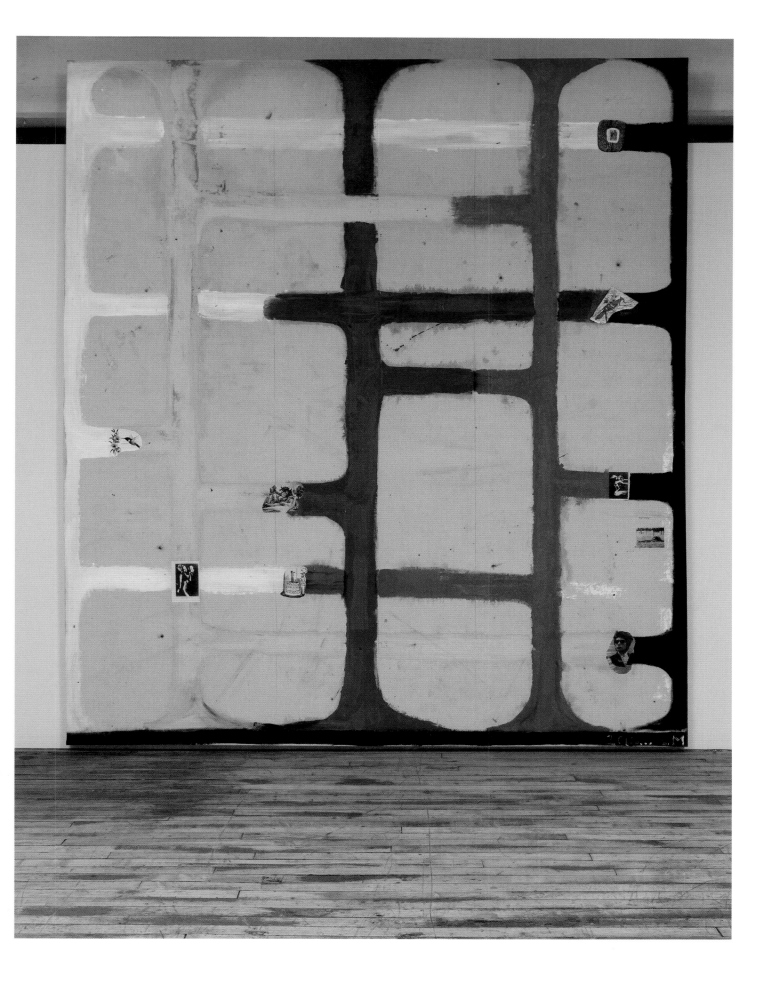

Chris Martin
Red, Yellow, Green #2, 2012
Acrylic, gel medium, and collage
on canvas, 135 x 118"
Courtesy of the artist. Photo by
Zack Garlitos

Marlene McCarty
Hearth 2 (China Camp 2009,
China Camp 1975), 2010
Graphite on paper, 80 x 117"
Courtesy of the artist. Photo by
Zack Garlitos

Josiah McElheny
Walking Mirror 1, 2012
Cedar wood, mirror, cloth straps,
metal hardware, wood pedestal,
china marker drawing, performance
instructions, periodic performance,
61 9/16 x 20 15/16 x 19 9/16"
Courtesy of the artist and Andrea
Rosen Gallery, New York. Photo by
Rachel Styer

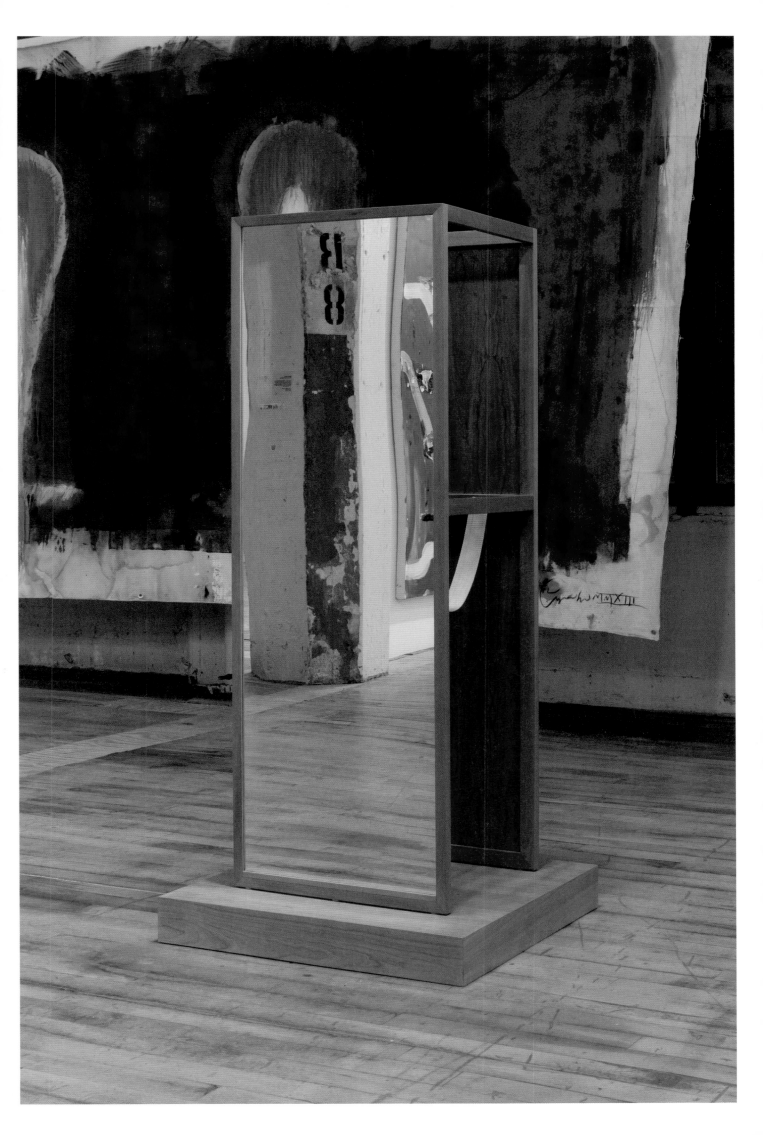

Jonas Mekas
Walden, 1969
Video, TRT 180 minutes
Courtesy of the artist

Mike Metz
(left to right)
snared-trapped elephant-opera glasses, 2011
Steel cable, wooden strut, building foam, 24 x 24 x 24";
snared-trapped pipe-axe, 2011
Steel cable, wooden strut, building foam, 24 x 24 x 24";
snared-trapped binoculars-toothache, 2011
Steel cable, wooden strut, building foam, 24 x 24 x 24";
snared-trapped vest-rabbit, 2011
Steel cable, wooden strut, building foam, 24 x 24 x 24";
snared-trapped high chair-pegasus, 2011
Steel cable, wooden strut, building foam, 24 x 24 x 24"
Courtesy of the artist. Photo by Rachel Styer

Donald Moffett
Lot 080711 (the radiant future), 2011
Oil on linen with wood panel
support, concrete mixer, driftwood,
wire, hardware, 104 x 91 x 45"
Courtesy of the artist and Marianne
Boesky Gallery. © Donald Moffett.
Photo by Rachel Styer

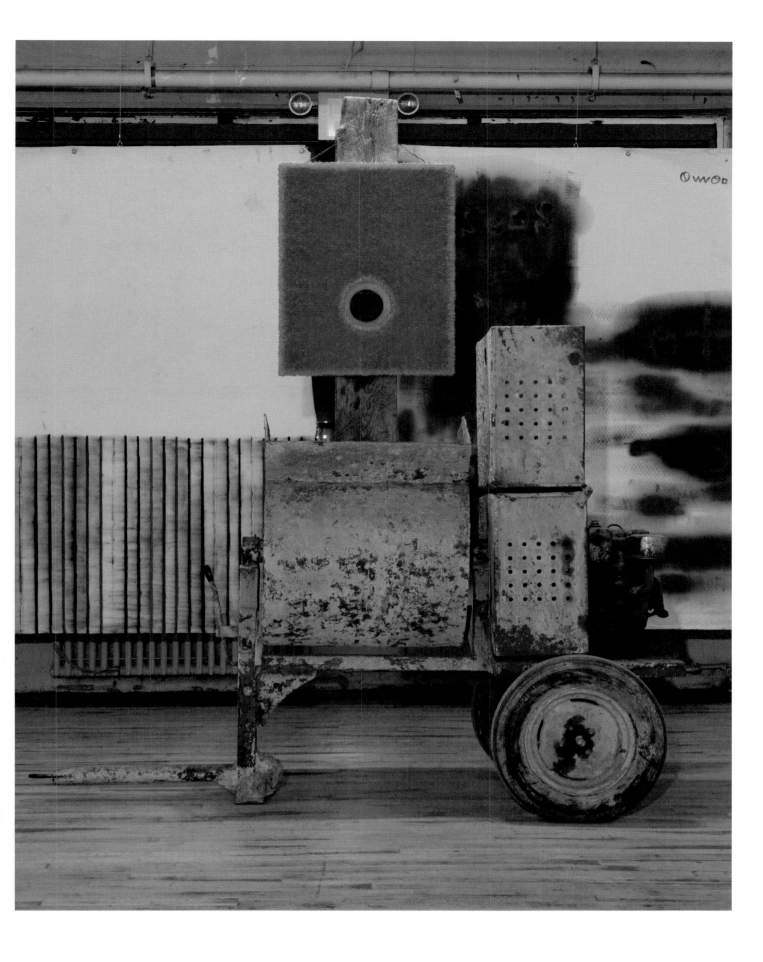

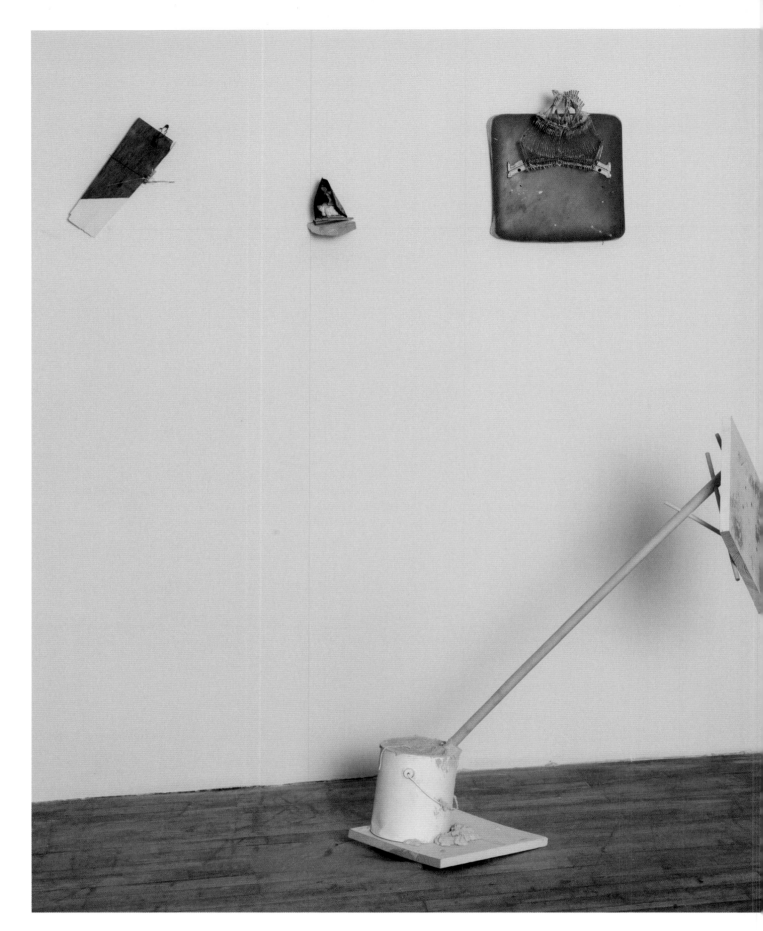

Cy Morgan
Projecting Wall Object A, 2013
Mixed media, dimensions variable;
Projecting Wall Object B, 2013
Mixed media, dimensions variable;
Propping Wall Object A, 2013
Mixed media, dimensions variable;
Propping Wall Object B, 2013
Mixed media, dimensions variable;
Standing Wall Object A, 2013

Mixed media, dimensions variable;
Standing Wall Object B, 2013
Mixed media, dimensions variable;
Projecting Floor Object A, 2013
Mixed media, dimensions variable;
Standing Group on Cart A, 2013
Mixed media, dimensions variable
Courtesy of the artist. Photo by
Rachel Styer

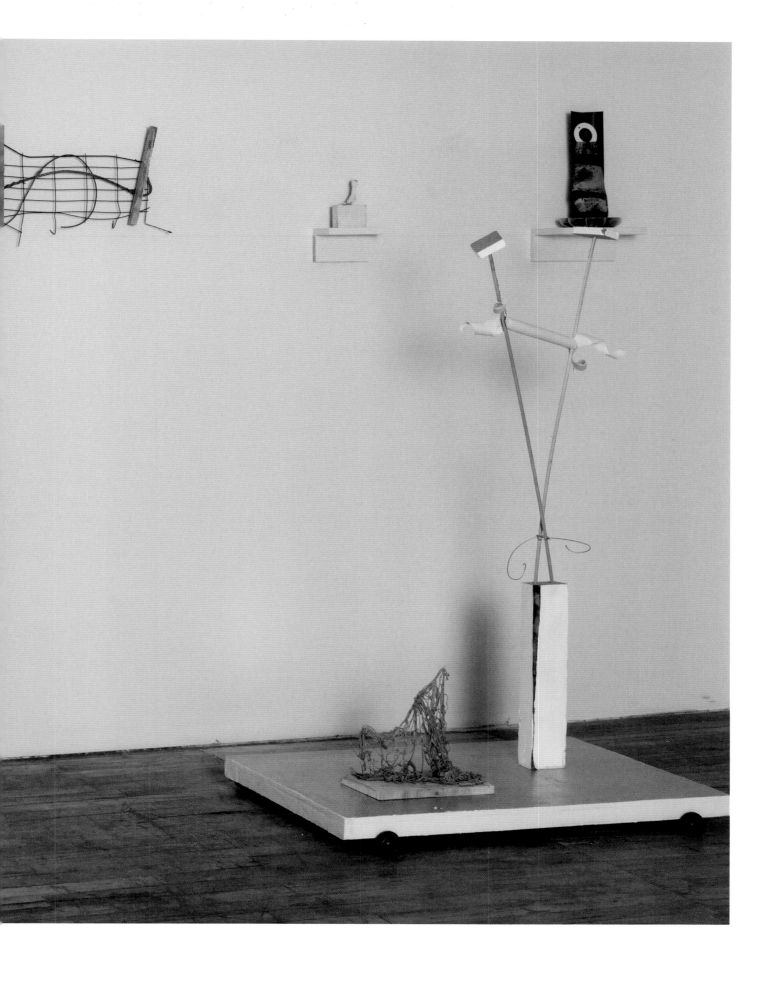

Carrie Moyer
Carnivalesque, 2012
Acrylic, glitter, graphite on canvas,
60 x 48"
Courtesy of the artist

Loren Munk
The Myth of the Avant-Garde,
1900–2000, 2013
Oil on linen, 30 x 24"
Courtesy of the artist

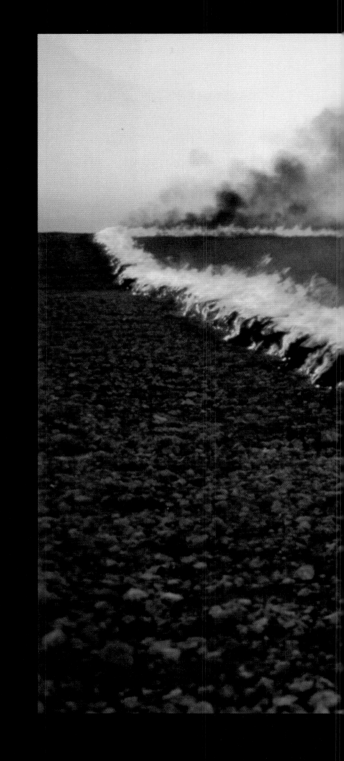

Shirin Neshat
Passage, 2001
Production still
© Shirin Neshat. Courtesy
Gladstone Gallery, New York
and Brussels

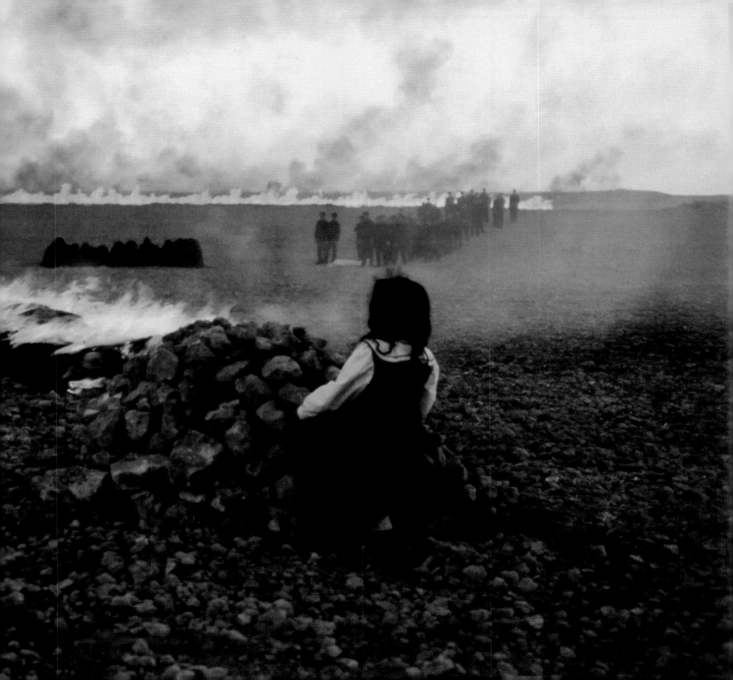

John Newman
Primaries' Retort, 2012
Blown glass, tulle, mutex,
cast acrylic, enamel paint,
10 1/2 x 10 x 8 1/2"
Courtesy of the artist and Tibor de
Nagy Gallery, New York

Jo Nigoghossian
4.9, 2012
Steel, aluminum floral gating,
cement, black spray paint, neon
tube, 65 x 33 x 63";
Xx, 2013
Steel, urethane rubber, silicone
rubber, dupioni silk, polka-dot mesh,
yellow neon, resin, shantung silk,
14 x 116 x 17"
Courtesy of the artist. Photo by
Brian Buckley

Thomas Nozkowski
Untitled (L-5), 2009
Oil on paper, 22 x 30"
© Thomas Nozkowski, courtesy Pace
Gallery. Photo courtesy Pace Gallery

Jennifer Nuss
The Battle at Goat Island, 2004
Gouache and collage on paper,
89 x 89"
Courtesy of the artist. Photo by
Zack Garlitos

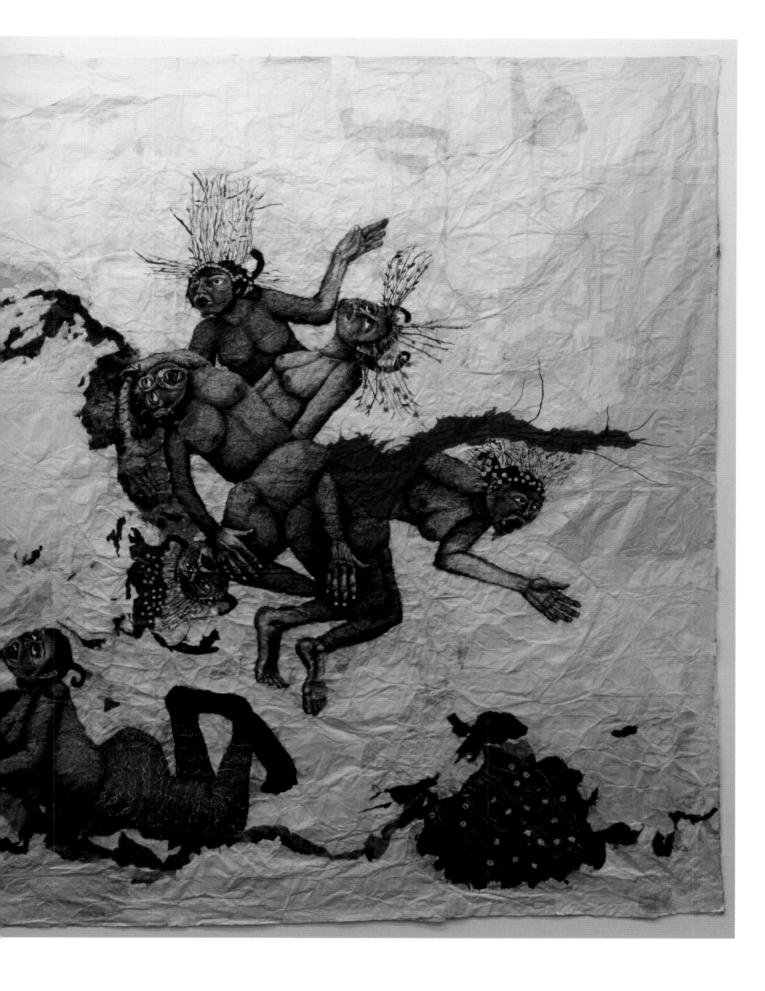

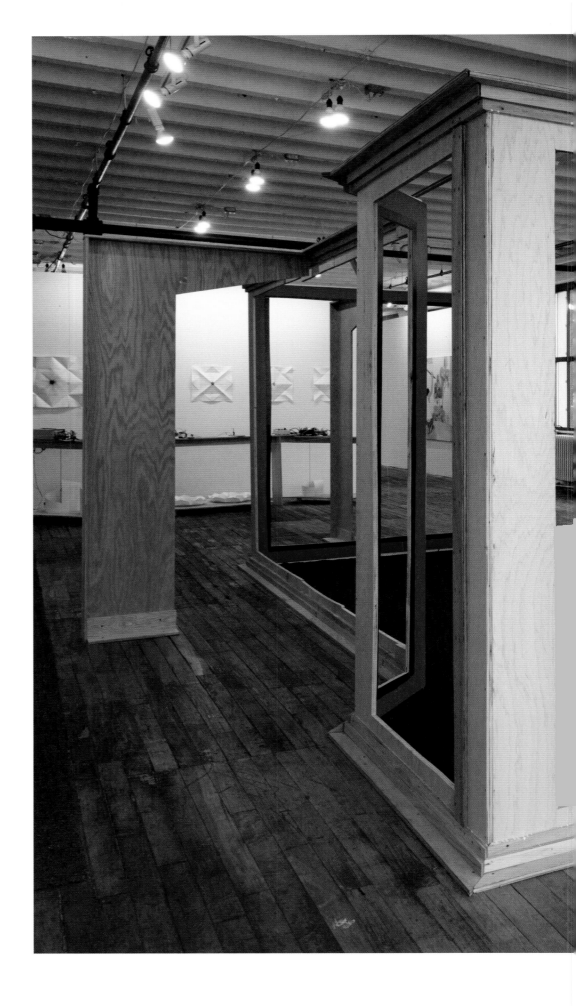

G.T. Pellizzi
The Red and the Black, 2013
Plywood, oil paint, dimensions
variable
Courtesy of the artist. Photo by
Zack Garlitos

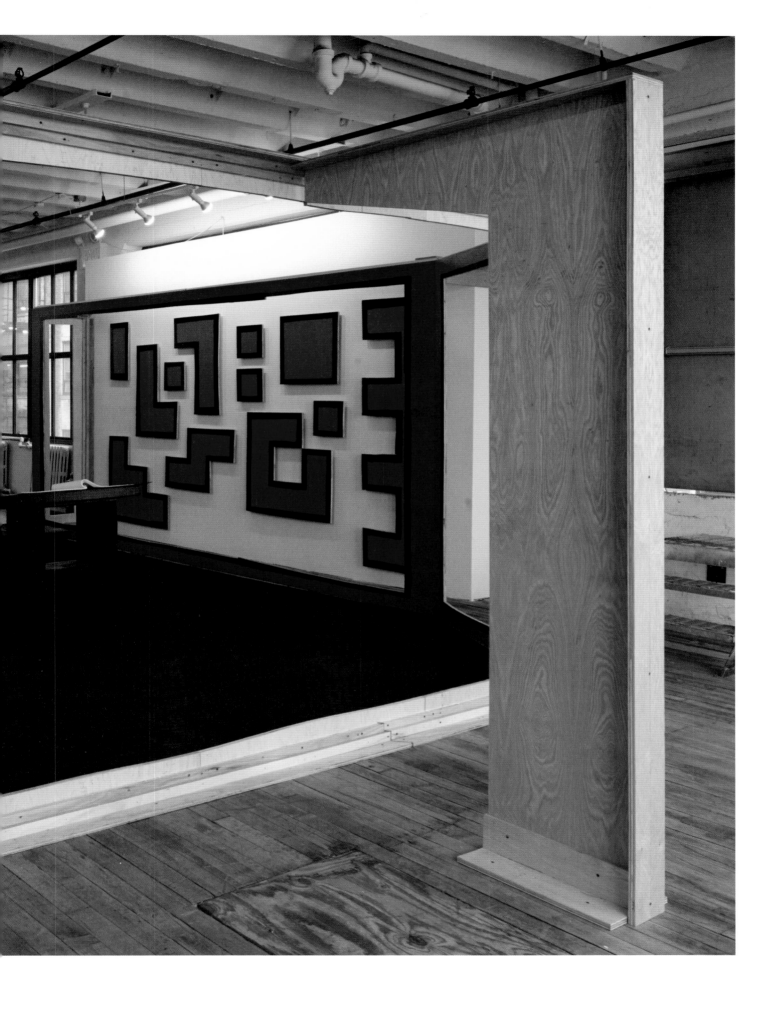

Sheila Pepe
(clockwise)
Modern Votive (painted tripod with),
2010
Painted fabric, metal and wood,
16 x 9 x 9";
*Top Hat with handle thing on white
cylinder*, 2009
Clay and glaze, 9 1/2 x 8 x 4";
Modern Votive (All-white sculpture),
2000
Hydrocal, 8 3/4 x 4 1/2 x 4"
Courtesy of the artist and Carroll
and Sons, Boston. Photo by
Brian Buckley

Ellen Phelan
(left to right)
Dark Woods, 2010
Oil on linen, 80 x 52";
Field through Trees, 2009
Oil on linen, 60 x 40"
Courtesy of the artist. Photo by
Brian Buckley

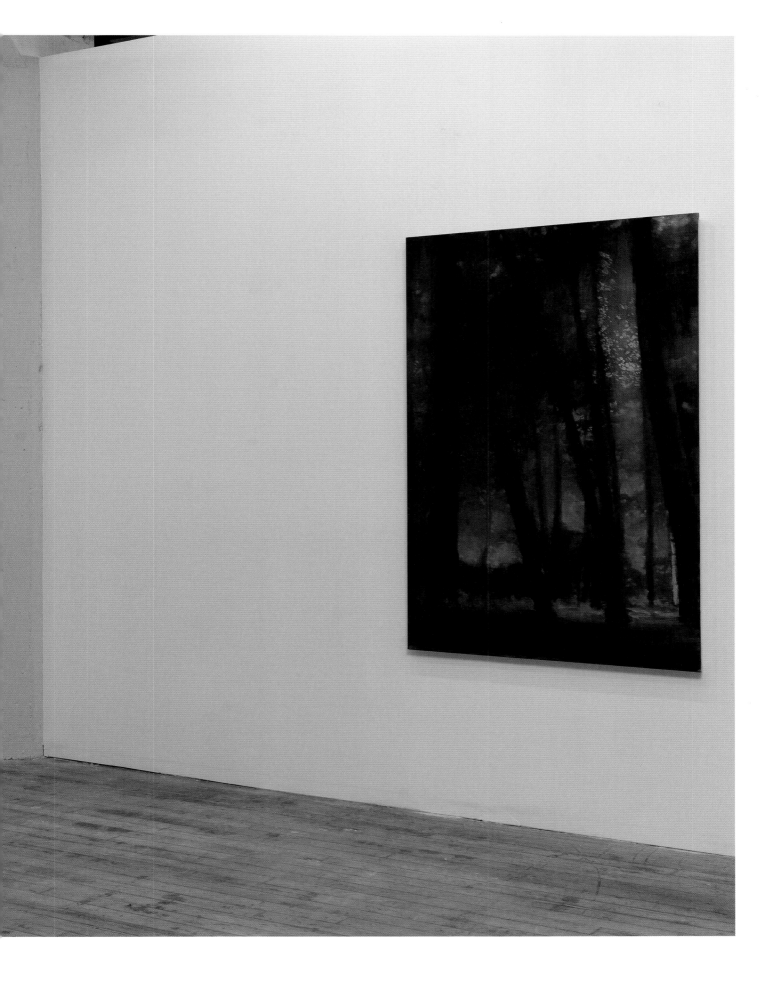

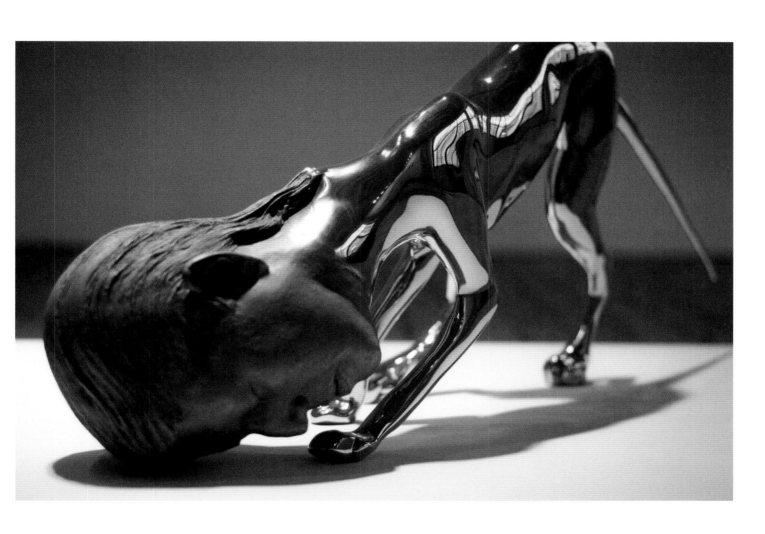

Rona Pondick
Fox, 1998–1999
Stainless steel, 14 1/2 x 8 x 38"
Courtesy of the artist and
Sonnabend Gallery, New York.
Photo by Taylor Dafoe

Joanna Pousette-Dart
2 Part Variation #2 (Red, Yellow, Blue), 2012–2013
Acrylic on canvas on shaped wood panels, 81 x 123"
Courtesy of the artist. Photo by Brian Buckley

Joyce Robins
Grey Rectangle, 2011
Clay, glaze, paint, 7 1/2 x 11 1/2"
Courtesy of the artist

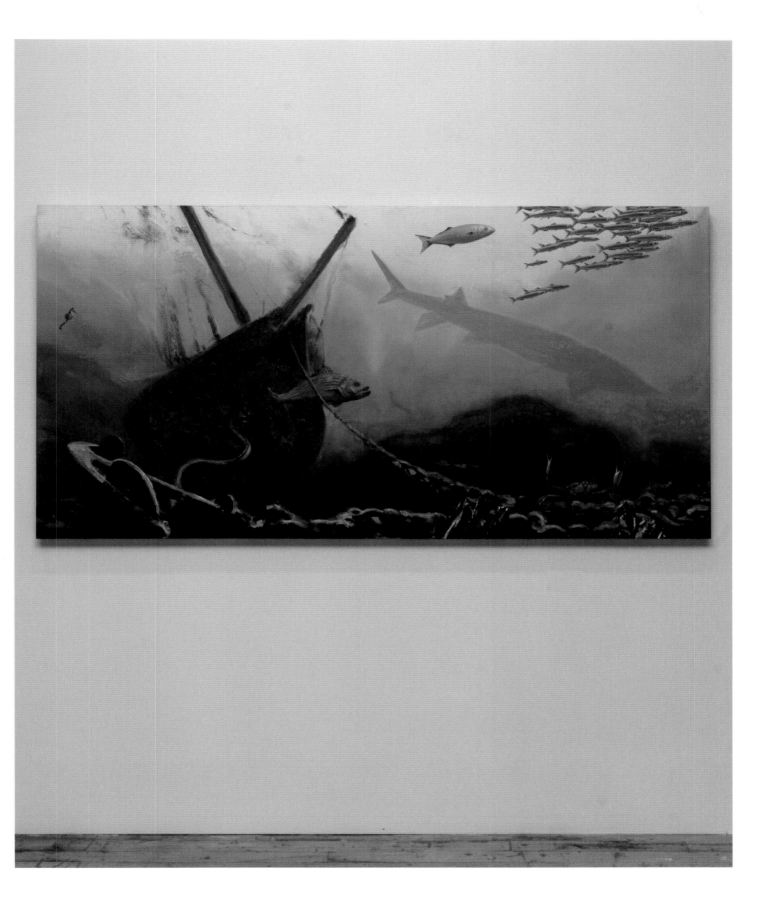

Alexis Rockman
Hudson Estuary, 2011
Oil and alkyd on wood, 40 x 80"
Courtesy of the artist. Photo by
Brian Buckley

Ugo Rondinone
Yellow white green clock, 2012
Stained-glass window and wire,
19 3/4 x 19 3/4"
Courtesy of the artist and Gladstone
Gallery, New York. Photo by
Brian Buckley

Alexander Ross
Untitled, 2007
Oil on canvas, 88 x 120″
Courtesy of the artist and David
Nolan Gallery, New York. Photo by
Brian Buckley

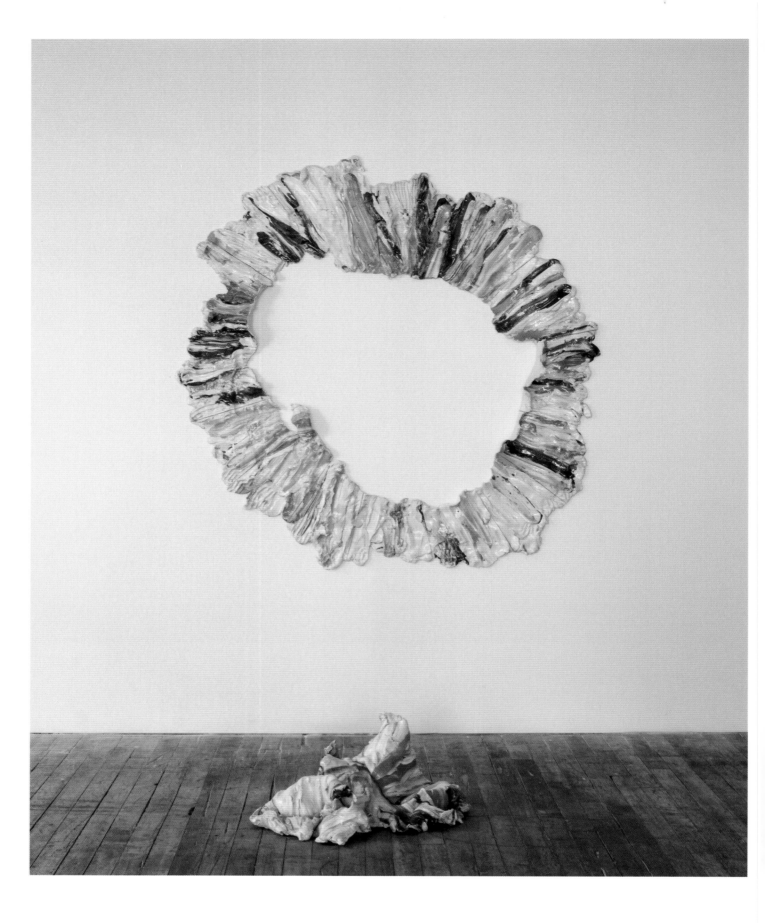

Brie Ruais
Perimeter with Crumpled Center,
2013
Pigmented clay, clear glaze,
hardware; wall-mounted ring:
70 x 72 x 5"; floor piece:
22 x 21 x 13"; floor piece:
18 x 11 x 7"
Courtesy of the artist and Nicole
Klagsbrun, New York. Photo by
Cary Whittier

Ethan Ryman
Untitled Convergence H17, 2013
Archival pigment ink-jet print
on aluminum panel, 37 x 78 x 3"
Courtesy of the artist. Photo by
Rachel Styer

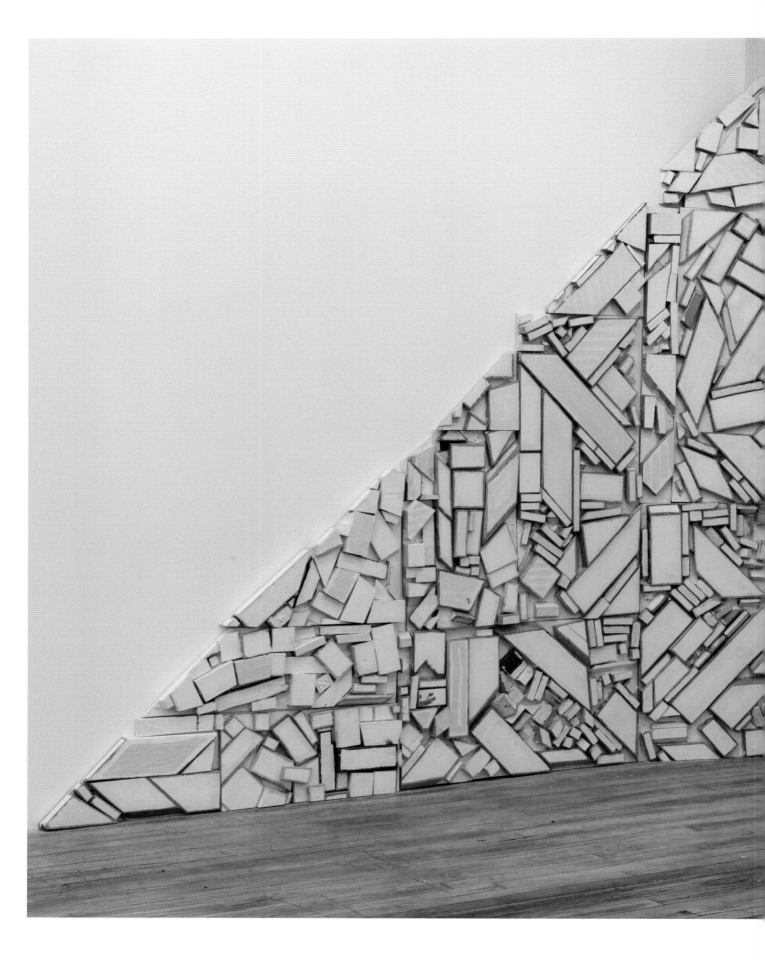

Cordy Ryman
JoDeck Mountain, 2013
Acrylic, enamel, shellac on wood,
232 x 118 x 2 1/2"
Courtesy of the artist and DODGE
gallery, New York. Photo by
Rachel Styer

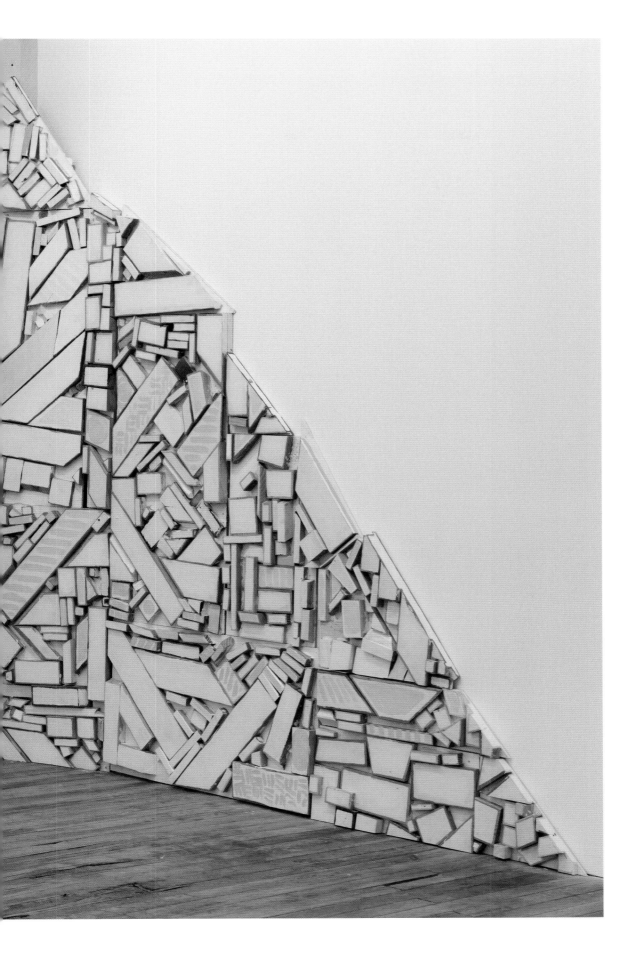

William Ryman
Untitled, 2013
AK-47 bullets cast in resin, spray
paint, wood, epoxy, 61 x 62"
Courtesy of the artist and Paul
Kasmin, New York

242

Katia Santibañez
Between the Waves, 2008
Acrylic on wood, 24 x 24"
Courtesy of the artist and Morgan
Lehmann Gallery, New York. Photo
courtesy Morgan Lehmann Gallery

Bill Schuck
Crests and Waves, 2013
Mixed media, oil on panel,
dimensions variable
Courtesy of the artist. Photo by
Zack Garlitos

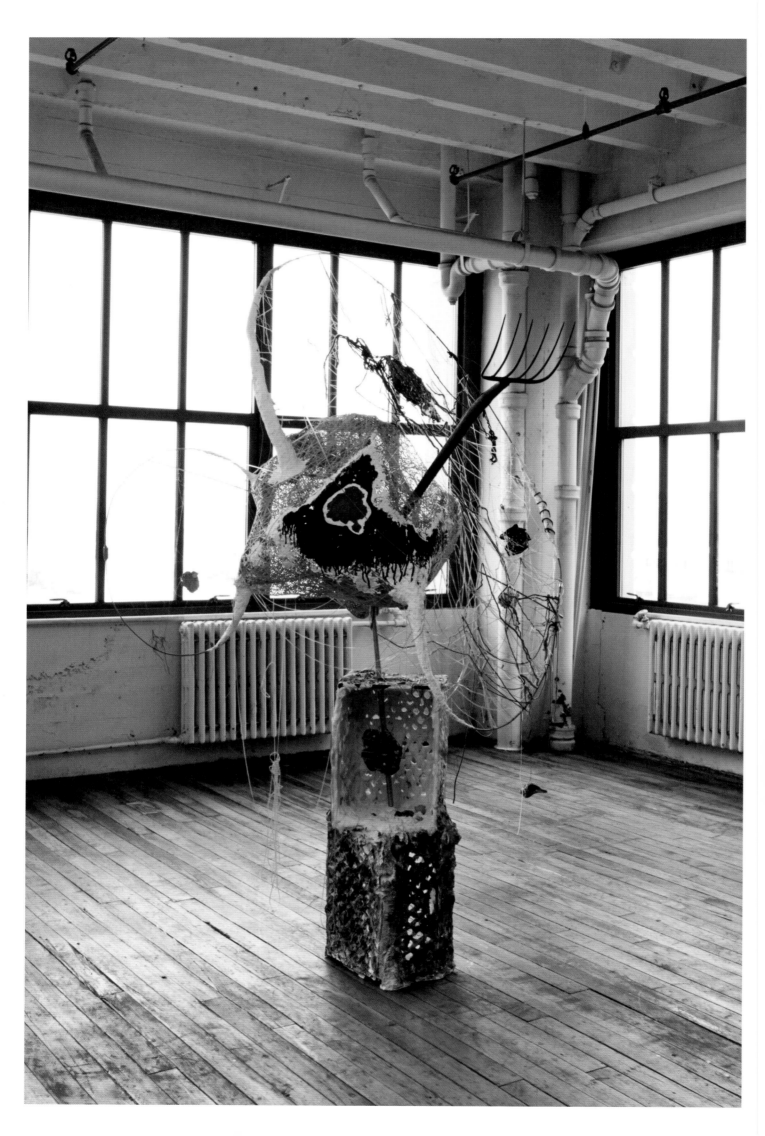

Michelle Segre
The Collector, 2012
Milk crates, plaster, paint, clay,
metal, plastic lace, yarn, thread,
wire, rocks, modeling clay, acrylic,
papier-mache, toothpicks, seashells,
pitchforks, 102 1/2 x 81 x 69"
Courtesy of the artist. Photo by
Zack Garlitos

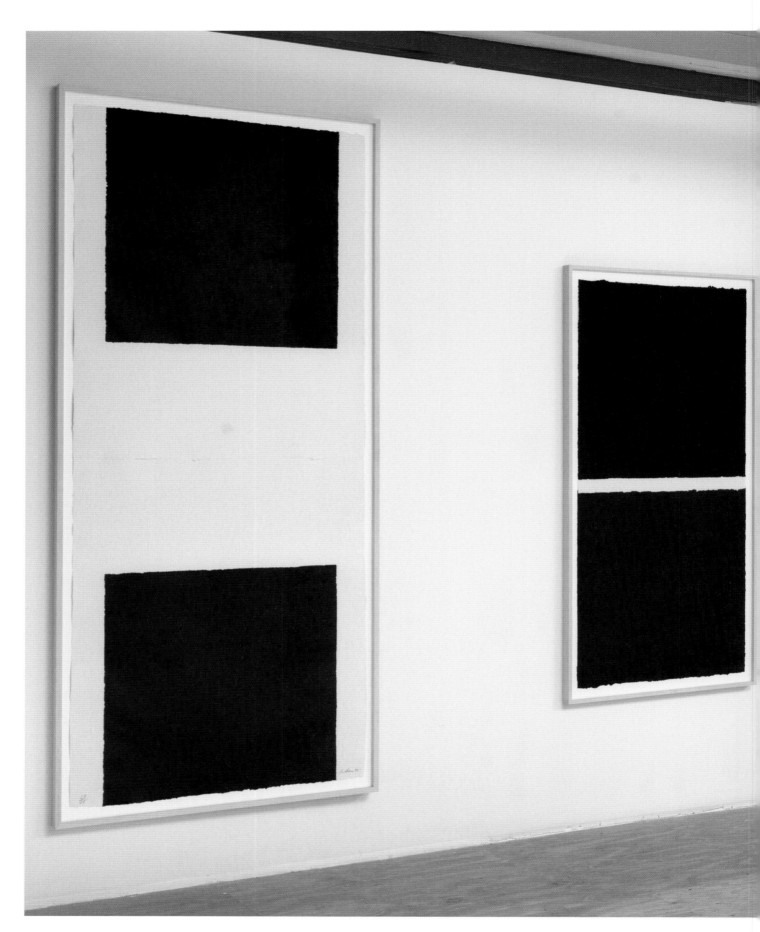

Richard Serra

(left to right)
W.M., 1995
Etching with aquatint on Watson
handmade paper, 96 x 40";
W.M. III, 1996
Etching with aquatint on Watson
handmade paper, 70 x 32";
W.M. II, 1995
Etching with aquatint on Watson

handmade paper, 66 x 32";
W.M. IV, 1996
Etching with aquatint on Watson
handmade paper, 64 x 32";
W.M. V, 1996
Etching with aquatint on Watson
handmade paper, 64 x 40"
Courtesy of the artist. Photograph
by Brian Buckley

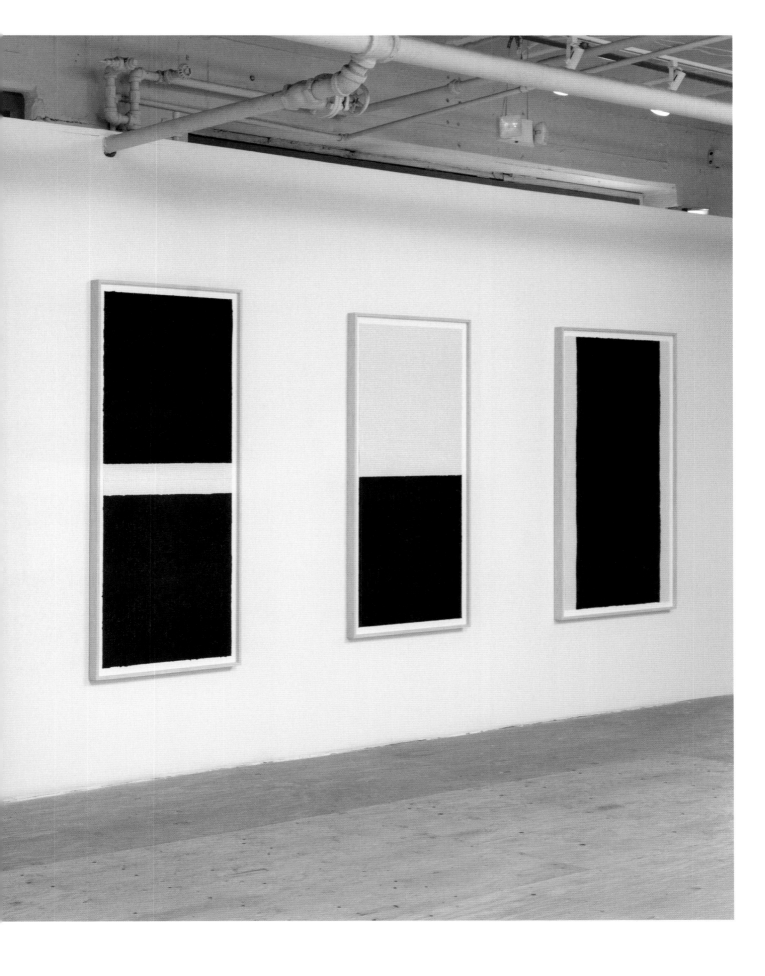

Joel Shapiro
Untitled, 2002–2007
Bronze, 13' 4" x 27' 9 1/2" x 12' 11"
Courtesy of the artist and Pace
Gallery. Photo by Brian Buckley

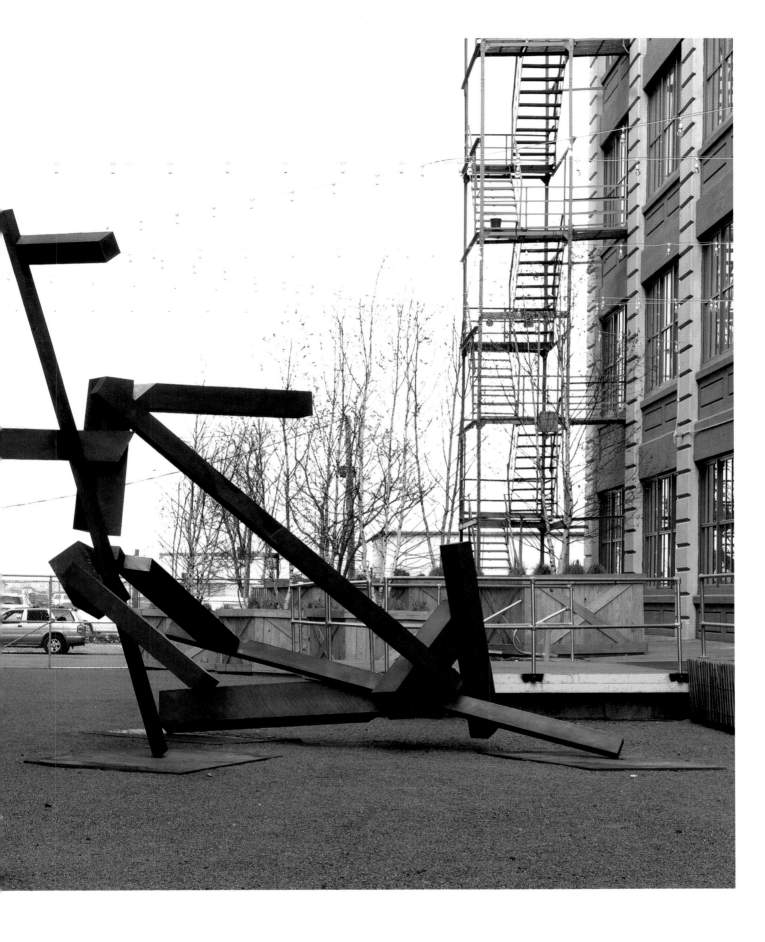

Sienna Shields
Untitled 37, 2013
Painted paper, acrylic, 80 x 80"
Courtesy of the artist

James Siena
Leviathan, 2009–2011
Enamel on aluminum,
29 1/16 x 22 11/16"
© James Siena, courtesy Pace
Gallery. Photo courtesy Pace Gallery

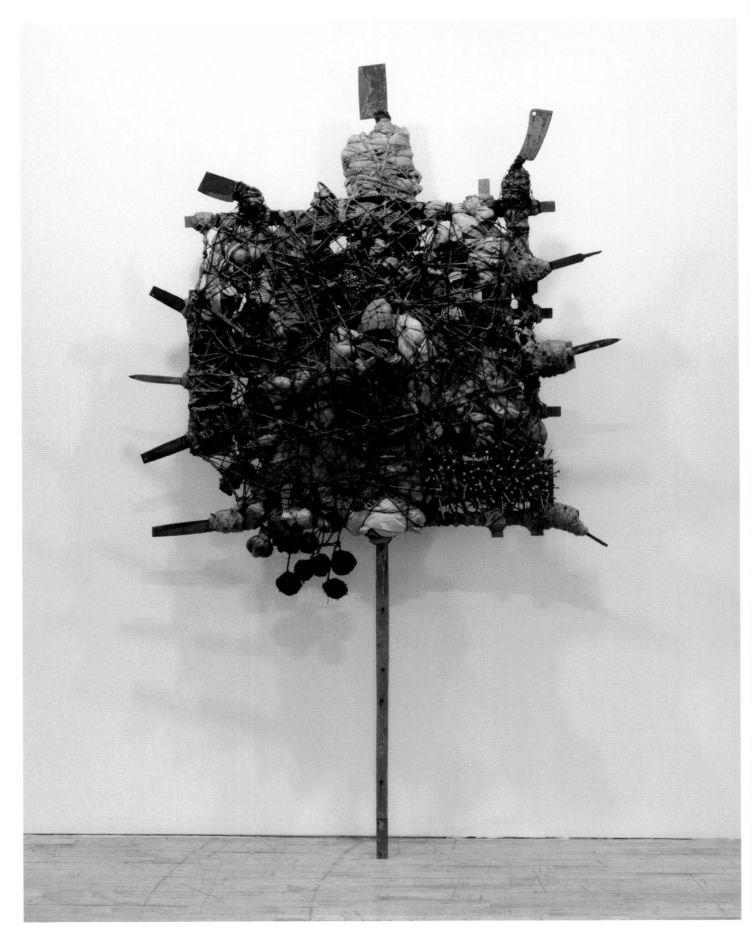

Arthur Simms
To Explain, Expound And Exhort,
To See, Foresee And Prophesy,
To The Few Who Could Or Would
Listen, 1995
Rope, wood, glue, knives, plastic,
metal, objects, 111 x 67 x 21"
Courtesy of the artist. Photo by
Rachel Styer

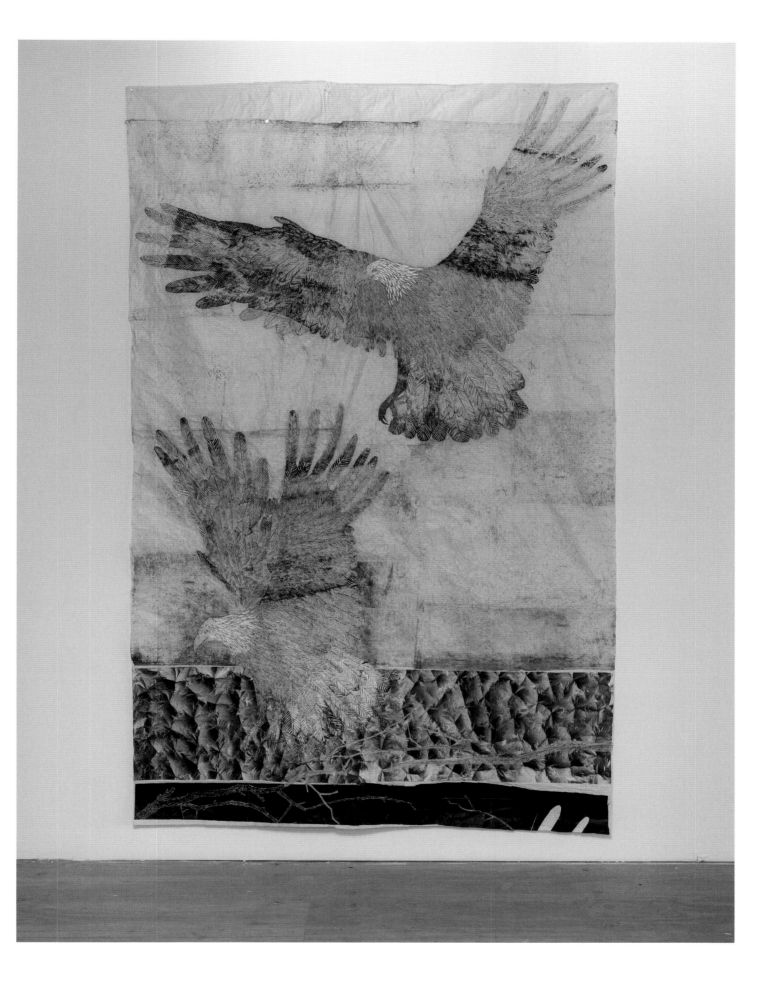

Kiki Smith
Guide, 2012
Ink on Nepalese paper, 9' 10" x 70"
Courtesy of the artist and Pace
Gallery. Photo by Brian Buckley

Ray Smith
Chico Huevon, 1987
Wood, tin, dimensions variable
Courtesy of the artist. Photo by
Brian Buckley

Colin Snapp
NV Regional, 2012
Single channel digital video,
TRT 90 minutes
Courtesy of the artist

Bosco Sodi
Untitled, 2013
Mixed media on canvas,
78 3/4 x 110 1/4"
Courtesy of the artist and Pace
Gallery. Photo by Rachel Styer

Gary Stephan
Untitled, 2013
Acrylic on canvas, 40 x 30";
Food Museum, 2013
Acrylic on canvas, 40 x 30";
Untitled, 2013
Acrylic on canvas, 40 x 30"
Courtesy of the artist. Photo by
Rachel Styer

Robert Storr
Suzy Fishing, 2002–2012
Flasche on board, 20 x 24"
Courtesy of the artist. Photo by
Zack Garlitos

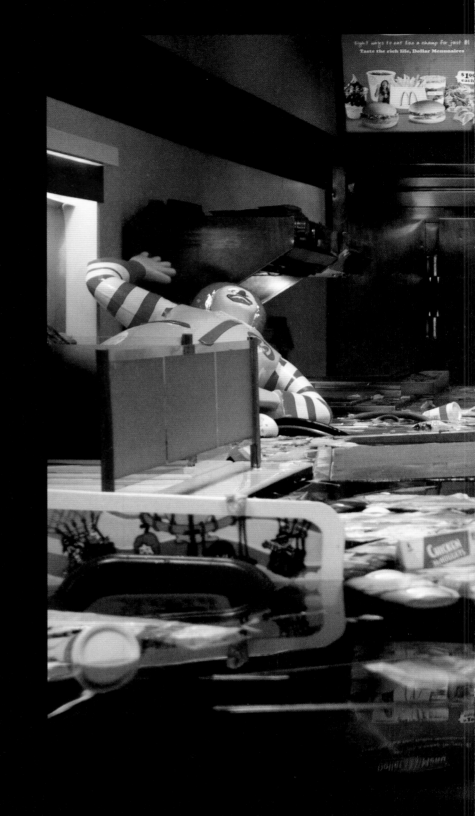

SUPERFLEX
Flooded McDonald's, 2008
Filmed on RED, PAL, TRT 21 minutes
Courtesy of the artist and Peter Blum
Gallery, New York

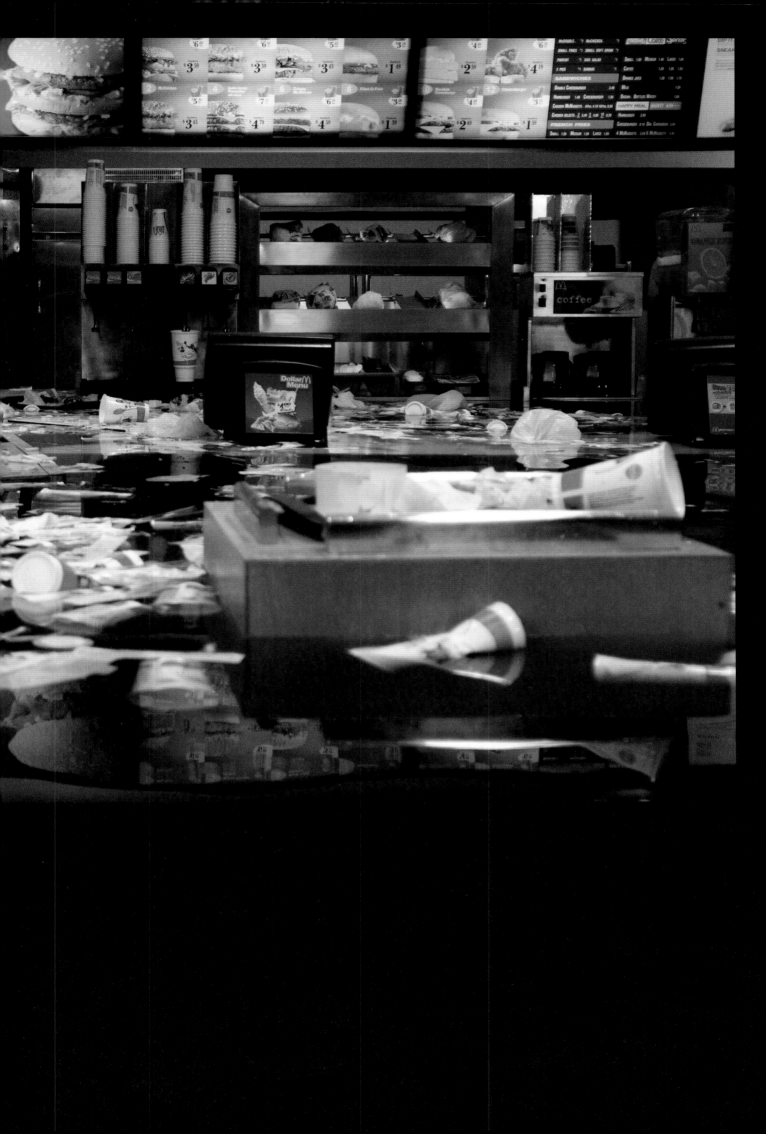

Lee Tribe
(left to right)
Orator II, Dignity, 2013
Formed, welded steel, dimensions
variable;
Orator I, Wisdom, 2013
Formed, welded steel, dimensions
variable
Courtesy of the artist. Photo by
Brian Buckley

Daniel Turner
Untitled, 2013
Maple, mdf, polyethylene,
aluminum, stainless steel, steel
wool, vinyl, saltwater, 24 x 28 x 108"
Courtesy of the artist. Photo by
Brian Buckley

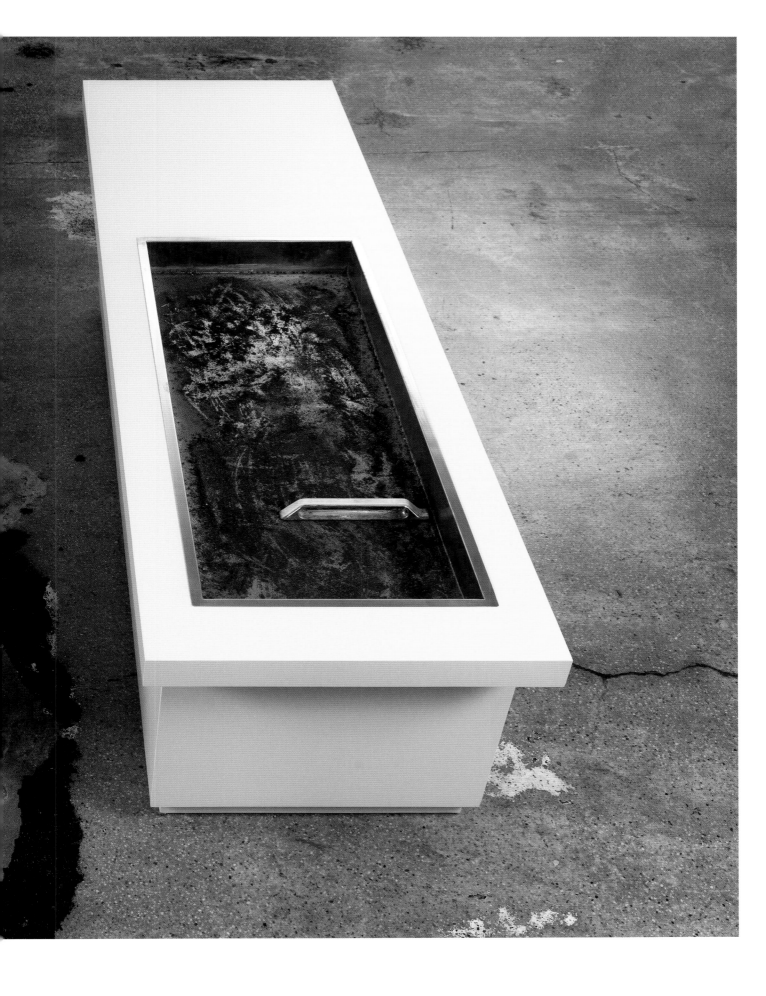

Don Voisine
(left to right)
Projector, 2012
Oil on wood panel, 18 x 18"; *Incorrigible*, 2011
Drop, 2011 Oil on wood panel, 18 x 18"
Oil on wood panel, 18 x 19"; Courtesy of the artist and McKenzie
Stygian Sky, 2012 Fine Art, New York. Photo by
Oil on wood panel, 18 x 19"; Brian Buckley

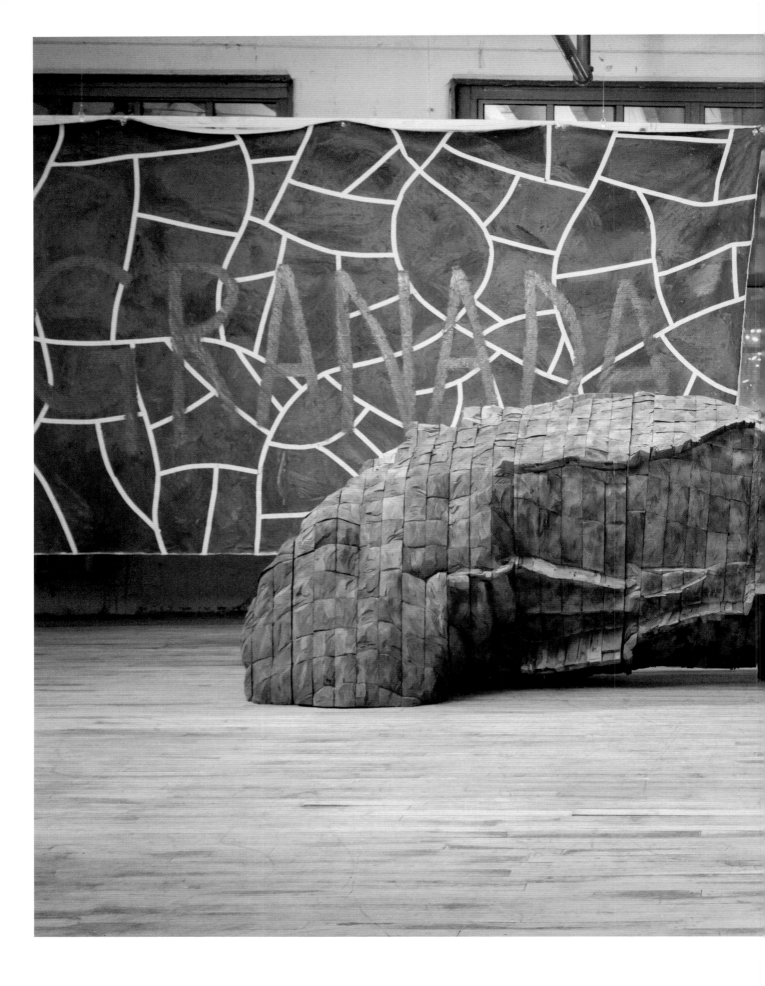

Ursula von Rydingsvard
Ocean Voices, 2011–2012
Cedar, graphite, 53 x 185 x 67"
Courtesy of the artist and Galerie
Lelong, New York. Photo by
Rachel Styer

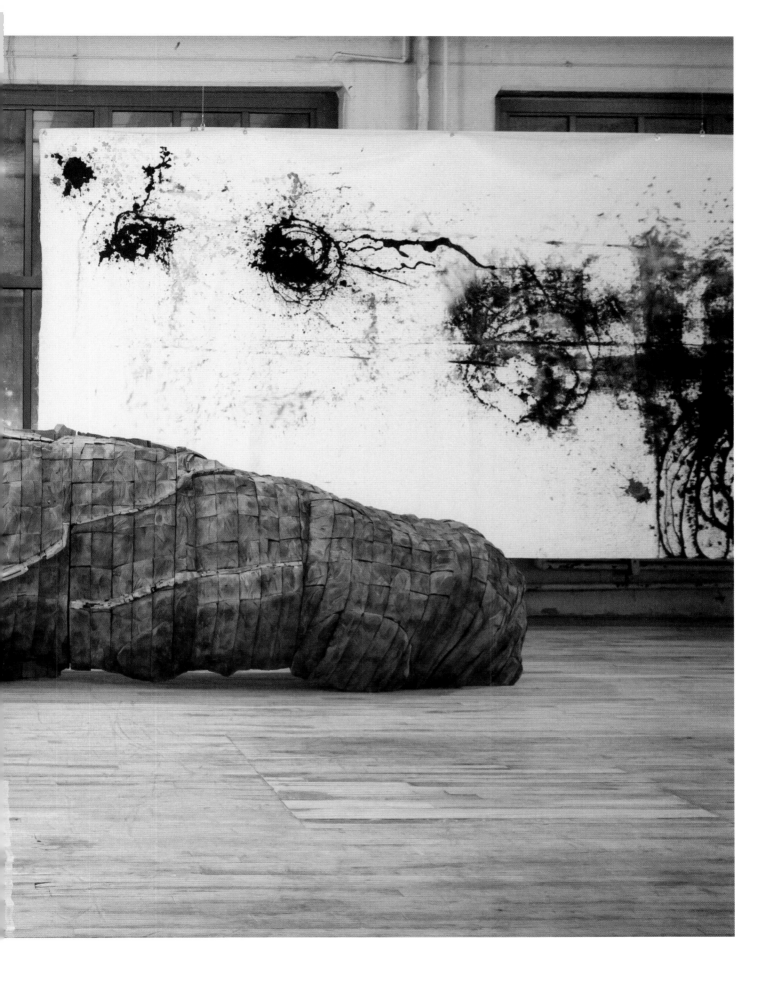

Tomas Vu
*Dark Side of the Moon, Side 2
(Eclipse)*, 2013
Oil on panel with collage, 84 x 96"
Courtesy of the artist. Photo by
Zack Garlitos

Merrill Wagner
Tsunami, 2013
Rust preventative paint on steel
snowplow parts, 52 x 84 1/2"
Courtesy of the artist. Photo by
Rachel Styer

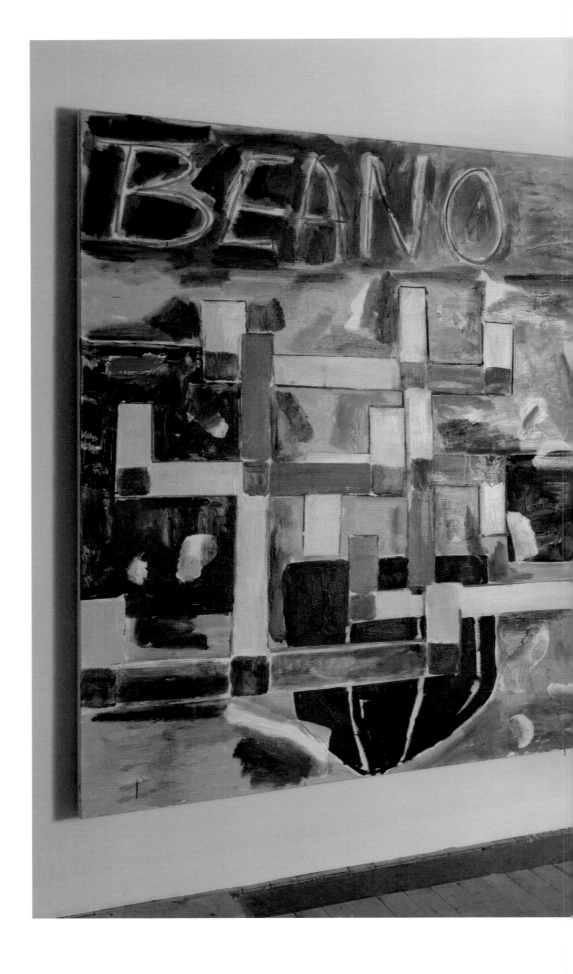

John Walker
Looking out to Sea III, 2013
Oil on canvas, 7 x 5 1/2';
Back and Forth, 2013
Oil on canvas, 7 x 5 1/2';
Coastal Touch, 2013
Oil on canvas, 7 x 5 1/2'
Courtesy of the artist. Photo by
Brian Buckley

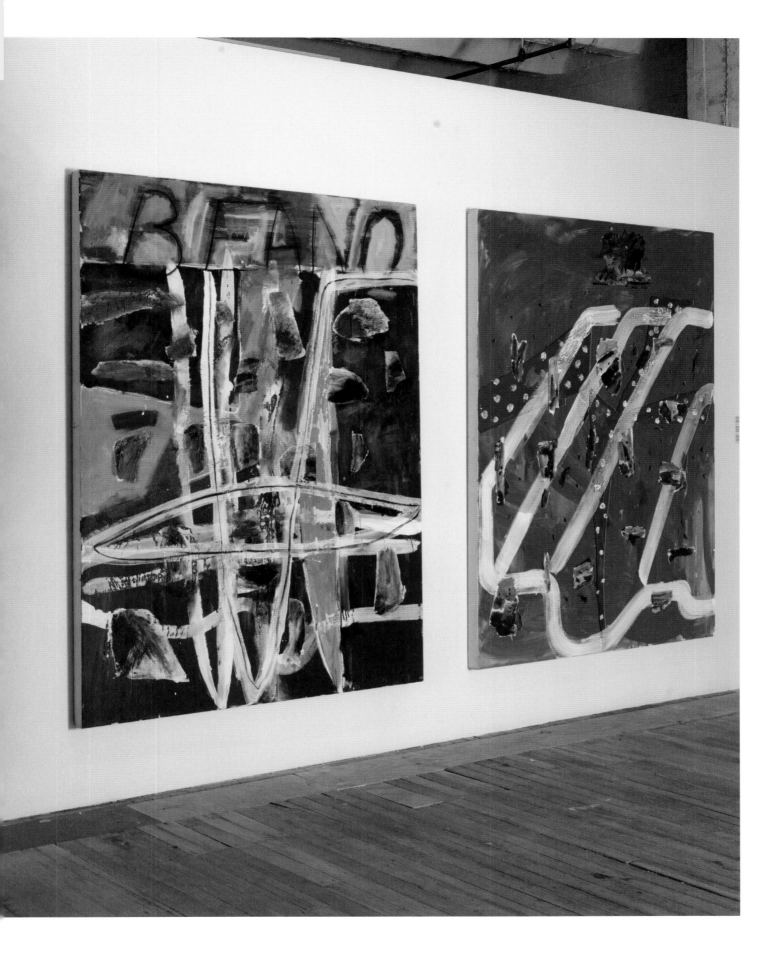

Nari Ward
We the People, 2011
Shoelaces, dimensions variable
Courtesy of the artist and Lehmann
Maupin Gallery, New York. Photo by
Brian Buckley

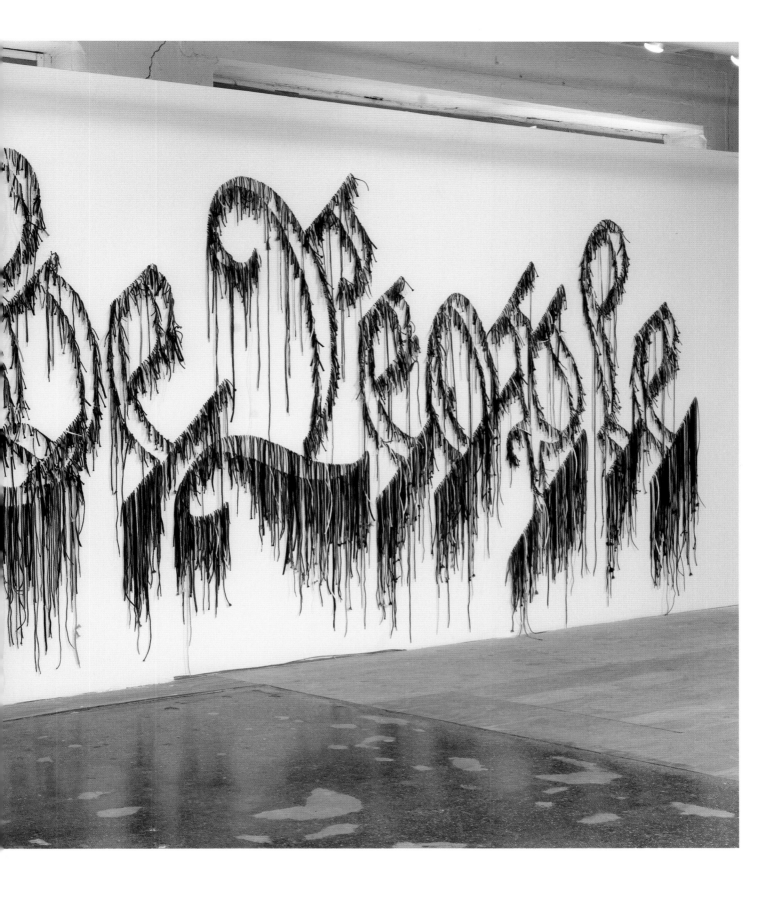

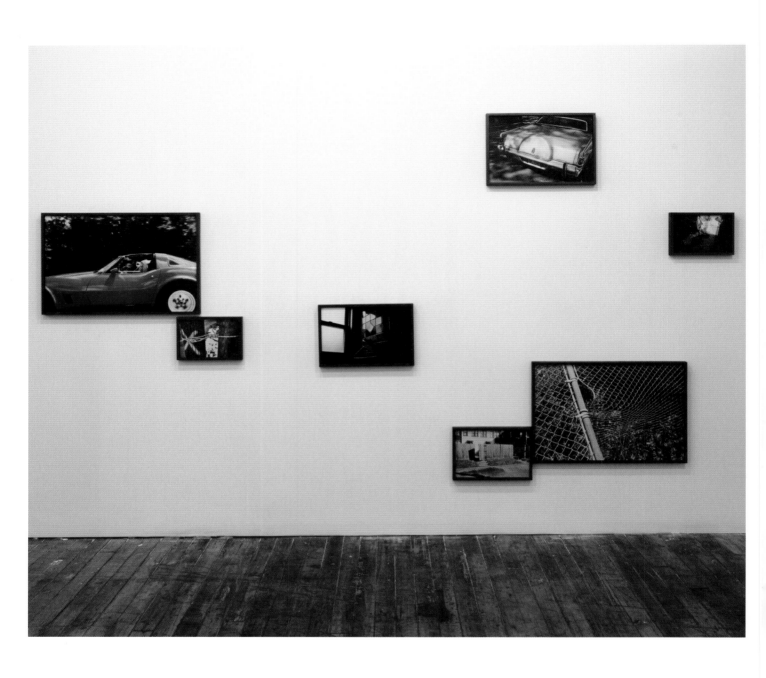

Nat Ward
Say Grace, 2013
7 photographs, 8 x 10'
Courtesy of the artist. Photo by
Zack Garlitos

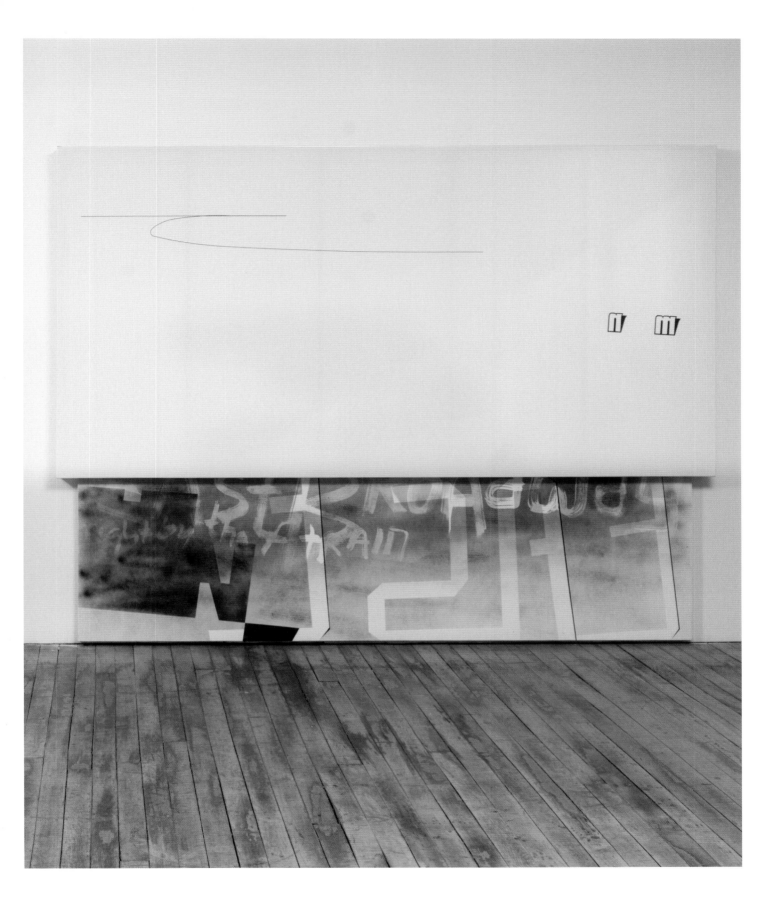

Wendy White
By the F Train, 2013
Acrylic on canvas, steel, inkjet print
on PVC, 91 x 115 x 4"
Courtesy of the artist. Photo by
Brian Buckley

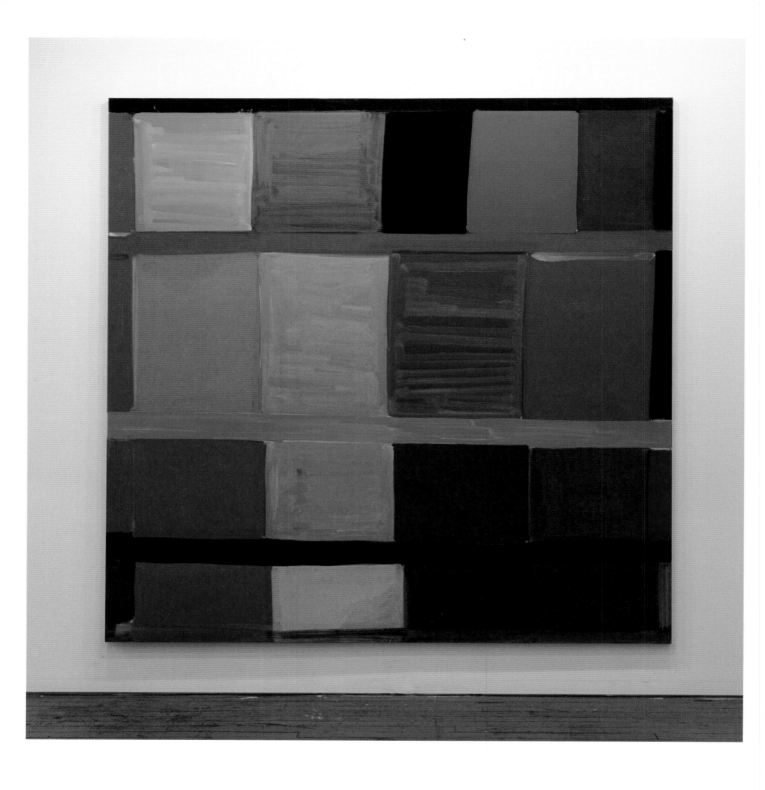

Stanley Whitney
Heart and Brains, 2012
Oil on linen, 96 x 96"
Courtesy of the artist and Team
Gallery, New York. Photo by
Zack Garlitos

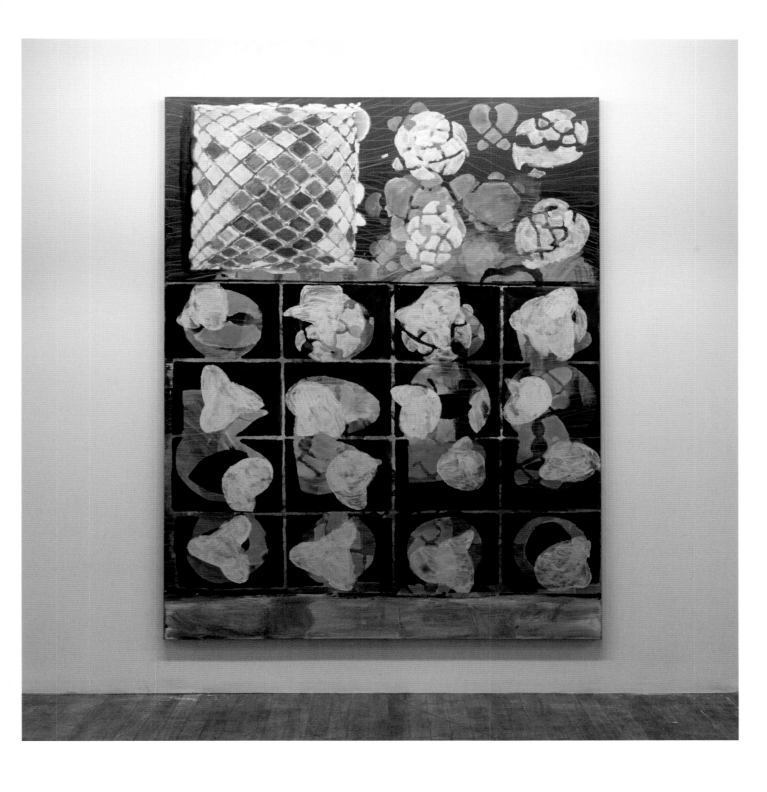

Terry Winters
Deformation Tools, 2008
Oil on linen, 99 x 76 1/2"
Courtesy of the artist. Photo by
Zack Garlitos

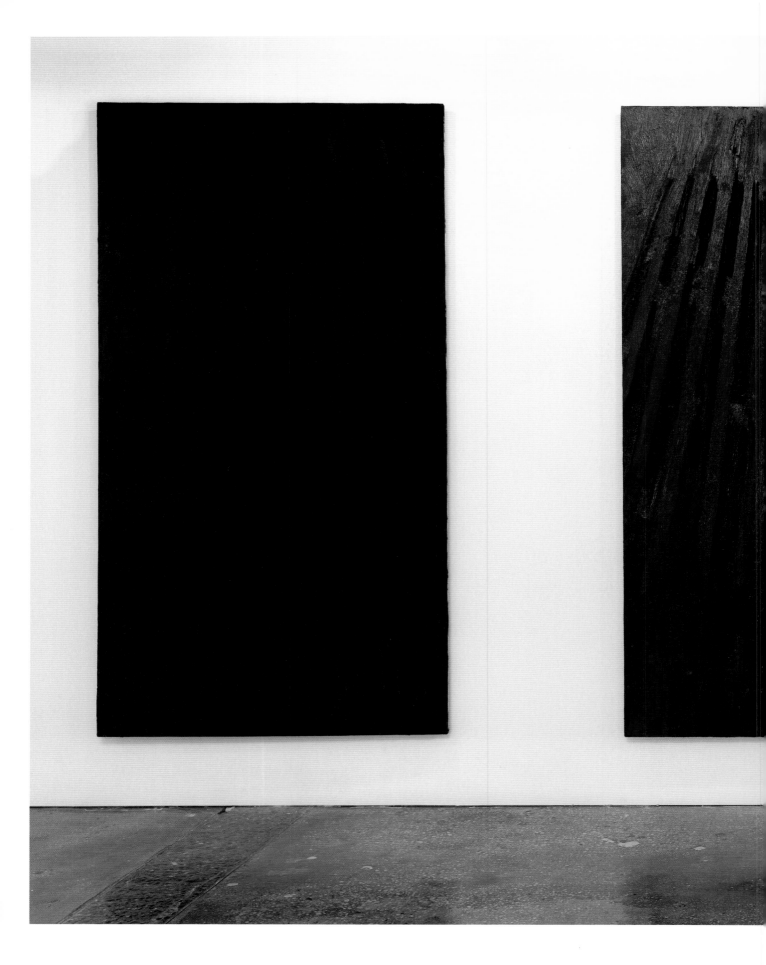

Nicole Wittenberg
(left to right)
Fox News 5, 2013
Oil on canvas mounted on panel,
96 x 48";
Fox News 4, 2013
Oil on canvas mounted on panel,
96 x 48";

Fox News 2, 2013
Oil on canvas mounted on panel,
96 x 48"
Courtesy of the artist. Photo by
Brian Buckley

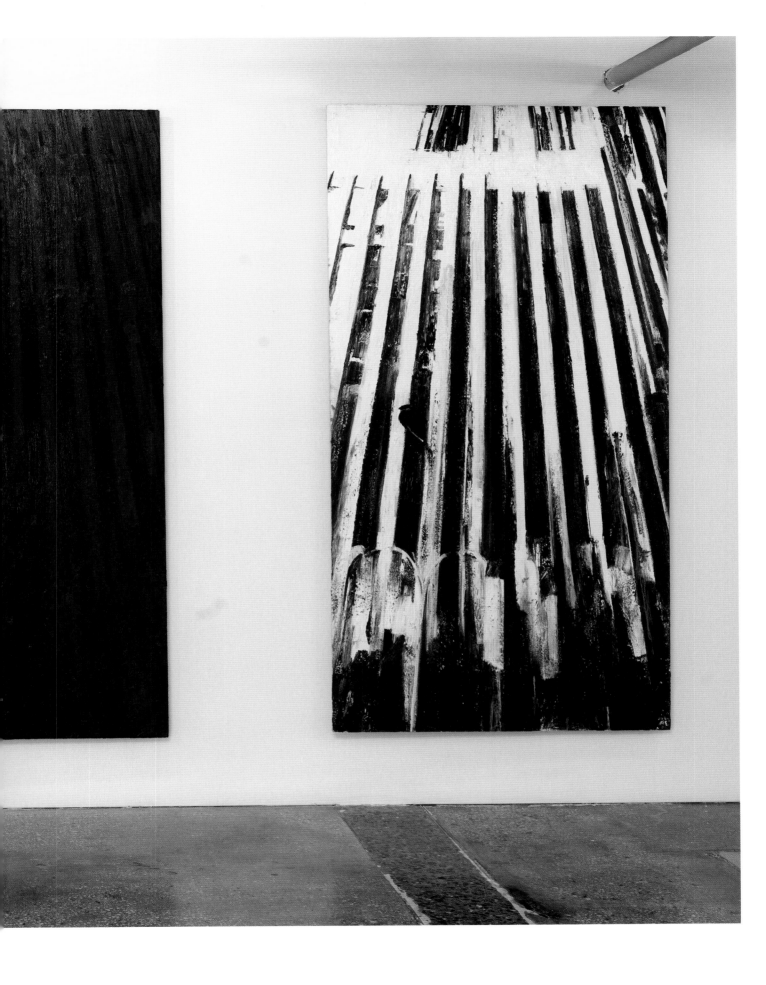

Bob Witz
Apollon-Musagète, 2011
Bronze, dimensions variable
Courtesy of the artist. Photo by
Brian Buckley

Will Yackulic
Enigma Variations (Portraits), 2013
Stoneware, cork, wax, unknown
contents, dimensions variable
Courtesy of the artist and Jeff Bailey
Gallery, New York. Photo by
Phillip Maisel

Dustin Yellin
The Triptych, 2013
Glass, acrylic, collage,
49 x 216 x 27", 24,000 lbs.
Courtesy of the artist. Photo by
David Deng

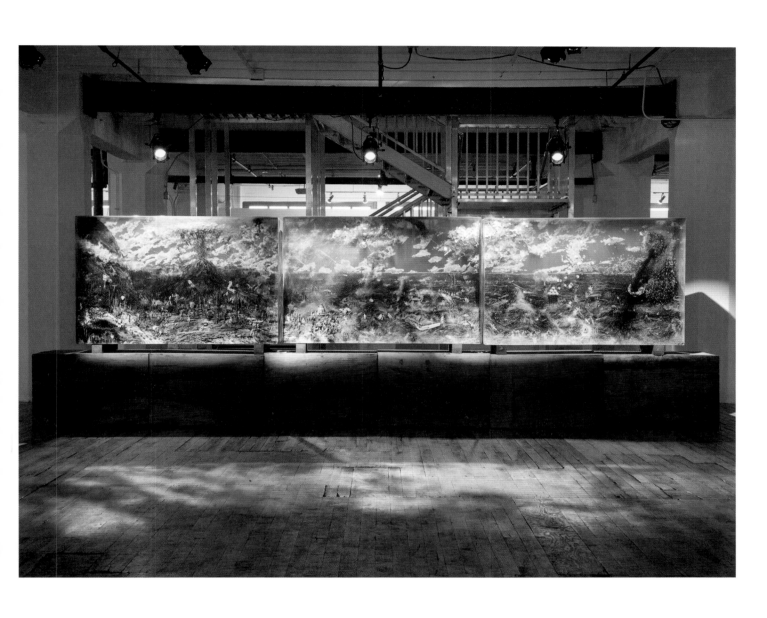

Lisa Yuskavage
A No Man's Land 2, 2013
Monoprint with pastel additions,
40 x 60"
Courtesy of the artist and Universal
Limited Art Editions

Joe Zucker
Untitled (Mop Painting), 2013
Cotton, wood, acrylic, 78 x 78"
Courtesy of the artist and Mary
Boone Gallery, New York